TEMPLE OF SCIENCE

TEMPLE OF SCIENCE

THE PRE-RAPHAELITES AND OXFORD UNIVERSITY MUSEUM OF NATURAL HISTORY

John Holmes

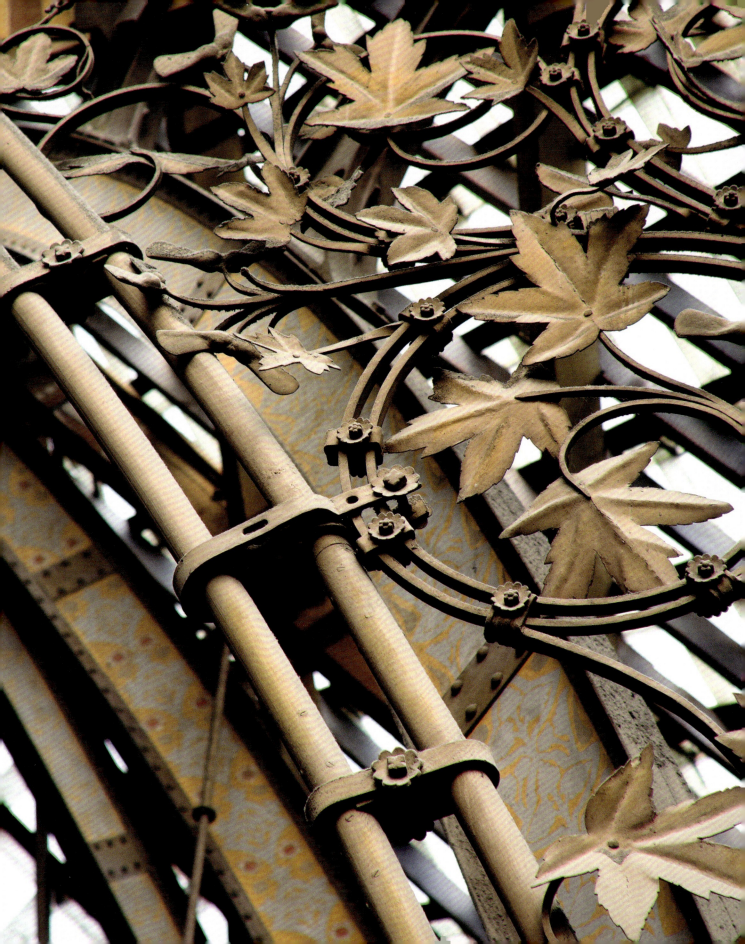

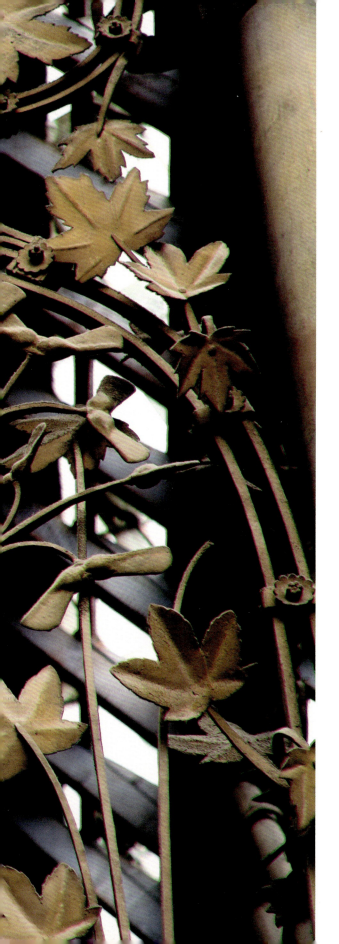

CONTENTS

	ACKNOWLEDGEMENTS	6
	INTRODUCTION	7
1	A Pre-Raphaelite natural history museum	10
2	'God's own Museum' The façade	54
3	The 'Sanctuary of the Temple' The central court	76
4	Building scientific disciplines The lecture rooms and laboratories	108
5	A scientific pantheon The portrait statues	124
6	Babylon	140
7	Legacies	156
	NOTES	170
	FURTHER READING	176
	PICTURE CREDITS	177
	INDEX	178

Acknowledgements

The first and biggest thank you for this book goes to the Oxford University Museum of Natural History itself. Since 2012, I have had the wonderful opportunity to work with the museum on several arts projects as well as to research its own art and architecture. The support and enthusiasm of the Director, Professor Paul Smith, and his team have been unfailing, and working with them has been one of the great pleasures of my professional life. Aside from Paul, especial thanks go to Scott Billings, who took several of the photos in this book, and to Ellie Grillo and Kathy Clough, who masterminded the museum's major arts projects in 2016 and 2019 respectively. I hope this book will underscore the extent to which the museum was born out of the union of the arts and sciences, and provide an inspiration and a resource for future reunions there and elsewhere.

As well as the museum, I would like to thank the Guild of St George and particularly its recent Master, Clive Wilmer. Although I had been fantasizing about writing this book for some time, it was a conversation over dinner with Clive in an Oxford pub that led me to revive and pursue the idea. Other conversations have shaped my thinking about the Oxford University Museum and natural history museum architecture more generally. Many of the most productive have been with Janine Rogers, Stefanie Jovanovic-Kruspel, Anita Hermannstädter, Will Tattersdill, Verity Burke, Helen Goulston and Claire Jones, so 'thank you' to you all.

Finally, I would like to thank Samuel Fanous, Janet Phillips and Leanda Shrimpton, along with their colleagues at Bodleian Library Publishing, for inviting me to write this book, encouraging me to raise my ambitions for it, and agreeing to publish it once it was written. The text has gained hugely from Janet's advice, the guidance of the Bodleian's anonymous peer-reviewer and Alison Effeny's meticulous and sensitive copy-editing. At the same time, the text is only one component of the book. Leanda's advice on and help with the selection of the illustrations, and the Bodleian team's production of the images themselves, have made this book what it is. I am delighted to have had this chance to work on such a beautiful record of the museum's art and architecture, and am very grateful indeed to the Bodleian for making a book I had dreamt of writing for so long into a piece of fine art in its own right.

Introduction

In July 1847, four Oxford dons signed a public memorandum calling for a museum to be built to set the teaching of science at Oxford University on a firm footing for the first time. A little over a year later, seven young artists met at a house in Bloomsbury to found the Pre-Raphaelite Brotherhood, committing themselves to the principle of truth in painting, poetry and sculpture. This book tells the story of how these two groups of men – scientists from the oldest university in England and the most controversial artists of the day – collaborated on the new museum. Built to be Oxford's first science faculty, its architecture was a hymn to science and nature. It combined the Gothic style with modern engineering, and cast a scientific vision of the natural world in stone, iron and glass. The very building itself was to be an education in science, teaching geology and natural history through its fabric and decoration, experimenting with new architectural principles and showing technology at work. To do this, it fused science with art, following the example of the Pre-Raphaelites themselves, drawing on their expertise as designers and employing them to sculpt the statues for a pantheon of great scientists.

Built by the Irish firm of architects Deane & Woodward (figure 1), the Oxford University Museum of Natural History (as it is now known) was the product of this pioneering collaboration between dynamic modern artists and scientists committed to teaching students and the public about the natural world. From a scientific perspective, it was the first building to communicate a complex, detailed conception of nature through architecture. Its vision of nature was grounded in its own age, but it has proven subtle and malleable enough to move with the times, keeping pace with changes in science itself. Even as the museum itself has changed its meanings, its legacy has shaped natural history museums across the world, from the Natural History Museum in London, built in the 1880s, to the Michael Lee-Chin Crystal at the Royal Ontario Museum in Toronto, which opened in 2007. As a site of art and design, the museum stands at the fountainhead of the Arts and Crafts movement and has a good claim to be the greatest single work of Pre-Raphaelite art. It is unquestionably the best place to see how the Pre-Raphaelite movement expressed and fulfilled itself in sculpture and architecture. In the end, though, there is no separating science from art at the Oxford museum. The building is a rare attempt to realize a comprehensive scientific vision in art, and a compelling witness to the fact that the two disciplines enrich one another, advancing each other's ends as well as their own when they work together.

FIGURE 1 Monogram for Deane & Woodward from their contract drawings for the museum, 1855.

1 A Pre-Raphaelite natural history museum

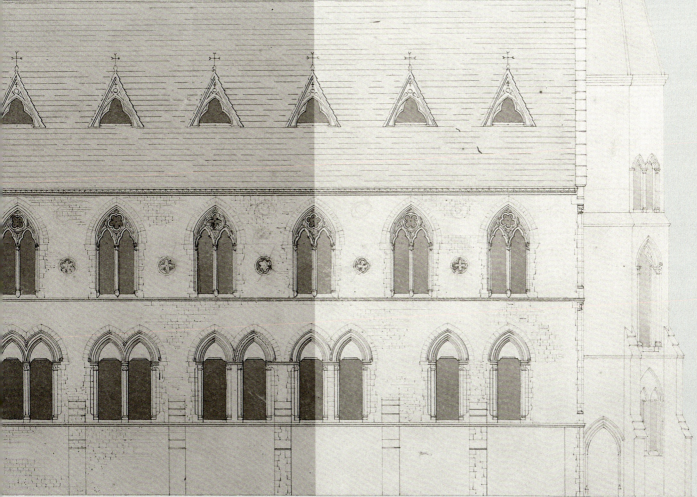

FIGURE 2 *previous spread* One of Benjamin Woodward's contract drawings for the museum, 1855, showing the façade.

FIGURE 3 *opposite* The Old Ashmolean Museum, now the History of Science Museum, Oxford. One of the first public museums in the world, the Ashmolean opened in 1683. It was the precursor to both the current Ashmolean Museum and the Oxford University Museum of Natural History.

In summer 1847 the British Association for the Advancement of Science (now the British Science Association) came to Oxford. Over a thousand people attended this annual festival.[1] It had last been held in Oxford fifteen years before, only a year after the British Association was founded. Throughout that time, science had struggled to establish itself at Oxford University. There had been a great deal of institutional inertia and not a little active resistance. Attendance was in decline at the few scientific lecture courses that did exist, and Oxford was falling conspicuously behind other centres of education and research. Laboratories, museums and even designated science colleges were springing up around the country. Back in the 1820s, University College London had established its own anatomy museum, now known as the Grant Museum after its founder, Robert Grant, who had taught Charles Darwin at Edinburgh before moving to London. The Royal College of Chemistry had opened on Oxford Street in 1845, while in 1846 a young physicist, William Thomson – who would end his career as Lord Kelvin – had begun pioneering laboratory research and teaching in Glasgow. Cambridge too was about to start teaching its natural sciences tripos.[2] In spite of the buzz caused by the British Association meeting, Oxford was looking increasingly behind the times.

A science faculty for Oxford

To capitalize on the moment, four Oxford academics wrote an open memorandum to the University on 12 July 1847, calling for it to build proper facilities for teaching science.[3] The most senior of them was Philip Bury Duncan, who was already in his mid-seventies. Duncan had been the Keeper of the Ashmolean Museum (figure 3) since 1826. He had been agitating for better facilities for teaching science at Oxford on and off throughout his long career, but as yet to little effect. Next oldest was Charles Daubeny (figure 4). Daubeny was the driving force behind the campaign for Oxford to integrate science fully into its curriculum. By now in his early fifties, he was a polymath who had studied classics at Oxford but ended up attending lectures on chemistry and geology, before going on to study medicine in London and Edinburgh and botany in Geneva. By 1847 he had

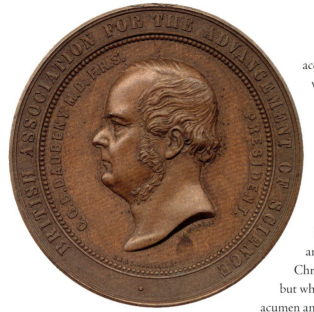

accumulated several professorial chairs at Oxford, beginning with chemistry in 1822, then botany in 1834 and finally rural economy in 1840, as well as being *Horti Praefectus*, as the director of the University's Botanic Garden is still officially known. Daubeny's own research ranged from atomic theory to volcanoes and crop rotation, but it was as an educational reformer that he made his most profound contribution to science. These two senior academics were joined by Robert Walker, the first full-time Reader in Experimental Philosophy at Oxford, then in his late forties, and Henry Wentworth Acland, Lee's Reader in Anatomy at Christ Church. Acland (figure 5) was only in his early thirties, but what he lacked in seniority he more than made up for in acumen and energy. As Victorian Oxford's leading physician and the son of a baronet, he was exceptionally well connected. In 1860 he would accompany the Prince of Wales (later King Edward VII) on a tour of North America as his personal physician. But he was also committed to public health and the practice of medicine more generally. When Oxford suffered an outbreak of cholera in 1854, it was Acland who instigated the sanitary reforms that successfully contained it. For Acland, the arts and sciences were united in a common endeavour to understand and improve the world. Medicine itself was 'an art … based upon Physics, Chemistry, experimental and observed Physiology'.[4] It was his vision above all that would shape the new Oxford museum.

Duncan, Daubeny, Walker and Acland had hoped that the success of the British Association meeting would persuade Oxford University to embrace science. Their hopes were disappointed. Oxford was a church foundation which offered an education grounded in the classics, mathematics and theology. Its religious convictions had deepened in the 1830s and 1840s with the formation of the Oxford Movement, led by John Henry Newman and Edward Pusey. Newman and Pusey advocated a revival of ritualism along Roman Catholic lines within the Church of England. By the late 1840s, Newman had abandoned Oxford and Anglicanism and had gone over to Rome, but Pusey and his many followers remained a powerful, at times reactionary, force within the University. For them, science was suspiciously liberal in its refusal to defer to the authority of revelation. At its worst, it smacked of atheism and materialism. While various sciences were taught at Oxford in the early Victorian period, they were only on offer as optional extras, not full degree programmes, and students had to complete the

FIGURE 4 *above* Medal commemorating Charles Daubeny's term as President of the British Association for the Advancement of Science, 1856. As Professor of Chemistry and Botany, Daubeny led the initial campaign to build a new science faculty at Oxford.

FIGURE 5 *opposite* John Everett Millais, *Henry Wentworth Acland*, 1853, painted at Glenfinlas in Scotland. Acland championed the use of art and architecture to communicate science at the Oxford University Museum.

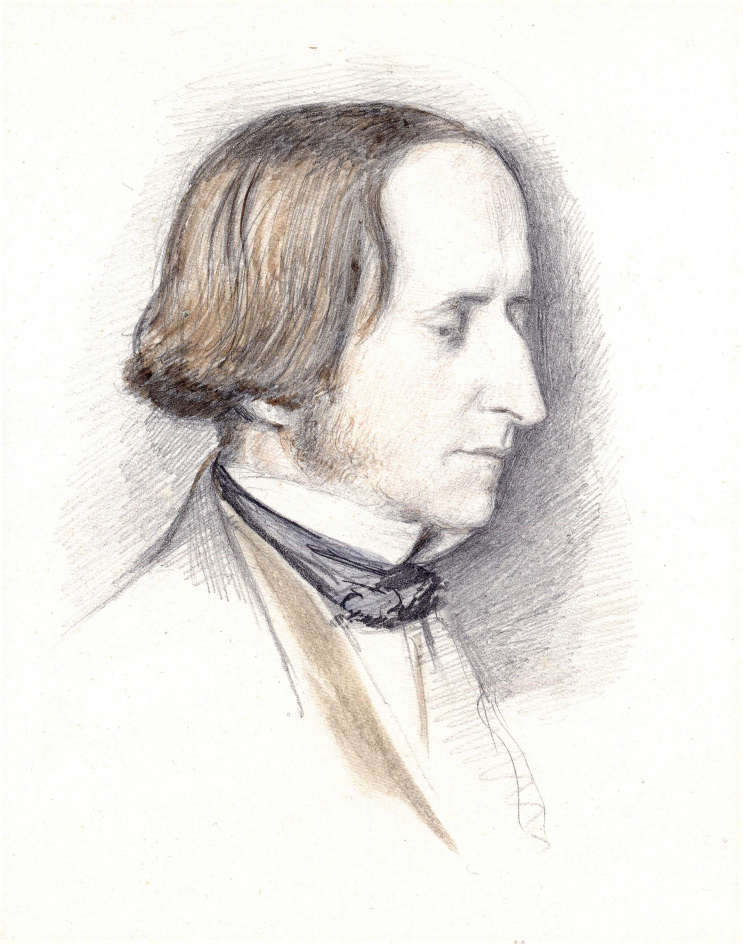

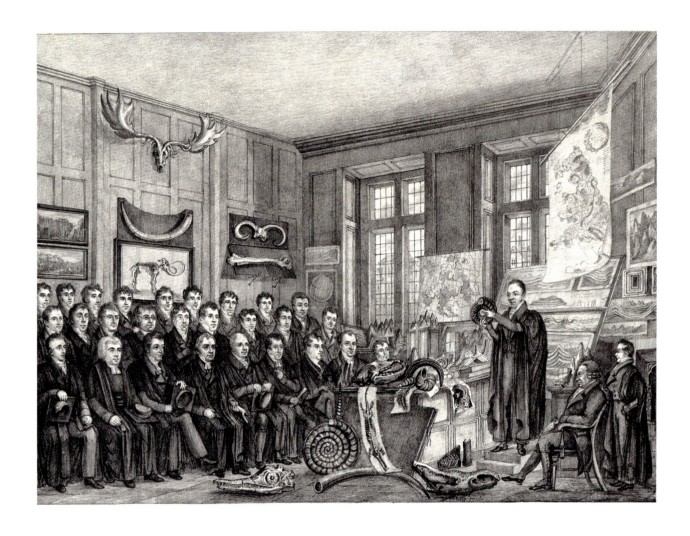

FIGURE 6 Lithograph after a drawing by Nathaniel Whitlock, *The Geological Lecture Room, Oxford*, 1823. The print shows William Buckland lecturing at Oxford. Despite being the University's most famous scientist, Buckland did not support the campaign for the new museum.

standard classical education too, regardless of where their aptitudes or interests lay. When Daubeny and his colleagues tried to persuade the most influential scientist at Oxford, the Reader in Geology William Buckland, to support their campaign, even he thought it was hopeless.[5] Buckland (figure 6) was an internationally famous geologist and comparative anatomist, Dean of Westminster Abbey and a friend of the recent prime minister, Robert Peel. He had written the first scientific description of a dinosaur, which he called *Megalosaurus*; proven that mammals now extinct had once roamed Britain; and introduced the Ice Age theory into England. Yet for all his distinction, he could not envisage science becoming part of the regular curriculum at Oxford.

Daubeny and Acland may have been discouraged, but unlike Buckland they were not despairing. After the University ignored their memorandum in 1847, they reissued it a year later.[6] While the University dragged its heels, Daubeny pressed ahead with building his own laboratory at Magdalen College. At the same time, he and Acland each issued pamphlets calling for the introduction of a proper science curriculum. As Daubeny outlined it, this would enable students to take a degree covering three primary sciences – natural philosophy (physics), chemistry and physiology (effectively biology) – plus mathematics, with specialization in the final year. For Daubeny, such a broad curriculum could not possibly be studied on top of a standard classics degree. Instead, under his scheme science was to have its own degree course, alongside the traditional Oxford education and, strikingly, an equivalent modern humanities degree covering literature, history, philosophy and languages.[7]

If Daubeny's proposals seemed radical, Acland sweetened the pill by writing a public letter to the new Regius Professor of Divinity, William Jacobson, reassuring him and his colleagues that the sciences comprised 'facts connected, illuminated, interpreted, so as to become the intelligible embodied expression to His creatures of the will of God'.[8] Acland's reassurances were genuine and plausible. Far from being materialist, science in Oxford in the first half of the nineteenth century had been dedicated to studying the creation in order better to know the Creator. Under the care of Duncan and his predecessor, his brother John Shute Duncan, the natural history collection of the Ashmolean had been laid out expressly:

> to familiarise the eye to those relations of all natural objects which form the basis of argument in Dr Paley's *Natural Theology*; to induce a mental habit of associating the view of natural phenomena with the conviction that they are the media of Divine manifestation; and by such association to give proper dignity to every branch of natural science.[9]

When John Kidd – the first champion of modern science at Oxford, whose lectures were attended by both Buckland and Daubeny – became Regius Professor of Medicine in 1824, he gave a course of lectures on 'comparative anatomy, illustrative of Paley's natural theology', which was 'generally recommended and read in the University'.[10] The 'argument from design' had first been proposed back in the seventeenth century, but William Paley had made this old argument with a new economy, elegance and precision in

1802 in his book *Natural Theology*. In 1829 the Earl of Bridgewater left £8,000 in his will for a rather more prolix series of eight treatises 'On the Power Wisdom and Goodness of God as Manifested in the Creation'. Two of the commissions went to Oxford scientists, with Kidd writing the volume on human physiology and Buckland the one on geology.

Acland's arguments eventually persuaded even Pusey to accept science on these terms.[11] But in case Oxford as an institution still had its doubts, he closed his pamphlet with a veiled warning. He and Daubeny were proposing 'to add some study of the fundamental arrangements of the Natural world to the general education' at Oxford. 'I fear', he concluded, 'that if we do not *add* it, we may live to see, what would be a great national evil, such knowledge *substituted* for our present system.'[12] If Oxford embraced science, it could continue to teach it as it believed it should be taught, alongside divinity and the classics, and in the service of natural theology. But science was coming, whether Oxford liked it or not.

Over the next few years, the campaign for science at Oxford, and for a museum and lecture rooms to support it, built up a head of steam. In 1849, the University's Convocation – its governing body, comprising all the dons sitting together – voted to establish a School of Natural Science, while the Oxford Museum Committee made the case for building 'a General University Museum … with distinct departments under one roof, together with Lecture Rooms, and all such appliances, as may be found necessary for teaching and studying the Natural History of the Earth and its Inhabitants'.[13] The resolution to build a museum was endorsed by a general meeting of the University's graduates, who promptly began fund-raising. Acland, Daubeny and Duncan each pledged £100, as did Peel and another, future prime minister, William Ewart Gladstone. The biggest donation by far, at £500, came from Richard Greswell, a Fellow at Worcester College and another long-standing advocate of science teaching at Oxford.[14] Greswell began to look into the practicalities of building a new natural history museum and science faculty, including consulting Charles Barry, who had recently built the Houses of Parliament, and Richard Owen, who as curator of the Hunterian Museum at the Royal College of Surgeons was England's leading museum scientist.[15] Meanwhile, Buckland's mental health began to falter, and he had to be replaced by a Deputy Reader in Geology. Hugh Strickland, who stepped into his shoes in 1850, also threw his weight behind Daubeny and Acland's campaign. Strickland was determined to bring Oxford into the modern world, arguing in his first lecture course that the study of geology carried with it material and technological benefits. At

the same time, he insisted, palaeontology provided natural theology with its trump card, by showing that the Creator had repeatedly intervened in his creation by miraculously generating new species.[16]

In spite of the vigour and connections of the Oxford scientists and the strength of their case, it took several years and much vacillation before the University finally agreed to build them their museum. Convocation appointed a new delegacy to look into the practicalities of the project in February 1853. Every detail of the plan was contested, from the site to the scale of the building and the budget.[17] When the delegacy advised that the University press ahead with the museum, Convocation initially turned down the advice. It was not until December 1853 that the dons at last agreed to purchase a plot of land for the museum in the University Parks. A grant of money to build the museum itself followed in March 1854, and the next month, the architectural competition to build it was launched.[18]

FIGURE 7 Arthur Hughes, *The Pre-Raphaelite Meeting*, after a drawing by William Holman Hunt, 1848. From left to right, Dante Gabriel Rossetti, John Everett Millais, Thomas Woolner, James Collinson, Frederick George Stephens and William Michael Rossetti. From Hunt, *Pre-Raphaelitism and the Pre-Raphaelite Brotherhood*, 1905.

The Pre-Raphaelites, art and science

While Daubeny and Acland were battling to turn Oxford into a modern university with science at its core, a group of young artists in London were launching their own revolution against another conservative educational institution. In September 1848 five painters and one sculptor, all in their late teens or early twenties, banded together to form a secret artistic club which they called the Pre-Raphaelite Brotherhood (figure 7). The painters were William Holman Hunt, John Everett Millais, Dante Gabriel Rossetti, James Collinson and Frederic George Stephens; Thomas Woolner was the sculptor. They had all been students at the Royal Academy Schools, and they all rejected the education they received there as fundamentally flawed. A seventh Pre-Raphaelite – William Michael Rossetti, the younger brother of Dante Gabriel – became the Brotherhood's secretary. He expressed succinctly what it was that they objected to when he declared in an article for the *Spectator* that 'No man is born into the world under obligation to subscribe to the opinions or see according to the perceptions of another.'[19] In their revolt against being taught to see according to the perceptions of others, the Pre-Raphaelite Brotherhood were joined by several other young artists, all recently enrolled at the Royal Academy, including the painters Charles Collins and Walter Deverell and the sculptors John Lucas Tupper and Alexander Munro.

The Royal Academy's orthodoxy was that the way to create great art was to imitate the practice and principles of those artists of the past who had come nearest to perfection, above all Raphael. Standards of beauty and decorum, the proper relationship of the foreground to the background, the best geometrical arrangement of figures, could all be inferred from the work of old masters. For the Pre-Raphaelites, these teachings were stultifying. As Tupper remarked in an article for the Pre-Raphaelites' manifesto magazine *The Germ*, published in 1850, you might as well say that you could determine what was great art by using 'callipers and compasses'.[20] Rather than

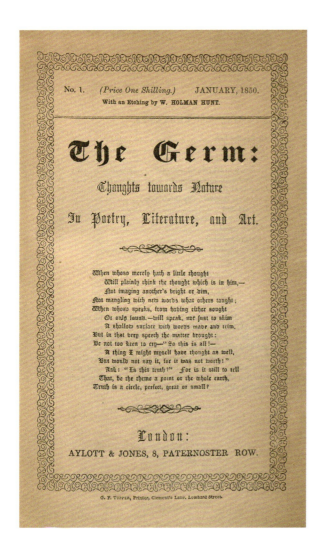

FIGURE 8 Frontispiece to *The Germ*, 1850. The magazine epitomizes the distinctive Pre-Raphaelite combination of the medieval and the scientific in its title, its aesthetic and the dedicatory sonnet, printed in black letter, written by its editor, William Rossetti.

imitation, art should be the result of, in William Rossetti's words, 'individual mind and views working from absolute data of fact'.[21] The name of the Pre-Raphaelite Brotherhood harked back to early Renaissance art not because they wanted to imitate what it looked like but rather because they believe that since Raphael the conventions of art and art-teaching had become rigid and artificial. Earlier artists had looked at the world for themselves and found their own ways to represent what they saw.

As William Rossetti explained, the Pre-Raphaelites were determined to use their art to pursue 'investigation for themselves on all points which have hitherto been settled by example or unproved precept' and to make 'unflinching avowal of the result of such investigation'.[22] Rossetti's language, with its emphasis on investigation of the data, hints at a major model for Pre-Raphaelite art besides the early Renaissance artists themselves. This was science. *The Germ* (figure 8) ran for only four issues, but each issue included an extended discussion of the relationship of science to art, as well as poems incorporating scientific ideas and a more pervasive critical language stressing truth, nature, fact and observation. Stephens made the case for art to model itself on science directly in his essay 'The Purpose and Tendency of Early Italian Art'. Although its title makes the essay out to be a study of medieval art, it is equally concerned with modern science. For Stephens, 'Truth in every particular ought to be the aim of the artist.' He was astounded by the speed with which sciences such as geology and chemistry had been transformed since the beginning of the nineteenth century, from mere speculation into complex systems that were at once extraordinarily expansive and meticulously precise. 'And how has this been done', he asked, 'but by bringing greater knowledge to bear upon a wider range of experiment; by being precise in the search after truth?' 'If', he continued, 'this adherence to fact, to experiment and not theory ... has added so much to the knowledge of man in science; why may it not greatly assist the moral purposes of the Arts?'[23]

The Pre-Raphaelites sought to match the rigour of science in their art. They were scrupulous in their observation of the external world, but their scientific exactitude was a marker of their moral seriousness and ambition too. If they could paint nature precisely, then they could also understand human nature and society, and address moral problems with the same precision. To do this, they had to be fully aware of the modern world, including all the material changes to Victorian England brought about by science and industry – what Stephens called, in a second essay in *The Germ*, 'the poetry of the things about us; our railways, factories, mines, roaring

cities, steam vessels, and the endless novelties and wonders produced every day'.[24] As Tupper explained, 'Art, to become a more powerful engine of civilization ... should be made more directly conversant with the things, incidents, and influences which surround and constitute the living world of those whom Art proposes to improve.'[25] Few Pre-Raphaelite paintings directly represent the modern industrial world, but it stands behind them all, even when it is out of sight.

As well as setting a standard for precise investigation and holding out the prospect that the arts, like the sciences, might at last be able to make progress rather than repeating the same old forms and ideas, science gave the Pre-Raphaelites a licence to try out new experiments of their own in art. The most sustained of these experiments was the practice of painting the landscape backgrounds to their pictures directly onto the canvas *in situ* and in unprecedented detail. Their object was to push to the limit what painting was capable of seeing and recording. Where conventional art prioritized the figures over the foreground and the foreground over the background, the Pre-Raphaelites painted all parts of the picture with the same degree of detail. They paid scrupulous attention to the forms, colours and habits of plants, animals and even fungi; to the movement of wind and water; to growth and decay; to the effects of light, colour and shade. The experiment began modestly in 1848 with the background to Hunt's *Rienzi Vowing to Obtain Justice for the Death of His Young Brother*, taken from a novel by Edward Bulwer Lytton and painted on Hampstead Heath. Along with Millais's *Isabella* and Rossetti's *The Girlhood of Mary Virgin*, this painting marked the Pre-Raphaelite Brotherhood's public debut in 1849. All three were exhibited signed with the artist's name followed by the mysterious initials 'P.R.B.', parodying the 'P.R.A.' or President of the Royal Academy. The experiment that Hunt initiated with *Rienzi* culminated triumphantly in 1852 with the exhibition at the Royal Academy of two of the greatest and still most famous Pre-Raphaelite paintings: Millais's *Ophelia* and Hunt's *The Hireling Shepherd*.

It was this distinctive practice of painting outdoors in meticulous detail that brought the Pre-Raphaelites and their work to Oxford. The Pre-Raphaelite connection with the city began in summer 1849 when Millais began to paint the background to *Ferdinand Lured by Ariel* (figure 9), a scene from Shakespeare's *The Tempest*, in Shotover Park, just off the main road towards London. When he was not at Shotover, he stayed with and painted James Wyatt, a former mayor of Oxford and an art dealer who traded on the High Street. Wyatt became the first of several important patrons to the Pre-Raphaelites. The following summer, Millais returned to Oxford with

FIGURE 9 John Everett Millais, *Ferdinand Lured by Ariel*, 1849–50. The first major Pre-Raphaelite work to be painted near Oxford, with the background drawn from Shotover Park.

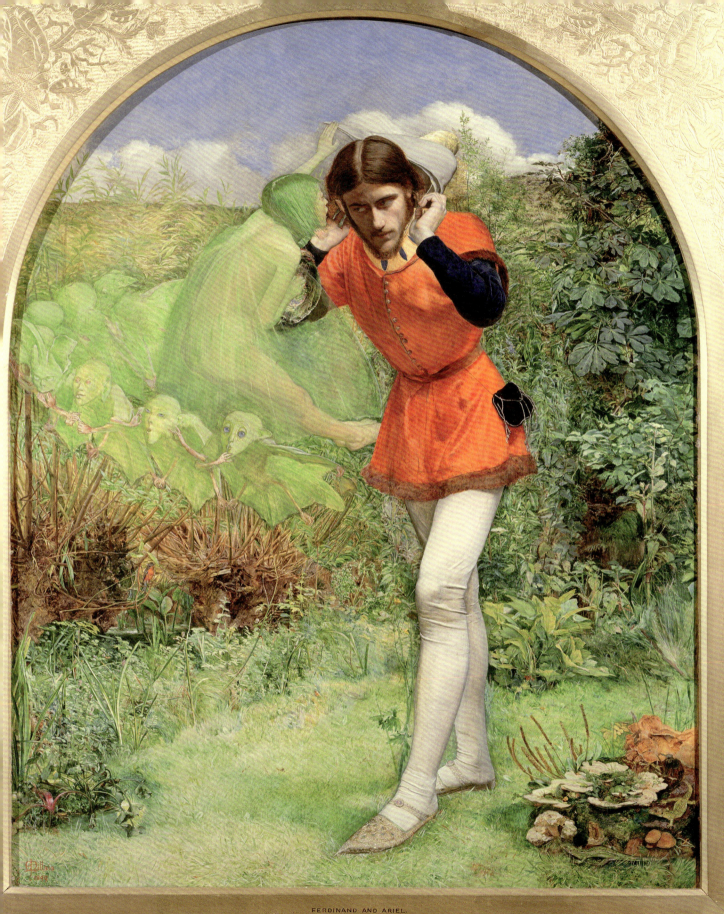

FERDINAND AND ARIEL.
SIR J.E. MILLAIS, BART. P.R.A.

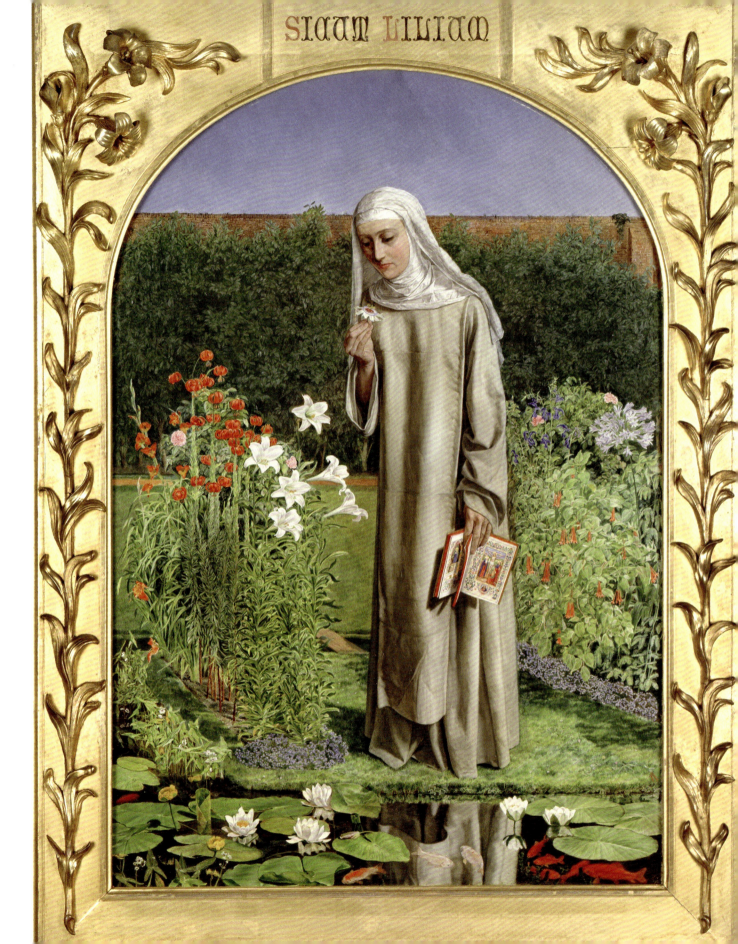

his close friend Collins. Millais painted the background to *The Woodman's Daughter* a few miles outside the city in Wytham Woods – now the site of the University's forestry research programme – and the window for *Mariana* in Merton College Chapel. Collins painted the flowers for *Convent Thoughts* (figure 10) from plants in the garden of Thomas Combe, printer to the University, who lived on site at the Clarendon Press in the Oxford suburb of Jericho. Combe (figure 11) became another major Pre-Raphaelite patron, buying up *Convent Thoughts*, Millais's *The Return of the Dove to the Ark* and Hunt's *A Converted British Family Sheltering a Christian Missionary from the Persecution of the Druids*, which had been painted outdoors in Homerton on the outskirts of London in 1849 while Millais was painting at Shotover. These three paintings would go on to form the core of the Ashmolean Museum's impressive Pre-Raphaelite collection.[26]

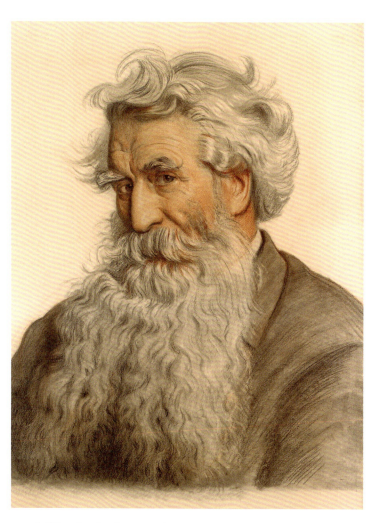

Combe was a dedicated adherent of the Oxford Movement. His collection shows how conducive Pre-Raphaelite aesthetics and subject matter were to High Church Anglicans. It would soon include the most famous of all Pre-Raphaelite sacred paintings, Hunt's *The Light of the World*, now in Keble College Chapel.[27] At the same time, in their uncompromising attention to detail in the study of the physical world, the paintings in Combe's collection and the others painted by Millais in and around Oxford in 1849 and 1850 epitomize the scientific aspect of the Pre-Raphaelite project. Like the Oxford scientists, the Pre-Raphaelites saw no conflict in principle between science and religion. Hunt, Millais and Collins put science at the service of religion in their paintings, just as Acland, Strickland and their colleagues did in their teaching.

As well as comprehending nature within a Christian worldview, the Pre-Raphaelites and the Oxford scientists shared the same basic conception of how science worked. Stephens's claim that science proceeds by 'experiment

FIGURE 10 *opposite* Charles Collins, *Convent Thoughts*, 1851, painted partly in the garden of University printer Thomas Combe.

FIGURE 11 *above* William Holman Hunt, *Thomas Combe*, 1860. A portrait of the University printer and major patron of the Pre-Raphaelites in Oxford.

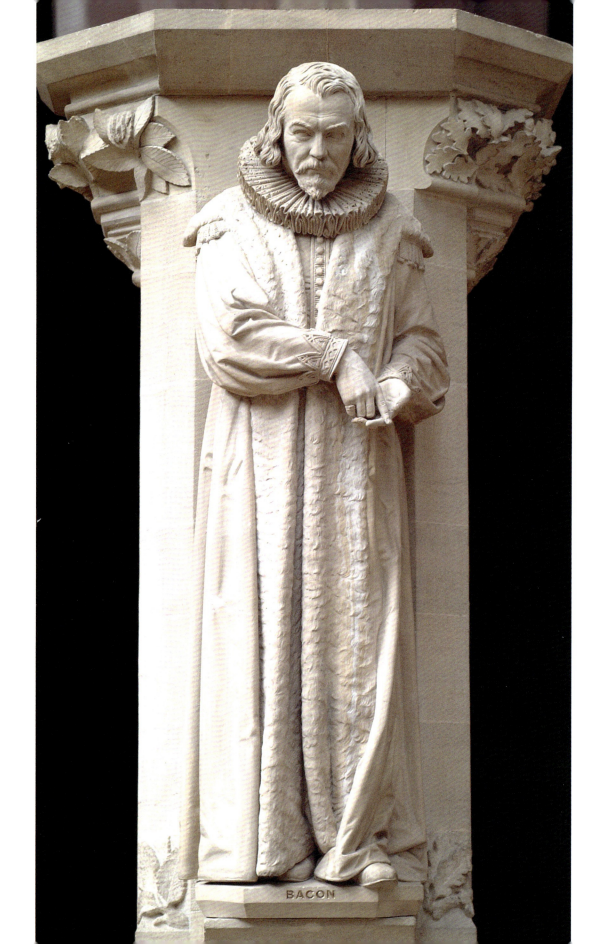

and not theory' may sound odd today, but it chimed with how the Oxford scientists themselves understood scientific research. For Strickland, geology succeeded as a science because it proceeded according to 'a strictly Baconian induction of facts'.[28] According to the seventeenth-century statesman and essayist Francis Bacon, the study of the natural world was built on the careful but neutral accumulation of data through observation and experimentation. Strickland's 'strictly Baconian' conception of geology was matched by Daubeny in the field of atomic chemistry. As he quaintly put it in a textbook on the subject:

> the labours of a few microscopic chemists, of men whose ideas might be supposed to be in a manner limited to the comparatively narrow field which their researches embraced, have done more towards the elucidation of one of the most abstruse questions on which the human mind can be engaged, than was effected by the profoundest intellects of the ages that preceded them, furnished with all the learning of the times in which they flourished, and inured to habits of abstract and subtle disquisition.[29]

The discovery of the atomic structure of matter was another 'triumph for the Baconian school of philosophy'.[30] Geology and chemistry were the two sciences singled out by Stephens in his essays in *The Germ*. When he proposed that art should model itself on them, he had Bacon's empirical method in mind. Hunt and Rossetti included Bacon (alongside Isaac Newton) on their list of chosen 'Immortals', and Stephens even went so far as to call him 'the greatest of all Englishmen'.[31] When the opportunity came to carve a statue of Bacon (figure 12) at the Oxford University Museum, it was fitting that the commission should go to Woolner, the one sculptor who had been a member of the original Pre-Raphaelite Brotherhood. The statue is a tribute to a thinker who was exemplary for both the Oxford scientists and the Pre-Raphaelites.

As they became better known in Oxford, the Pre-Raphaelites caught the attention of the scientists who were campaigning for the new museum. Acland first met Hunt when he was staying with Combe in 1851.[32] A few months earlier the prominent art critic John Ruskin had come out in support of the Pre-Raphaelites when much of the art establishment was scoffing at them. He wrote letters to *The Times* in praise of *Convent Thoughts*, *Mariana* and *The Return of the Dove to the Ark* – the same paintings that Millais and Collins had made at Oxford, which were then on show at the

FIGURE 12 Thomas Woolner, *Sir Francis Bacon*, 1856–7. The seventeenth-century empirical philosopher Francis Bacon was an intellectual hero to both the Pre-Raphaelite Brotherhood and Oxford's scientists.

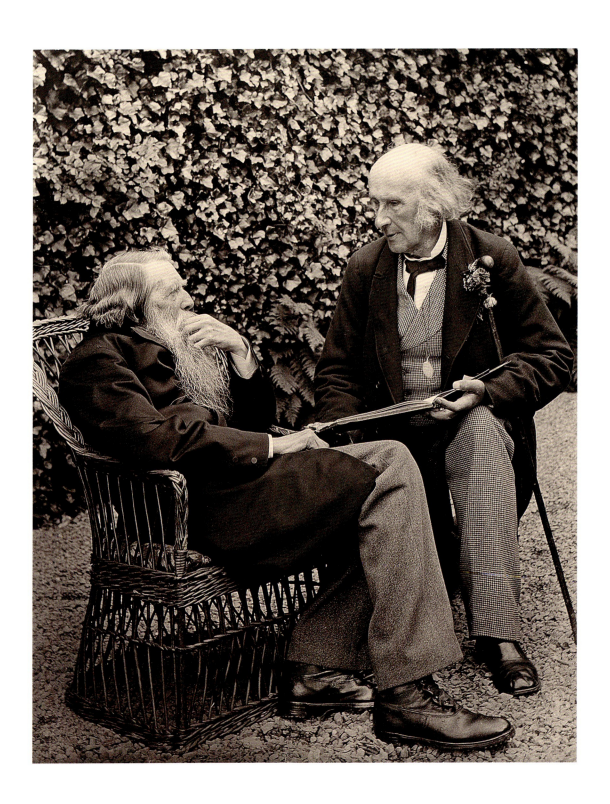

Royal Academy. Acland and Ruskin (figure 13) had been fellow students and friends at Christ Church back in the 1830s and had remained close. As a student Ruskin drew diagrams for Buckland's lectures and went on to be an amateur geologist of some standing.[33] In the mid-1840s, he championed J.M.W. Turner at a point when the great English landscape painter's reputation was at a low ebb. At the end of the decade, he turned his attention to architecture, publishing *The Seven Lamps of Architecture*, followed in the early 1850s by three volumes on *The Stones of Venice*, including the famous chapter 'The Nature of Gothic', celebrating the creative freedom of the masons who had worked on the great medieval cathedrals. Ruskin's idealized view of medieval art and labour would provide the model for the working practices and decorative art of the Oxford University Museum.

Throughout the 1850s, Ruskin was the Pre-Raphaelites' most influential advocate and sponsor. In 1853, he and his wife Euphemia, known as 'Effie', invited Millais and his elder brother, the landscape painter William Millais, to come to Scotland with them for a working holiday.[34] On the way they stopped off with Ruskin's friends Sir Walter Trevelyan and his wife, Lady Pauline at Wallington Hall in Northumberland, before arriving at Glenfinlas in the Trossachs. Ruskin was working on a series of lectures on art and architecture which he was due to give in Edinburgh that autumn. Millais drew architectural designs to accompany Ruskin's lectures, but his main project was painting the background to a portrait of Ruskin himself (figure 14), posed standing by a mountain stream. Acland was on holiday in Edinburgh at the same time, so he came over to Glenfinlas for a few days to join the party. According to his contemporary biographer, it was he who proposed that Millais paint Ruskin's portrait.[35] He even held the canvas as Millais applied the first spots of paint, so he had the chance to witness first-hand the extraordinary care and dedication of a Pre-Raphaelite artist painting details of the natural world – the rocks, the lichen, the ash tree above the stream, even the flow of water itself.

Millais began the painting on 28 July 1853 and worked on it for three full months before heading over to Edinburgh for Ruskin's lectures. It still was not finished, so he returned to the same site for another month's work the following year.[36] In the fourth of his Edinburgh lectures, Ruskin declared:

> Pre-Raphaelitism has but one principle, that of absolute, uncompromising truth in all that it does, obtained by working everything, down to the most minute detail, from nature, and

FIGURE 13 John Ruskin (l) and Sir Henry Acland (r) photographed in 1893 by Acland's daughter, Sarah Angelina Acland. Forty years before, Acland and Ruskin had campaigned together to make the Oxford University Museum a masterpiece of Gothic architecture and Pre-Raphaelite art.

from nature only. Every Pre-Raphaelite landscape background is painted to the last touch, in the open air, from the thing itself.[37]

Like Ruskin's praise of Gothic architecture, this core principle of Pre-Raphaelitism, which chimed with Ruskin's own views on art and was epitomized in Millais's painting, was to have a profound effect on Acland and on the museum he was determined to build.

Choosing Gothic

In 1853, as the campaign to build the Oxford University Museum gathered momentum and the creative partnership between Millais and Ruskin came to fruition, the concept behind the museum's architecture began to take shape. Under Ruskin's influence and with Acland's support, voices were raised in favour of building the museum in a Gothic style. On the face of it, this was an eccentric choice. Why build a science museum in a style that dated to a time when science as we know it barely existed? As Owen, looking on from the Hunterian Museum, succinctly put it in a letter to Acland, 'The sciences were not born or nursed where that style originated.'[38] Surely it was better, as the *Athenaeum*'s architecture critic argued, to make 'a building destined as a tribute to the dignity of Experimental Philosophy' in the English Renaissance style 'loved and honoured by men such as Bacon'?[39]

The diocesan architect for Oxford, George Edmund Street, did not agree. Street was one of the leading architects of the Victorian Gothic Revival. His commitment to Gothic architecture was not just aesthetic. It was ideological. For Street, Gothic architecture was Christian architecture. He played a major part in the nineteenth-century resurgence of church building, designing places of worship up and down the country, as well as for Anglican and Episcopalian communities in Rome and Paris. In Street's eyes, the finest English architecture was that of the medieval churches and cathedrals, so as well as being Christian, modern Gothic architecture was a patriotic revival of a distinctive national tradition. His grandest secular building, the Royal Courts of Justice, is a homage to the English Middle Ages and the common law. He recognized, too, the sheer ambition of the medieval cathedrals, realized through astonishing feats of engineering which enabled their architects to build higher with less stone and more space and glass than any other buildings before or – up to Street's time – since. The dismissal of Gothic as backward was absurd, when it could accomplish so much more than other styles of architecture. Rather, Street insisted, it was the most advanced form of architecture yet attempted.

FIGURE 14 John Everett Millais, *John Ruskin*, 1853–4. Henry Acland proposed that Millais paint this portrait while they were all holidaying together at Glenfinlas in Scotland. Soon after, Acland would adopt the Pre-Raphaelites' precise representation of nature as the model for the art of the Oxford museum.

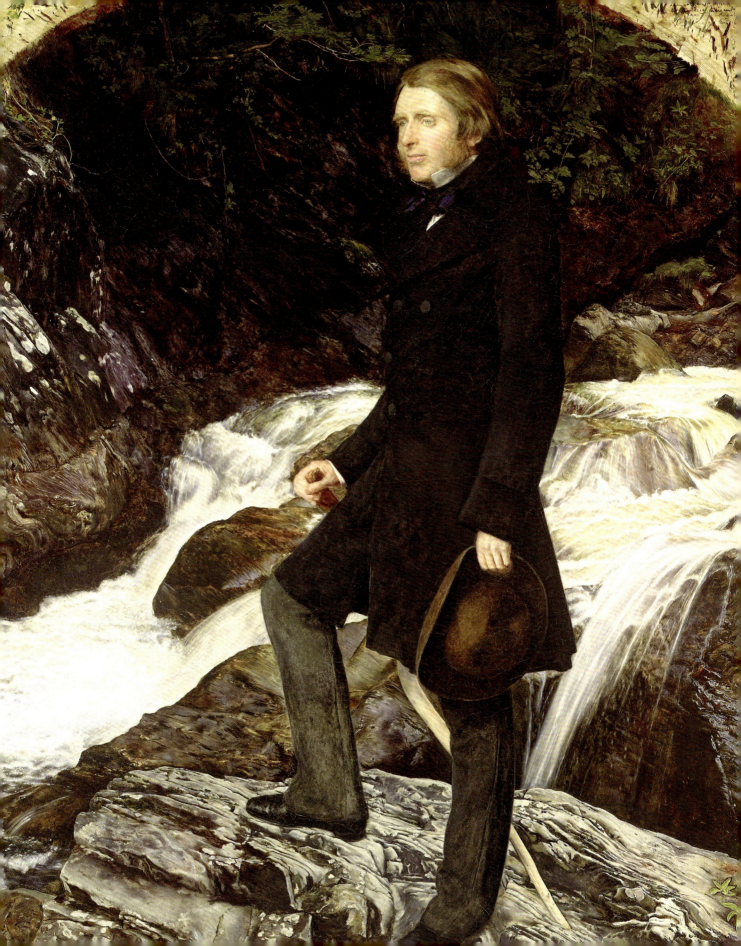

FIGURES 15A *below* **AND 15B** *opposite*
Two imaginative views of a Gothic natural history museum from 1853, before the architectural competition was launched. From G.E. Street's *An Urgent Plea for the Revival of True Principles of Architecture* and J.H. Parker's *The Old English Style of Architecture*.

Along with Acland, Street led the campaign in Oxford to build the museum in a Gothic style. He made his case in a pamphlet stridently titled *An Urgent Plea for the Revival of True Principles of Architecture in the Public Buildings of the University of Oxford*. It was not only that Gothic was more Christian, more English and structurally more advanced than neo-classical architecture. It was also better suited to the museum's purpose. Rather than looking to the history of science to determine its architectural style, Street argued that the museum should take its inspiration from its own subject matter. According to Street, the Gothic architects and stonemasons of the fourteenth century 'took nature as their guide', while every carving they made 'was a true reproduction of a living form'.[40] What could be a more appropriate style for 'a Museum intended mainly for the reception of a collection illustrative of Natural History'? 'Surely,' Street insisted, 'where nature is to be enshrined, there especially ought every carved stone and every ornamental device to bear her marks and to set forth her loveliness.'[41]

Street's views on Gothic owed a lot to Ruskin's – he even closed his pamphlet with an inspirational quotation from *The Stones of Venice* – but his proposal that the Oxford University Museum use its architecture to interpret its subject was his own. The architectural forms of public buildings had always borne a symbolic relation to their function. The cruciform plan of churches is a familiar example. What was new was Street's suggestion that architecture could become a representational art form in its own right, with a building's style and decorations directly articulating its meaning. At the same time, it would 'enshrine' nature as God's creation. As Daubeny put it, once the building work was underway, the museum's central court was to be 'the Sanctuary of the Temple of Science, intended to include all those wonderful contrivances by which the Author of the Universe manifests Himself to His creatures', while the individual lecture rooms and laboratories would be 'the chambers of the ministering Priests, engaged in worshipping at her altar, and in expounding her mysteries'.[42]

Street made the case for adopting an architectural style which could represent the natural history that the museum set out to teach. A second pamphlet, attributed to the archaeologist John Henry Parker, who later became the Keeper of the Ashmolean Museum, argued for Gothic on practical grounds. 'English Gothic architecture', Parker wrote, 'can be made subservient to almost any plan without in the least degree destroying its character.'[43]

The adaptability of Gothic (figures 15a and 15b) would become a key line of argument when it came to choosing the architects for the museum. The choice was made through an open competition. By October 1854, when the competition closed, thirty-three different designs had been submitted. When they were exhibited publicly at the Radcliffe Library in November, the *Athenaeum*'s reporter lamented that 'scarcely half-a-dozen indicate a predilection for classical traditions'. Instead 'the dreary asceticism of the first and middle pointed school of ecclesiology,—emulating, in an entire absence of grace, the *naïve* transcripts of nature, so painfully elaborated by the votaries of pre-Raffaelism,—dominate over and trammel the independence of too many of the competitors'.[44] It was not only their opponents who saw an affinity between the Gothic Revival architects and the Pre-Raphaelites. Street identified himself as a Pre-Raphaelite, telling the Gothic church architects of the Ecclesiological Society in 1858 that 'the Pre-Raphaelite movement is identical with our own'.[45] The Oxford museum would be at once a Gothic museum and a Pre-Raphaelite one.

Although Street and Parker's preferred Gothic style dominated the field of competition entries, the Goths, as they were known, had not yet secured victory. On 11 November 1854, the delegacy which the University had appointed to oversee the architectural competition shortlisted six entries in a range of styles. They submitted them to an independent firm of architects that was not involved in the competition, Philip Hardwick and his son and partner Philip Charles Hardwick, to assess whether they could be built for the sum available, set at £30,000. Faced with the advice that none of the six designs could be built within this tight budget, a sub-committee of the delegacy, including Acland, nonetheless pressed ahead and selected two designs to be put forward for Convocation to choose between.[46] All the designers had been required to submit their competition entries anonymously, each with its own Latin motto. The two that made the final cut were an ornate, neo-classical building (figure 16) designed by Edward Middleton Barry, the son of the architect of the new Houses of Parliament, and a Gothic design by the Dublin firm of Deane & Woodward.

When the dons debated the two designs, their primary concern was with practicality and cost, but these issues were inseparable from the argument over style. As the Radcliffe Observer, Manuel Johnson was the University's senior practical as opposed to theoretical astronomer. He argued at a meeting of the delegacy on 4 December 1854 that the requirements of different sciences in terms of laboratories, collections and teaching space were so diverse that it would be absurd to try to fit them into a building

designed to be symmetrical. 'That kind of architecture', he concluded, 'was to be preferred, which did not recognise symmetry as one of its essential conditions' – that is to say, Gothic architecture.[47] Acland made a similar case in a memorandum he issued anonymously a week later, the day before Convocation was due to vote on the designs. The building had always been intended to be extendable so that, as teaching and research in the sciences expanded at Oxford, they could be properly provided for. Barry's plans included provision for an extension, but as the current budget would only cover the first part of the building, if Convocation were to choose that design the University would be left 'in the dilemma of either keeping an incomplete, unfinished building, in a style where proportion and symmetry are necessary; or of paying one-half more than the original cost to complete it'. By contrast, Deane & Woodward's design, as well as maintaining the old 'Collegiate associations of Oxford', could be extended at will, as and when it was required and without the initial building seeming unfinished in the meantime, because Gothic was fundamentally an accretive, rather than a symmetrical, style.[48]

On 12 December 1854, Convocation made its choice. The first vote was on whether to adopt either design. There was still active resistance to building the museum at all. As one opponent of the scheme had put it in another anonymous memo, 'the proposed buildings are, both in magnificence and size, disproportioned to the present state of physical science in Oxford, and it would be no act of judicious kindness to its distinguished promoters to over-house them so greatly'.[49] For many Oxford dons, science was self-aggrandizing and needed to be put back in its place. The first vote was close, with the supporters of the museum winning by only six votes. Once that vote had been clinched, however, the case for Gothic prevailed, and Deane & Woodward's design was chosen by a substantial majority, even though several dons who had voted in the first round disdained to vote at all in the second.[50] Looking back at the mottos of the two entries this might seem a foregone conclusion. '*Fiat Justitia, ruat Coelum*', which accompanied Barry's classical design, is a legal principle, secular and self-righteous, declaring 'Let justice be done, though heaven fall'. '*Nisi Dominus aedificaverit domum*', by contrast, is taken from Psalm 127, which opens 'Except the Lord build the house, they labour in vain that build it.' Pious and humble, Deane & Woodward's motto, like their Gothic design, matched the Christian sensibilities of Oxford. The momentum to build the museum was at last unstoppable, and the foundation stone was laid on 20 June 1855 (figure 17), nearly eight years after Daubeny and Acland had launched their campaign.[51]

FIGURE 16 *following spread* The runner-up: Edward Middleton Barry's design for the Oxford University Museum in a neo-classical style, 1854.

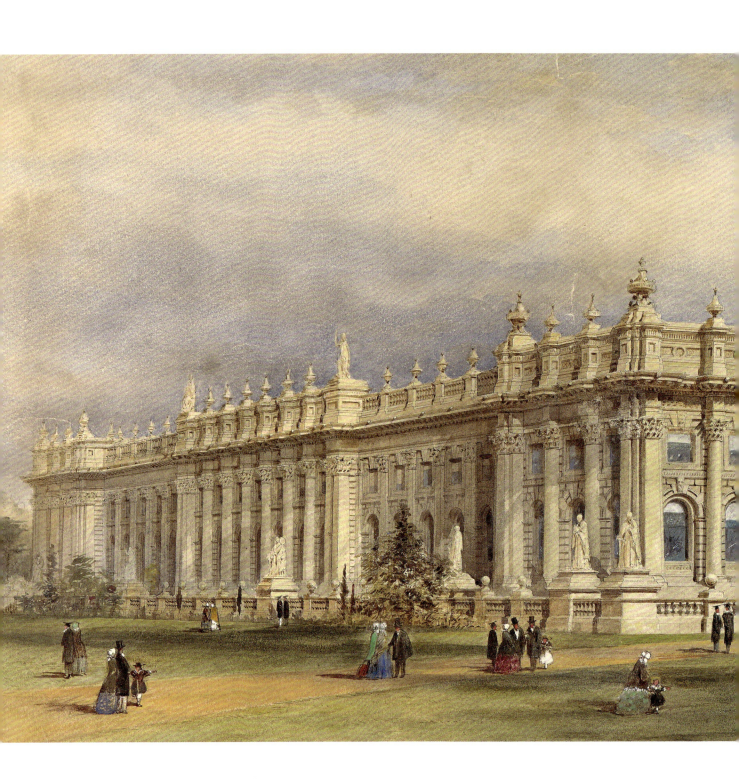

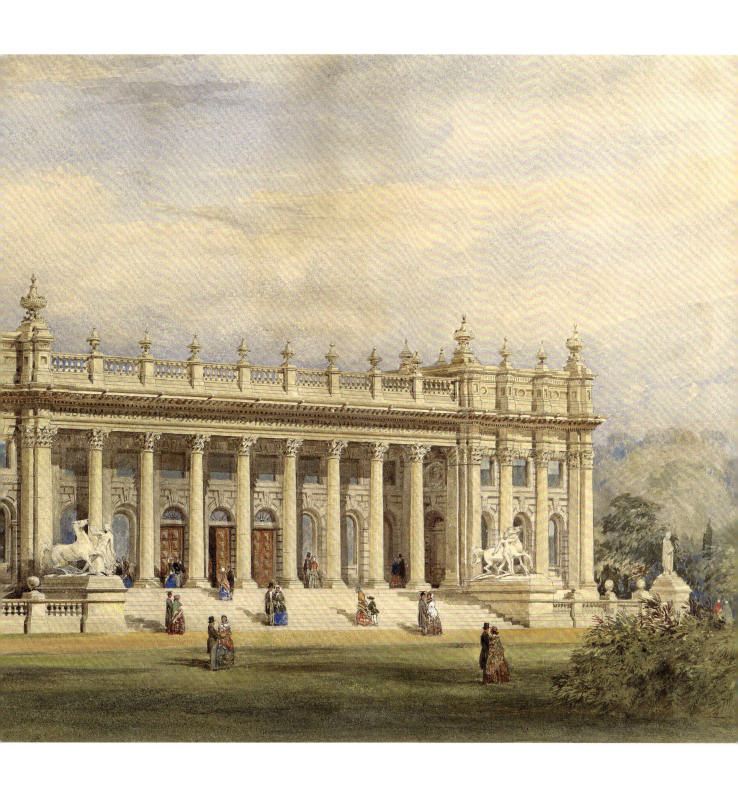

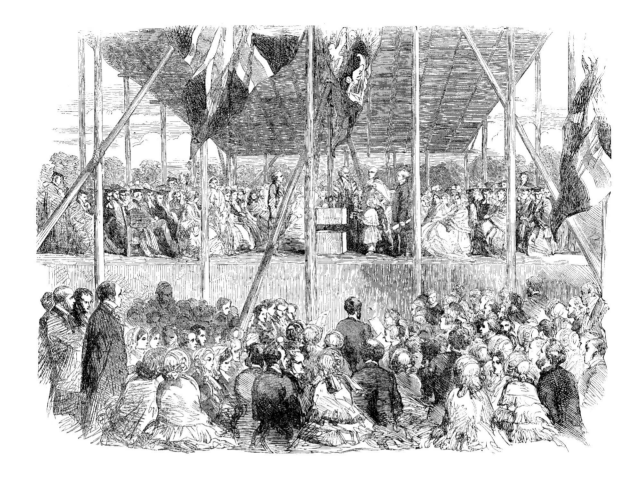

FIGURE 17 *above* The foundation stone for the museum being laid, as depicted ten days later in the *Illustrated London News*, 30 June 1855.

Building a vision of nature

On 11 December 1854, Ruskin wrote to Millais to tell him that he and his parents had finally taken possession of the portrait that Millais had begun painting in Scotland the year before.[52] The following evening he received a telegram from Acland telling him that Deane & Woodward had won the competition to build the Oxford University Museum. He was ecstatic. He wrote immediately to Acland, declaring 'I hope to be able to get Millais and Rossetti to design flower and beast borders – crocodiles and various vermin, such as you are particularly fond of.'[53] He wrote to Pauline Trevelyan too, his words tumbling over each other in his excitement:

> The main thing is – Acland has got his museum – Gothic – the architect a friend of mine – I can do whatever I like with it – and if we don't have capitals and archivolts! I expect the architect here today – I shall get all the pre-Raphaelites to design one each an archivolt and some capitals – and we will have all the plants in England and all the Monsters in the Museum.[54]

Ruskin's enthusiasm may have been dampened a little when Millais broke off contact with him a week after delivering the portrait.[55] In Glenfinlas, the young painter and Ruskin's wife Effie had fallen inexorably in love. Ruskin did not contest Effie's wish to annul their marriage, but Millais found it impossible to maintain friendly or even professional relations with him. Hunt was not available either, as he was in Jerusalem on the first of several trips to paint biblical scenes according to the strict empirical principles of the Pre-Raphaelite project. Ruskin was able to bring Dante Gabriel Rossetti on board, however, writing to him on 1 January 1855 to tell him that he had given his name to Acland as someone who could help with the decoration at the museum.[56] The Pre-Raphaelite sculptor Alexander Munro became involved too. He had been a friend and associate of both Rossetti and Acland since as early as 1847, and had recently completed a low-relief portrait of Acland's wife Sarah.[57]

Ruskin, Rossetti and Munro formed something of an unofficial committee on the museum's decoration. With their support, Acland took Street's principle that a natural history museum should epitomize its subject in its architecture and applied it with flair, turning the museum into a systematic vision of nature as understood by science. On 18 May 1855 he argued at a meeting of the delegacy overseeing the museum that every component of its decoration should be 'of significance with reference to the object of the building'.[58] Less than a month later, and just a week before the foundation stone was laid, he explained the University's ambitious plan to the Oxford Architectural Society:

> Oxford was about to perform an experiment; it was about to try how Gothic art could deal with those railway materials, iron and glass; and he was convinced, when the interior court of this museum was seen,—with its roof of glass, supported by shafts of iron, while the pillars and columns around were composed of variously coloured marbles, illustrating different geological strata and ages of the world, and the capitals represented the several descriptions of floras,—that it would be felt that problems had been solved of the greatest importance to architecture.[59]

The museum building was to be scientific through and through. As Acland wrote many years after, the aim was that 'all decoration should illustrate the Kosmos'.[60] It would provide a record of botany in its carvings and of geology in its very fabric. The vaulted roof would combine the Gothic pointed arch

– the greatest innovation in the history of structural engineering, according to Street – with modern technologies and industrial building materials.[61] The decorative schema was to be completed with a series of inscriptions of biblical or classical proverbs apt to the study of science and nature (most of which were never carved) and a series of statues forming a pantheon of great scientists from the past. Finally, the whole building was to be 'an experiment' to test 'problems' in architecture: how to unite the advantages of medieval and modern engineering; how to represent the natural world in a style that evoked its creator; and how to use art and architecture to embody science.

While Acland articulated the vision for the museum, the task of turning this ideal into a systematic schema fell to the museum's first Keeper, John Phillips (figure 18). In 1853 Strickland, who had sung the praises of 'the steam-engine, the railway, the electric telegraph' in his lectures to his students, was killed by a train while examining the geology revealed by the cuttings made for the Manchester, Sheffield and Lincolnshire Railway.[62] Phillips, who replaced him, was cut from a different cloth from Acland and the rest of the Oxford establishment. Orphaned before he was ten, he was adopted by his uncle, the pioneering practical geologist William Smith. Phillips began working with his uncle in 1815, the year Smith published the first geological map of England and Wales. In 1826, when still in his mid-twenties, he was invited to become the first keeper of the Yorkshire Museum. By 1853, when he was appointed Deputy Reader in Geology at Oxford, he had been a professor at King's College London and Trinity College Dublin, was secretary to the British Association, and had worked for several years for the Geological Survey. He went on to succeed Duncan as Keeper of the Ashmolean in 1854, a brief which at this stage included the new museum, and Buckland as Reader in Geology in 1856, becoming the University's first Professor of Geology in 1860.

Phillips set about planning out how Acland's vision of a natural history museum might work in practice so that the decoration would not end up as 'a haphazard collection of pretty stones crowned by pretty flowers' but rather be '*really* and *obviously useful*, as a part of the exhibition of natural objects'.[63] He determined which granites, limestones, serpentines and other decorative rocks to use for the columns and where to place each one, so that the colonnades around the central court could offer a comprehensive if not exhaustive record of the geology of the British Isles and of different periods in Earth's history. He planned out too which species of plants representing which botanical families would be carved on the capitals and corbels. But Acland and Phillips were scientists, not architects, and they needed someone

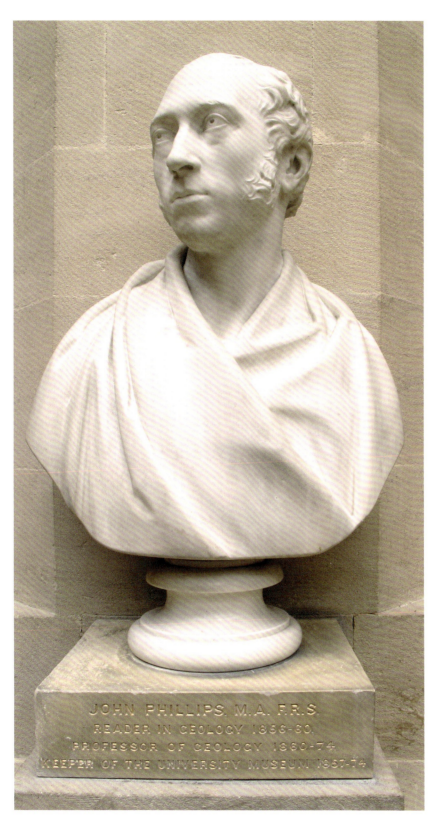

FIGURE 18 Matthew Noble, *John Phillips*, 1849. Phillips was the museum's first Keeper.

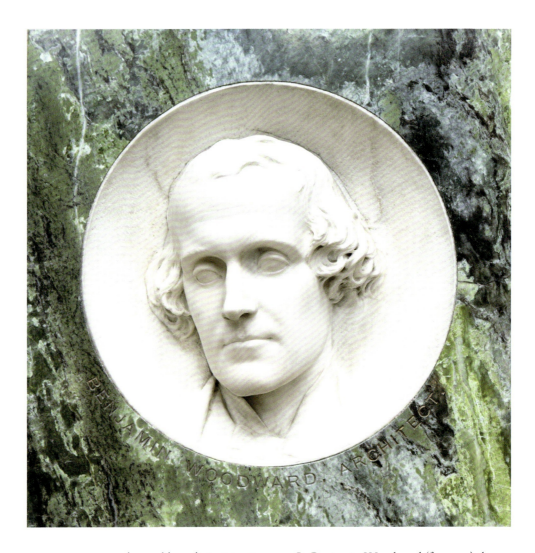

FIGURE 19 *above* Alexander Munro, *Benjamin Woodward*, 1861. A memorial to the architect of the Oxford University Museum.

FIGURE 20 *opposite* The interior of the Museum Building at Trinity College Dublin, 1854–60, designed and built by Deane & Woodward. Like the Oxford University Museum, it includes columns in various marbles topped with natural history carvings.

who could set their vision in stone. In Benjamin Woodward (figure 19) they found the architect they needed. Woodward was the creative partner within Deane & Woodward. The senior partner was Sir Thomas Deane, who had been friends with Acland since the late 1830s.[64] He was well connected, but he was already in his sixties by this point and had begun to take a back seat. In practice, the firm was now run by the two junior partners. Woodward, who had joined the firm in 1846, was the chief designer while Deane's son, Thomas Newenham Deane, handled the business side.

A careful student of Ruskin's ideas, Woodward was one of the most imaginative architects of the Gothic Revival. He was a quiet but impressive

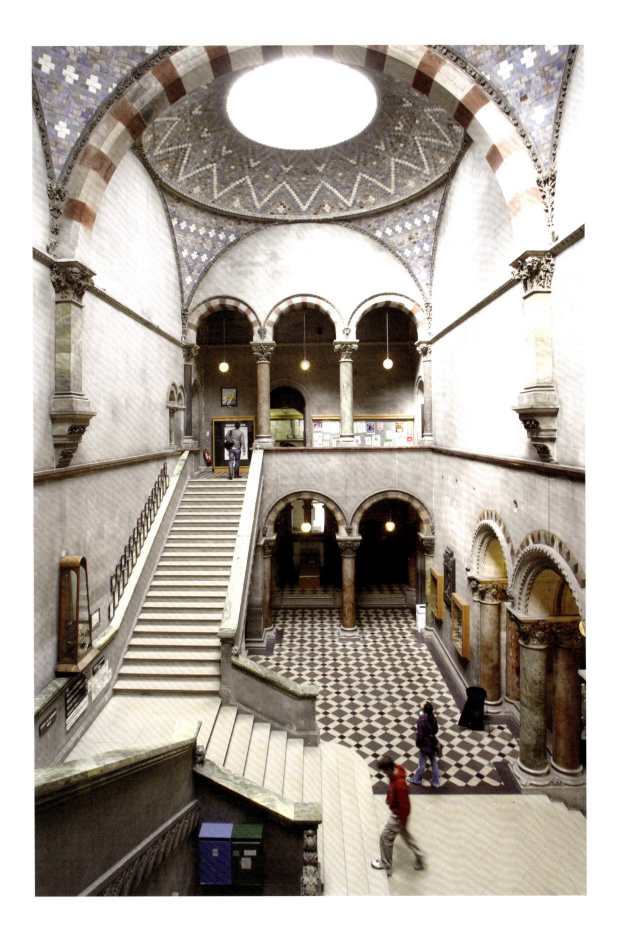

man. In a letter to the painter William Bell Scott, Dante Gabriel Rossetti, who became a close friend, characterized him as 'well worth knowing – but the stillest creature out of an oyster-shell'.[65] By the time he set to work on his design for the Oxford University Museum he had several years of experience designing and constructing university buildings. In the late 1840s Deane & Woodward had built the new Queen's College in Cork, and in 1853 they were awarded the contract to build the Museum Building at Trinity College Dublin (figure 20). Over the coming decade, as well as the Oxford museum, they built the Oxford Union Society debating chamber, decorated with a carved tympanum by Munro and murals by Rossetti and a band of younger Pre-Raphaelite artists, and renovated the famous library at Trinity College Dublin, giving it the magnificent barrel-vaulted ceiling that it has today. The Trinity museum included columns and banisters made of various Irish marbles and Cornish serpentine. It was decorated with beautiful carvings of plants and animals on the capitals and around the windows. The museum itself was not built to be a natural history museum, however, but rather an engineering faculty, including geology for largely practical ends. In Dublin, the columns and carvings were there to showcase Irish building materials and craftsmanship. At Oxford, the same architectural language would be repurposed to communicate scientific principles and knowledge.[66]

Woodward's design gave the Oxford museum grandeur and composure. Rossetti remarked that his genius as an architect lay in creating 'elevation and harmony in the whole'. His designs produced a feeling 'akin to *poetic* beauty'.[67] Within these parameters, the details of the decoration were largely left up to the individual artists who worked with him on the building. In a lecture he gave in 1858 to raise money for the museum, Acland told his listeners:

> we have sought to hinder all ornament, unless that ornament be free from vicious carelessness; and to stop all professing transcript of Nature, unless it be painstaking, sagacious, and honest. Herein, we owe a just debt of gratitude to the young school of Artists, called, half in jest, Pre-Raffaelites.[68]

In Glenfinlas, Acland had seen for himself the rigour of Pre-Raphaelite art. He knew that the Pre-Raphaelites had set a new standard for the depiction of nature, combining extraordinary care and clarity with moral seriousness, independent judgement and imaginative reach. The Pre-Raphaelites had taken science as a model for their art. Now the Oxford scientists returned the compliment, adopting the principles of Pre-Raphaelite art to embody science.

The summer of 1855 saw the beginning of a flurry of designing by members of the wider Pre-Raphaelite circle for the museum. Ruskin submitted a portfolio of twelve drawings sketching out designs for windows, including both capitals (for the tops of dividing columns) and archivolts (concentric bands to be carved around the window arches).[69] Several of these were later incorporated into the carvings on the museum's façade. His close friend Pauline Trevelyan, who was a keen botanist as well as an artist, worked on designs for several capitals, with suggestions from William Bell Scott, who was beginning a series of murals of the history of Northumberland at Wallington.[70] The pioneering feminist and social reformer Josephine Butler, whose husband George was the secretary to the delegacy overseeing the building of the museum, also sketched a design for a capital showing 'Solomon's lilies' (figure 21) one night in the garden of St John's College.[71] These designs by Trevelyan, Scott and Butler are recorded in memoirs and

FIGURE 21 Carvings of arum lilies on the north side of the central court of the Oxford University Museum, attributed to John O'Shea, perhaps inspired by a design by Josephine Butler.

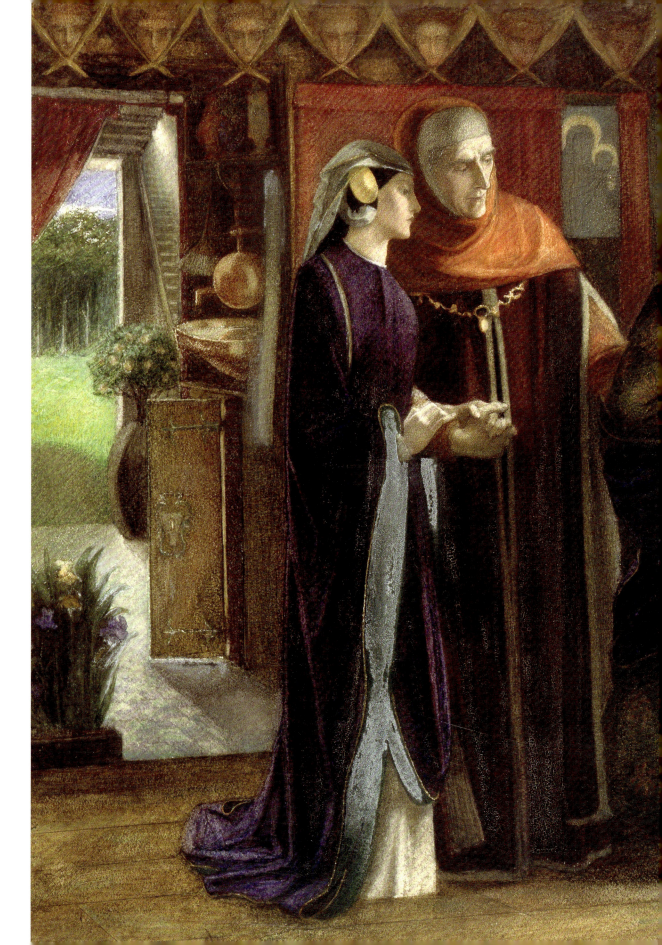

archives, although the drawings themselves no longer survive. Phillips too sketched out designs of his own.

Ruskin also brought his latest Pre-Raphaelite protégé, Rossetti's lover and artistic collaborator Elizabeth Siddall (figure 22), to Oxford, primarily so that Acland could take charge of her precarious health. Encouraged by Ruskin, Acland began to build up his own collection of Pre-Raphaelite art, buying a painting by Siddall based on Wordsworth's poem 'We Are Seven' and two of Rossetti's compositional studies for his painting *The Passover in the Holy Family*.[72] In early July Rossetti wrote to his mother to say that he had been asked 'to do some designing for the Museum, and probably shall'.[73] At much the same time, he wrote to the Irish poet William Allingham saying that he and Woodward had discussed the possibility that Siddall might prepare some designs for the Dublin museum.[74] In the end Rossetti did not make any designs for the Oxford University Museum, but he played an important role in involving other Pre-Raphaelite artists in the project. In June 1855, he introduced Woodward to Woolner, who had recently returned to England after an unsuccessful attempt at making his fortune through prospecting in Australia.[75] The following year Woolner was commissioned to carve the statue of Bacon, and went on to draw a design for the main entrance to the museum and to carve a memorial statue of Prince Albert which stands in its central court.[76] Next Rossetti took pains to set up a meeting between Woodward and Tupper, who was eventually given the commission for the statue of Linnaeus.[77]

Tupper signed his statue of Linnaeus with the inscription 'Designed & Carved by J.L. Tupper' (figure 23), to make the point that, in an age when most portrait sculpture was worked up mechanically from the sculptor's models, he still carved the entire work by hand. Indeed, most of the designs that were drawn for the Oxford University Museum, particularly for the botanical carvings, while they helped to form the Pre-Raphaelite style and shaping of the decoration, were superseded by the work of the carvers themselves. This was in line with both Ruskin's teaching and the core principles of Pre-Raphaelitism. In 'The Nature of Gothic', Ruskin had argued that medieval Gothic architects had allowed individual stonemasons the freedom to be artists in their own right, expressing their own natures and the nature around them for themselves. At Trinity, Woodward had employed the brothers James and John O'Shea and their nephew Edward Whelan on this basis. When Woodward came over from Dublin to England to work on the Oxford museum, the O'Shea family joined him (figure 24). The trust Woodward placed in them to design their own carvings

exemplified Ruskin's principles as much as, if not more than, his own designs. The O'Sheas' task was more precise at Oxford than it had been at Trinity. Phillips told them which species of plants he wanted carved where. In the preface to the second edition of *Modern Painters*, which came out in 1844, Ruskin insisted that 'Every herb and flower of the field has its specific, distinct, and perfect beauty. ... The highest art is that which seizes this specific character, which develops and illustrates it.'[78] For the artist who studies them carefully, every flower is 'a living creature, with histories written on its leaves, and passions breathing in its motion'.[79] Sixty years later, the Head Master of New College School, William Tuckwell, reminisced about how 'every morning came the handsome red-bearded Irish brothers Shea, bearing plants from the Botanic Garden, to reappear under their chisels in the rough-hewn capitals of the pillars' of the museum.[80] As director of the Botanic Garden, Daubeny must

FIGURE 22 *previous spread* Dante Gabriel Rossetti, *Dante drawing an Angel on the Anniversary of Beatrice's Death*, 1853. Both Rossetti and Elizabeth Siddall, who modelled for the young woman on the left, worked with Acland, Woodward and Ruskin in the mid-1850s on the Oxford and Dublin museums.

FIGURE 23 *above* John Lucas Tupper's signature on his statue of Linnaeus, 1859.

A PRE-RAPHAELITE NATURAL HISTORY MUSEUM | 47

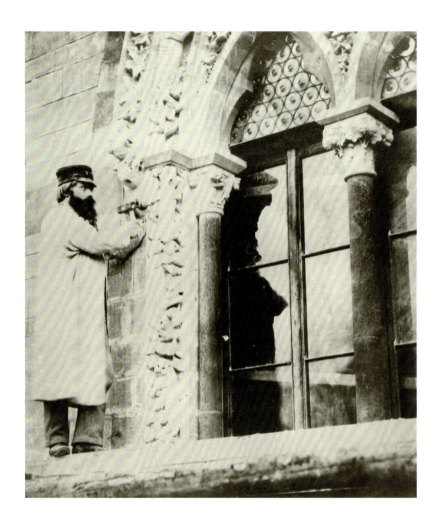

FIGURE 24 *above* James O'Shea posing as if carving the Cat Window, his most famous composition at the Oxford University Museum, c.1859.

FIGURE 25 *opposite* Illustration from *The Builder*, 18 June 1859, showing a selection of the O'Shea family's carvings at the Oxford University Museum.

have supplied them with particular individual plants. The O'Sheas then set about capturing the specific characters of these living organisms with a precision and honesty in line with Pre-Raphaelite principles, as Acland demanded. They fulfilled their brief with extraordinary skill. Their carvings in the museum's central court (figure 25) are some of the Victorian age's most exquisite pieces of decorative sculpture.

While the O'Sheas took on the stonework, Woodward entrusted the ironwork to Francis Skidmore. Like Acland, Street and Woodward, Skidmore was an enthusiastic reader of Ruskin. Based in Coventry, he became the Gothic Revival's metalworker of choice, making several cathedral screens for Sir George Gilbert Scott and collaborating with

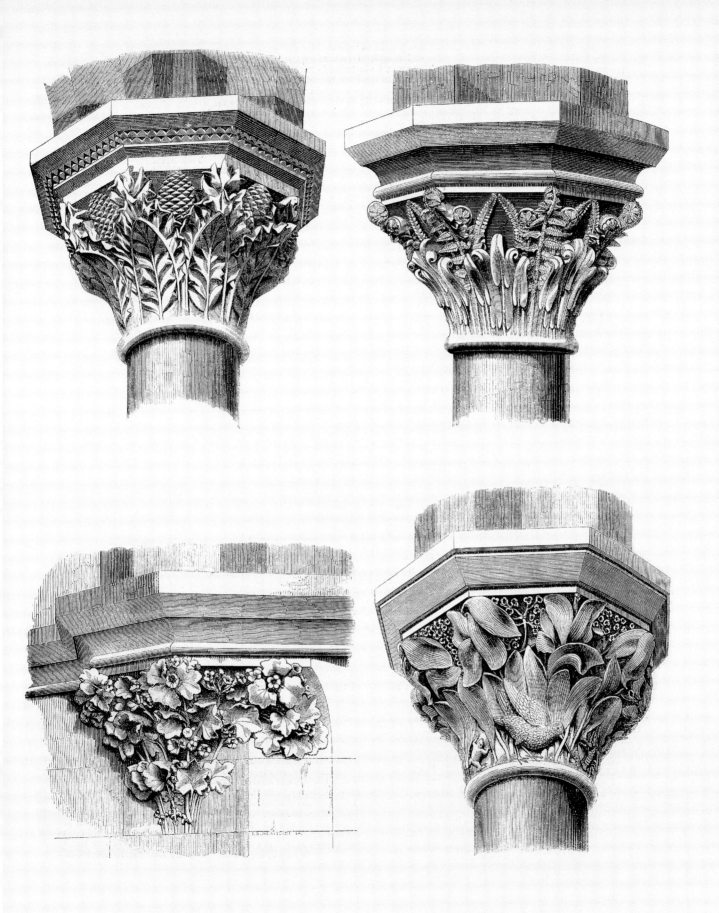

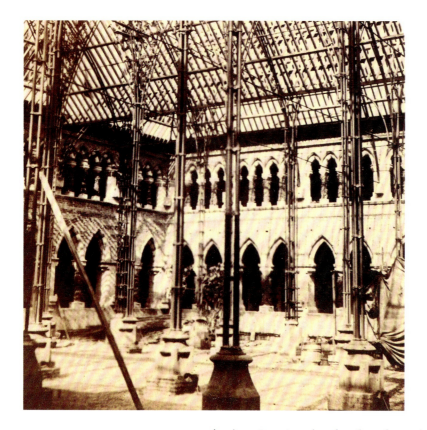

FIGURE 26 *above* An early photograph of the museum under construction, showing the first roof, which collapsed in February 1858. From an album of photographs of Oxford, Malvern and London by Richard Phené Spiers, c.1856–7.

FIGURE 27 *opposite* Illustration from *The Builder*, 7 July 1855, showing one of Francis Skidmore's iron spandrels from the Oxford University Museum.

him on the Albert Memorial. In 1854 he read a paper at the Oxford Architectural Society calling for England to strive for pre-eminence in the art as well as the manufacture of metals.[81] When work began on the museum the following year, the Society expressed its confidence in the project and in Skidmore in particular.[82] As an engineer, he did not live up to their expectations, as his first design for the roof, with the glass supported entirely by wrought iron (figure 26), failed and the roof collapsed. Artistically, on the other hand, their trust was well founded. In February 1858, as Skidmore was working on the museum, Ruskin told an audience in Tunbridge Wells that 'iron is eminently a ductile and tenacious material', especially well-suited to represent 'fluttering leaves' or 'twisted branches'.[83] Skidmore's wrought-iron brackets (figure 27) and capitals at the museum capture exactly this quality, representing leaves and flowers with precision and delicacy.

In his 1855 speech to the Oxford Architectural Society, Acland made it clear that the physical structure of the museum and its decorations were not there solely to be beautiful nor even to represent nature as a fitting subject matter. They were there to teach. Back in 1853, Greswell had proposed that the museum could be *'the silent teacher'* of zoology at Oxford in the absence of a professor. The way to do this, he suggested, was to arrange the specimens in 'their natural order', reflecting the order of 'God's own Museum, *the Physical universe*'.[84] By combining this principle with Street's ideal of Gothic architecture as a representational art form, Acland, Phillips and their collaborators had created not just a collection but a building that could be an illustrative model of God's creation, uniting meticulous observation with scientific taxonomy and the Christian symbolism of the Gothic. The columns formed an encyclopaedia

of geological samples for the professors and their students to refer to whenever they needed. The capitals in stone and iron stood in for a herbarium. The statues offered inspiring examples of scientific practice and a record of key ideas and inventions in the history of science. The individual departments and lecture rooms too were to be decorated with art illustrating key principles of their science. In the Entomology Museum, the fireplace, carved by Edward Whelan, showed the life cycles of the death's-head hawk-moth and the stag beetle. In the Geology Lecture Room another of Ruskin's acolytes, Richard St John Tyrwhitt, painted huge murals to show how different landscapes could be formed by glaciers and volcanic eruptions. In Acland's office, his own fireplace was inscribed with a Greek quotation from Hippocrates, the father of empirical medicine, cautioning students, or perhaps Acland himself, that, in medicine, 'Life is short; but Art long; Opportunities fleeting; Experience deceitful; True judgement difficult'.[85] Everywhere you looked, the details of the museum's Pre-Raphaelite art and Gothic architecture contributed not only to its decoration but to its mission, to give science a new prominence and value within Oxford University's curriculum.

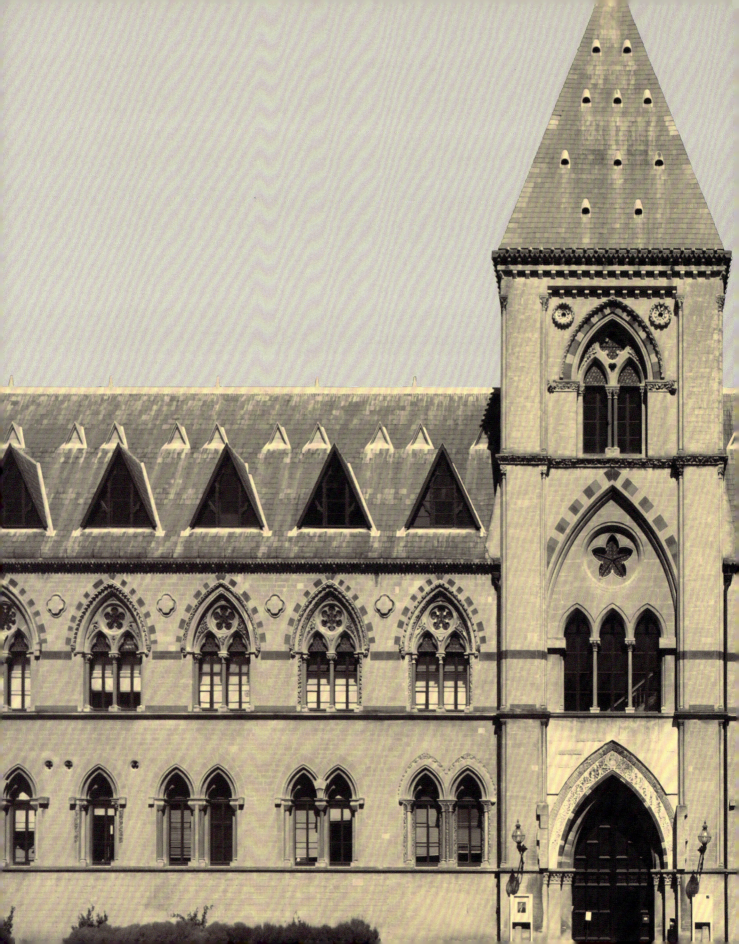

2 'God's own Museum'
The façade

WHEN HE CHARACTERIZED the universe as 'God's own Museum', Greswell set the keynote for the new Oxford University Museum.[1] It was to be the physical expression of science understood as the study of God's creation. Yet for Acland, God was not just a mechanical designer. He was 'the Everliving, Everworking, Artist', so art and architecture became instrumental in communicating the museum's commitment to natural theology.[2] Street, the diocesan architect for Oxford, called for the new museum to play a role in 'the revival of Gothic,—or, as it is better called,—Christian architecture', and the choice of Gothic for its architectural style was an overt signal of its place within the University's religious mission.[3] The museum's façade, with its rows of Gothic windows and end towers with conical roofs, combines collegiate with ecclesiastical architecture. The central tower and the understated polychromy of the roof tiles and the stonework hint at the civic Gothic of Northern European town halls, but the museum's entrance, framed by an arch depicting Adam, Eve and an angel, leaves no doubt that this is a Christian building. At the same time, the carvings around the windows, showing plants, birds and other animals, tell us that it is dedicated to the natural world (figures 28 and 29).

Mankind and the Creation: the entrance

The Oxford University Museum was built to be a Christian Temple of Science in honour of God's creation. No single detail of the building declares this more directly than the arch over the main entrance. The evolution of its design shows the complex interaction between practical requirements, artistic inspiration and scientific ideas in the design and decoration of the museum. Woodward's original contract drawing for the museum includes a porch (figure 30) that would have projected forwards from the front of the building. His design is suggestive, rather than finished, but it clearly resembles the entrance to a Gothic church. The figure in the roundel above the entrance recalls images of God as father, king and creator, while the second figure above the arch itself might be a saint, founder or angel. Had the porch been built to this design, the architectural effect would have been unmistakeably ecclesiastical.

FIGURE 28 *previous spread* Exterior view of Oxford University Museum of Natural History, built 1855–60, as it looks today.

Woodward's architectural designs for the doorway became first more ambitious, with more projection and richer decoration, and then less. When it became clear that there would be no money for the porch, he settled for an arch of Carrara marble with the spandrels above faced with white Portland stone.[4] This way the porch would at least stand out visually, if not physically. Woodward had hoped that Rossetti would design the carvings for the arch, but as Rossetti kept putting him off he instead approached Woolner, who had already carved the statue of Bacon for the central court and was, as a sculptor, better qualified. In September 1858, Woolner proposed 'the *"Tree of Knowledge"* as exhibited in the *"Temptation"* and *"Expulsion"'* as the subject for the carving of the spandrels, and in July 1859 the delegacy authorized Woodward to contract the sculpture to him.[5] The museum's copy of Woolner's design (figure 31) was drawn for the Pre-Raphaelites' Oxford patron Thomas Combe in June 1860; the original is now in the British Museum. It draws on Michelangelo's painting *The Fall of Man* in the Sistine Chapel in Rome. Woolner reshapes the composition to fit into the space around the arch, while intensifying the intimacy between Adam and Eve, both in their erotic connection in the first panel and in their sympathy for one another in the second.

The Fall of Man is a myth which centres on a prohibition against knowledge. It is not clear why Woolner thought that it would be 'the most poetical and appropriate' subject for a museum dedicated to science.[6] Perhaps because it was decided that it was not so appropriate after all, his design was not carved and the project was passed on to another artist with Pre-Raphaelite affiliations, John Hungerford Pollen. Pollen had a long-standing connection with Oxford. In 1850, while briefly a Fellow at Merton, he had renovated the ceiling of the college chapel, working alongside Millais, who was at work on *Mariana* in the chapel at the time. In 1855, Pollen moved to Dublin to take up a post as Professor of Fine Arts at John Henry Newman's new Catholic university. While there, he got to know Woodward. It is not certain whether he collaborated directly with Woolner on the entrance for the museum, but he picked up his theme and integrated key aspects of his composition as well as Woodward's original contract drawing into his own design (figure 32), which is also kept at the museum.

Pollen's design includes Eve on the right-hand side of the arch, but curiously it omits Adam. The arch is surmounted by a roundel containing an angel, combining the two figures from Woodward's contract drawing. Below the angel, we can just glimpse the face and hand of Christ in an act of blessing. Above it, Woolner's Tree of Knowledge has been transformed

FIGURE 29 *following spread* An early perspective drawing of the museum published in *The Builder*, 7 July 1855, soon after the foundation stone was laid. Based on Woodward's designs, it shows their clear debt to church architecture.

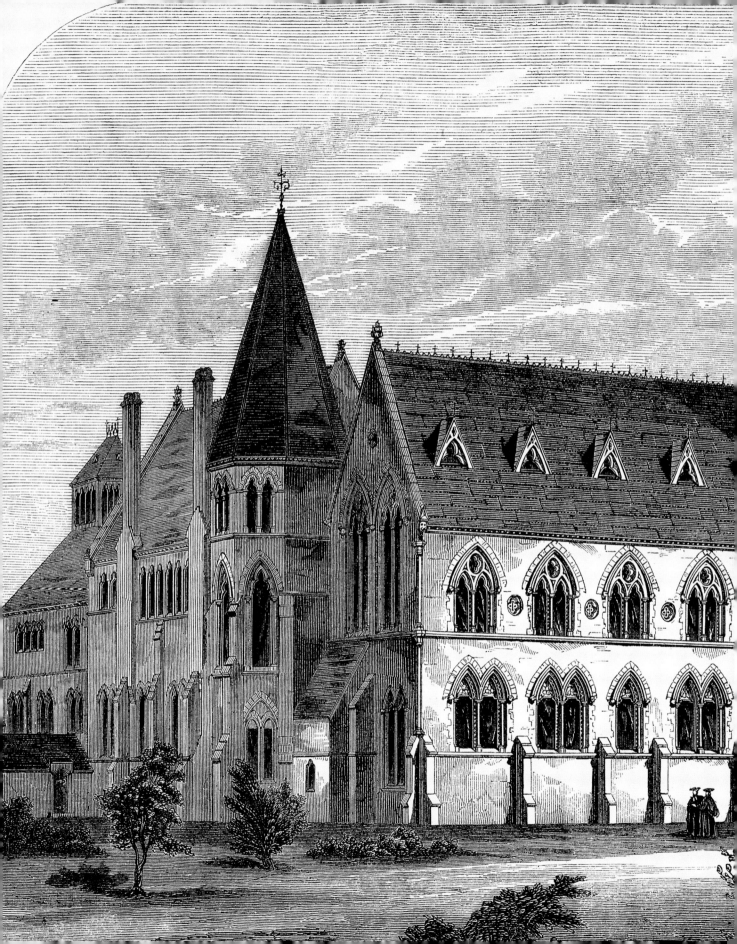

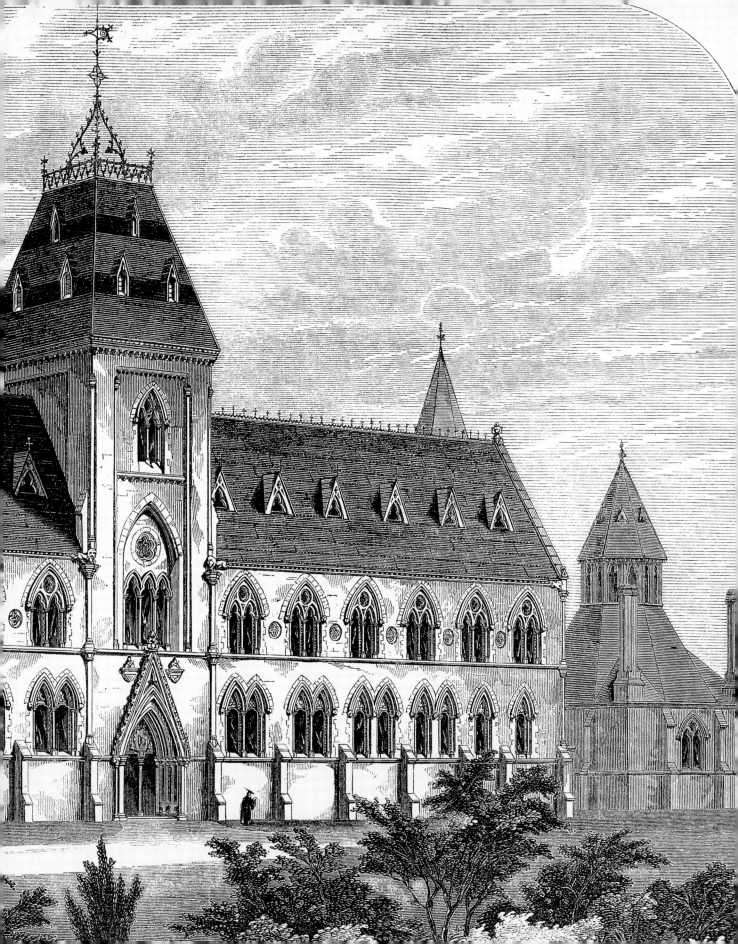

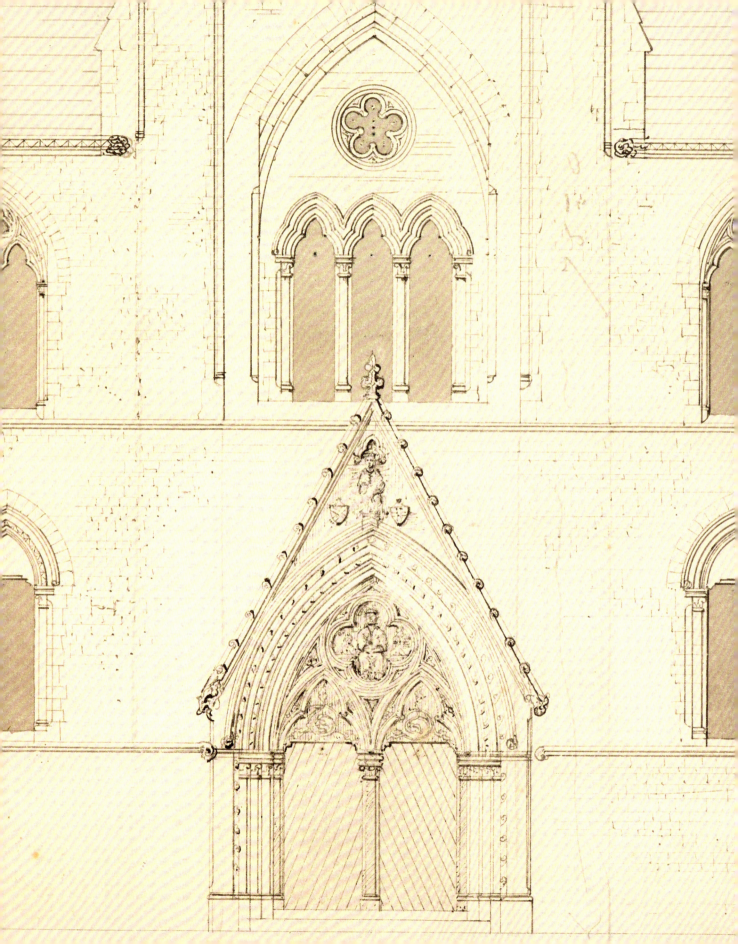

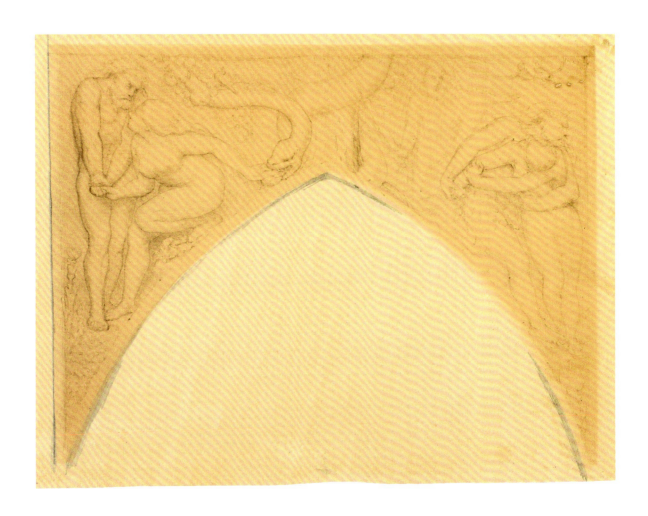

FIGURE 30 *opposite* Detail from one of Benjamin Woodward's contract drawings for the museum, 1855, showing his original design for a projecting porch.

FIGURE 31 *above* Thomas Woolner's design for the spandrels above the entrance to the museum, 1859–60, depicting Adam and Eve's fall and their expulsion from the Garden of Eden.

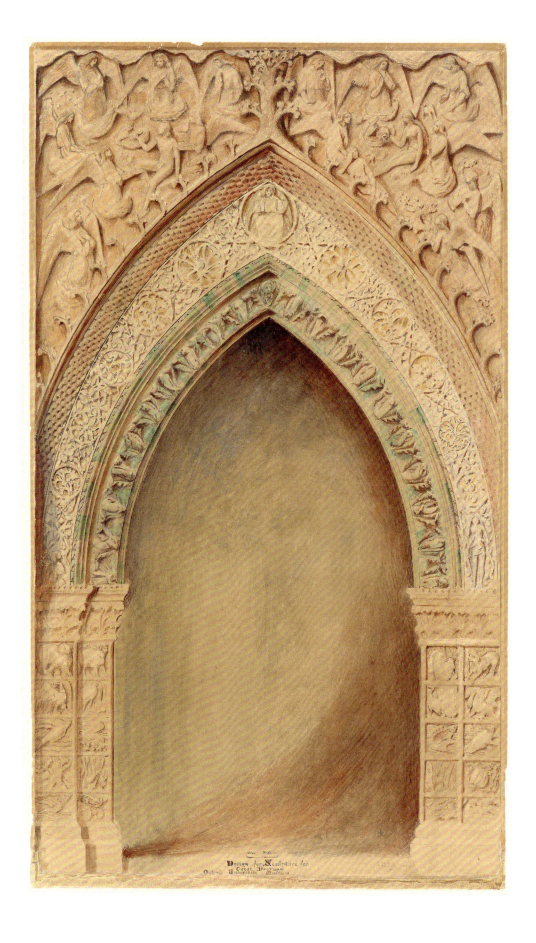

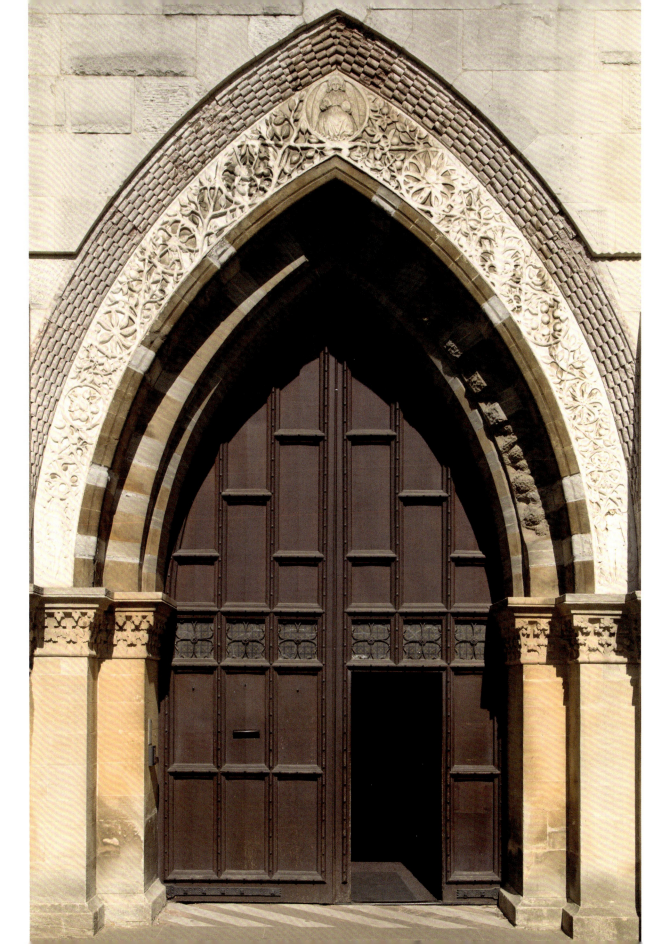

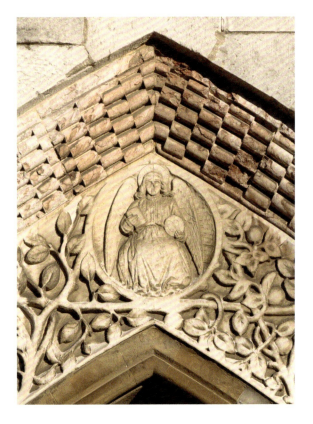

into the Tree of Life, with more angels welcoming the resurrected souls of men and women into Paradise on either side. The pillars supporting the arch are divided into panels representing a hierarchy of living things working down through the days of the Creation, with the beasts of the field at the top, then birds and fishes, then plants. The bottom panels show the Holy Spirit as a dove, animating life, the creation of the sun and the moon, and perhaps the division of the land from the waters. Where Woolner's design, read from left to right, begins with Paradise but ends with the Fall, Pollen's, read from bottom to top, begins with creation and culminates in a scene of universal salvation.

As it happened, money was even tighter than thought, and the arch was only ever partly carved, with the spandrels left bare and stark above it. Such as it is, the carving (figure 33) is based largely on Pollen's design, but with a couple of striking changes. Adam has been reinstated, with his hand on the head of a bloodhound, representing, according to Acland, the 'type of material ferocity and agent of material death, restrained until sin had broken loose upon man'.[7] The figure of Eve is now paired with a winged serpent. Because the spandrels remain uncarved, Woolner's original theme for the arch has regained its prominence. Even today, as you walk into the museum to gain knowledge, you run the gauntlet of a design that appears to warn you against it.

The other key modification to Pollen's design in the finished carving is to the angel. In the design the angel holds two books, representing the Book of God – the Bible – and the Book of Nature. The Book of Nature is a medieval image for the natural world as a fixed creation, written by God. In the carving itself, it was replaced by 'a Disc, on which are carved the dividing cells and nuclei of *Schwann* and of *Schleiden*', to quote Acland again (figure 34).[8] It would be hard to think of a single image that could represent better the museum's aims. When the archway was carved in 1861, cell theory was cutting-edge science. It brought together botany, zoology and the latest scientific technology, in the form of microscopes powerful enough to see cell division or mitosis in process. Cells had been discovered in plants by Matthias Schleiden in 1838 and in animals the following year by Theodor Schwann. Cell division was observed by Robert Remak in 1841, but it was

FIGURE 32 *previous spread left* John Hungerford Pollen's final design for the entrance, 1860–61.

FIGURE 33 *previous spread right* The entrance as carved in 1861, based on Pollen's design with modifications.

FIGURE 34 *above* Detail of the carving above the entrance, 1861, showing an angel holding the Bible and a disc showing dividing cells.

not until the mid-1850s that scientists could affirm with confidence that the nucleus of each new cell came into being from the division of an existing nucleus. Cell theory had a bearing on medicine too, as had been shown very recently indeed in Rudolph Virchow's book *Cellular Pathology*, which had only been published in 1858 and was not translated into English until 1860, the year the museum opened. In taking an angel holding dividing cells as its emblem, the museum identified itself equally with natural theology and with the most up-to-the-minute scientific discoveries with applications across many fields, both theoretically and practically. The message was clear: Christianity could accommodate modern science and, no matter what science discovered, it would continue to be the study of God's creation.

Natural histories: the windows

While the entrance to the museum assured visitors that science was natural theology, the rest of the carvings on the façade, principally around the windows, fostered an enthusiasm for natural history. Again, it is possible to trace their development in some detail. The basic form of the façade, including the shape and placement of the windows, was set in February 1855 in the original contract drawing by Woodward. According to Acland's reminiscences nearly forty years later, the carvings on the upper windows were intended 'to illustrate some part of the Fauna and Flora of our planet', with those on the south side of the central tower given over to 'the vertebrate classes,—Man, Quadrumana, Carnivora'.[9] Beyond the fact that the windows that were carved are richly decorated with birds, smaller mammals and plants, there is little evidence of this schema remaining and nothing to corroborate Acland's suggestion that this was ever more than one conception of how the windows might be used to illustrate nature in a scientific way.

A more decisive influence on the windows was the involvement of John Ruskin, who pledged £300 towards the cost of carving them and took an active role in their design.[10] Ruskin's writings were a key influence on the museum's architecture from the outset. Through his window designs, he made a more direct contribution to its decoration. Ten of Ruskin's sketches are at the Ashmolean Museum in Oxford. There is one finished design at the Birmingham Museum and Art Gallery and a further sketch at the Ruskin Library and Research Centre at Lancaster University, making twelve surviving designs altogether, though whether these last two were part of the original portfolio it is hard to know. Of the surviving designs, eight show features that were incorporated, in one way or another, into the carvings on the façade. The other four imagined an alternative form for the first-floor

windows, with covered balconies (figure 35) which would have overlooked the museum's front lawn, bringing an Italian Renaissance self-confidence and elegance to the museum.

The first of the upper windows to be carved was not to one of Ruskin's designs. Instead it was designed by the carver himself, James O'Shea, in accordance with the principles set out by Ruskin in 'The Nature of Gothic'. This is the second of the windows to the right of the tower, which, by Acland's account, should have been used to illustrate the 'Quadrumana' – the non-human primates, classified as 'four-handed' by the mid-Victorians to police the line between them and the two-handed humans or 'Bimana'. O'Shea included a lively sketch (figure 36) for a window surrounded by monkeys in a letter to Acland, although whether it was intended for this window is not clear.[11] According to Acland, O'Shea began carving monkeys, in line with instructions from Woodward. Frederick Plumptre, the Master of University College, who was on the delegacy overseeing the museum building, came by and demanded to know what he was doing. When he said he was carving monkeys, Plumptre accused him of destroying the University's property and demanded he come down from the window. The next day, O'Shea took the initiative and cheekily began re-carving the monkeys into cats.[12]

The Cat Window (figure 37) is O'Shea's most exuberant piece of sculpture at the Oxford University Museum. It is teeming with cats, stalking here and there, catching mice, sitting and playing on the tops of capitals and poking their heads out from the walls like gargoyles. Above the window itself, cats climb among the fruit trees which grow around the inner band of the arch, while the outer band is alive with maple leaves. The window is weathered, but even allowing for that the cats are not naturalistic like the sculpture around the central court. The Victorian architecture critic James Fergusson, who scorned the Gothic Revival, remarked dryly, 'It is to be hoped that no stuffed specimen of the modern genus Felis will be introduced into

FIGURE 35 *opposite* One of John Ruskin's designs for a window with a covered balcony, 1855.

FIGURE 36 *above* Sketch by James O'Shea for a window depicting monkeys, 1859.

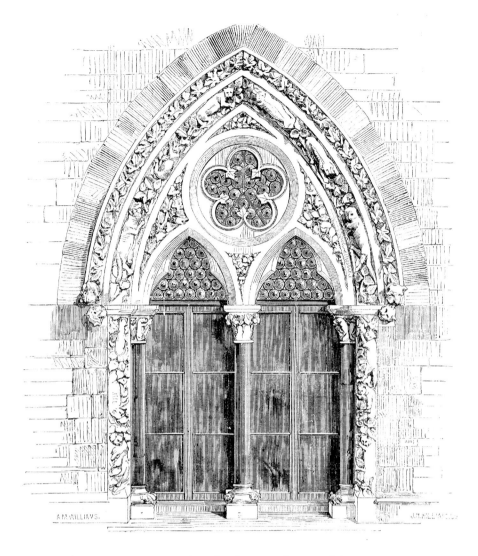

FIGURE 37 Illustration from *The Builder*, 23 June 1860, showing the Cat Window carved by James O'Shea in 1859.

the museum, or we may lose the illusion to be gained from contemplating the long-backed specimens of the Medieval species which crawl round the windows of the library in such strangely prehistoric attitudes.'[13] O'Shea's cats do indeed resemble playful medieval grotesques, whether or not it is because they began their lives as monkeys.[14]

After the Cat Window, O'Shea began carving the window directly beneath it, repressing the seemingly irrepressible and producing a much more tempered piece of carving. The reason for this change of style is that he was no longer working to his own design. Instead, he closely followed one that had been worked out in detail by Ruskin over three sheets of drawing. One of Ruskin's drawings from the Ashmolean sketches out the overall form of the window, including plants on the capitals and leaves growing up the jambs, apparently showing the same leaf in different stages of growth. In another sheet (figure 38) we see Ruskin tackling over several drawings the problem of how to capture the form of a strawberry plant in stone. First he

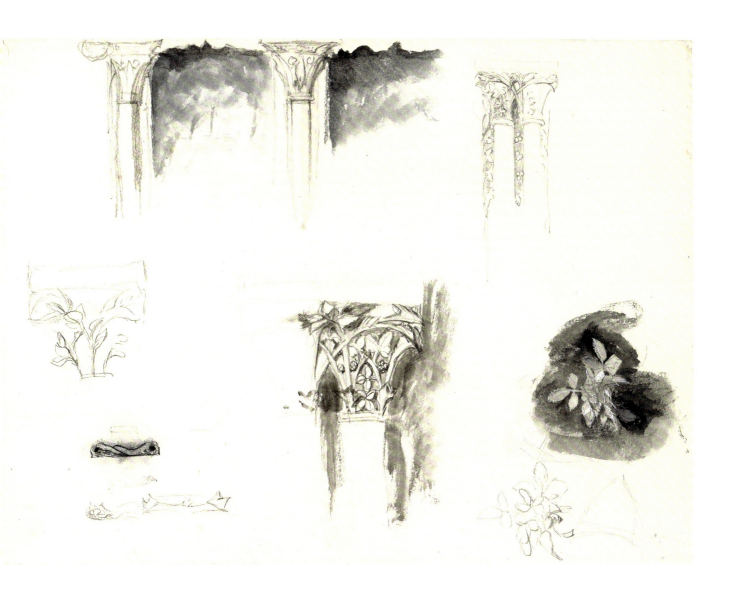

FIGURE 38 Sheet of sketches and designs by John Ruskin, 1855, for a capital for one of the windows, featuring strawberry plants.

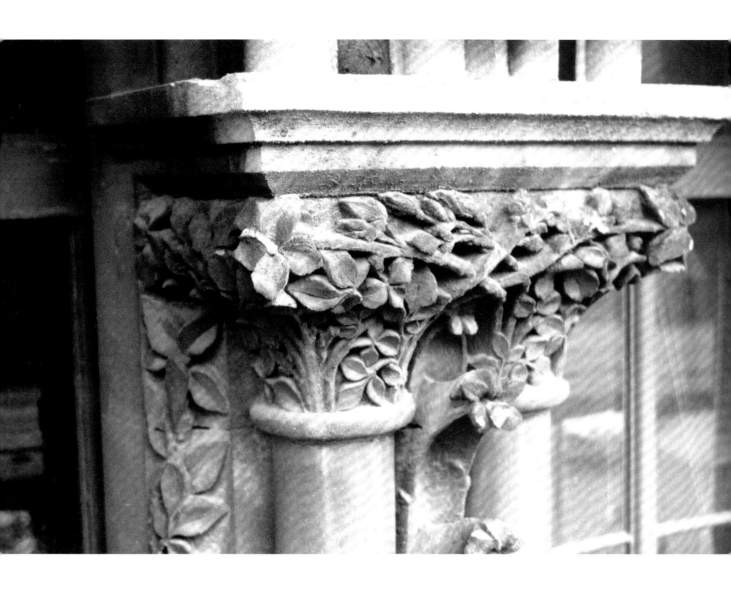

Figure 39 *above* Detail of James O'Shea's carving of the strawberry plant, based on Ruskin's designs, carved between November 1859 and January 1860.

FIGURE 40 *opposite* Detail of James O'Shea's carving on his bird window, 1860.

roughly sketches the plant, then he draws it from life, then he begins to work out how to interweave two stone strawberry plants growing from the capitals at the centre of the window. All these features are developed further in the final design, now in Birmingham, and in O'Shea's precise and careful carving around the window itself (figure 39). If the Cat Window is unrestrainedly Gothic, Ruskin's drawings and O'Shea's carving in this window are Pre-Raphaelite in their truth to nature.

In spring 1860 O'Shea moved back up to the first floor to start carving the windows to the left of the central tower. Like the Cat Window, these

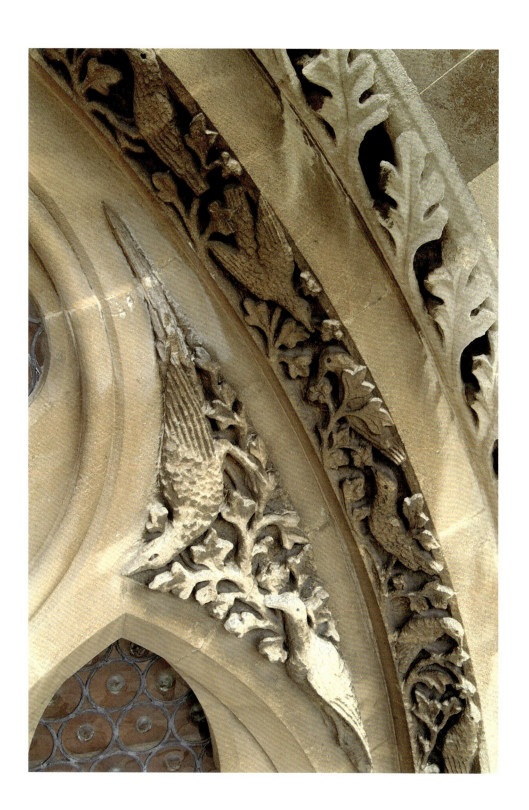

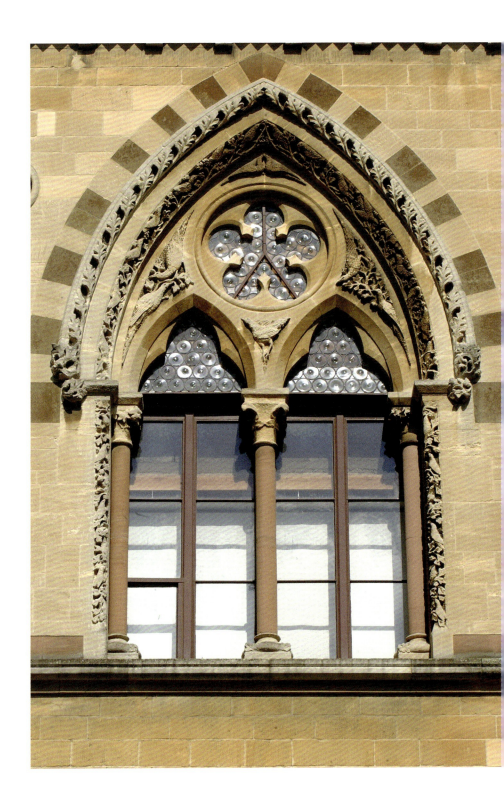

FIGURE 41 Window carved with birds by James O'Shea, 1860.

FIGURE 42 *opposite* John Ruskin's design for a window, 1855, including the bird incorporated into James O'Shea's carving.

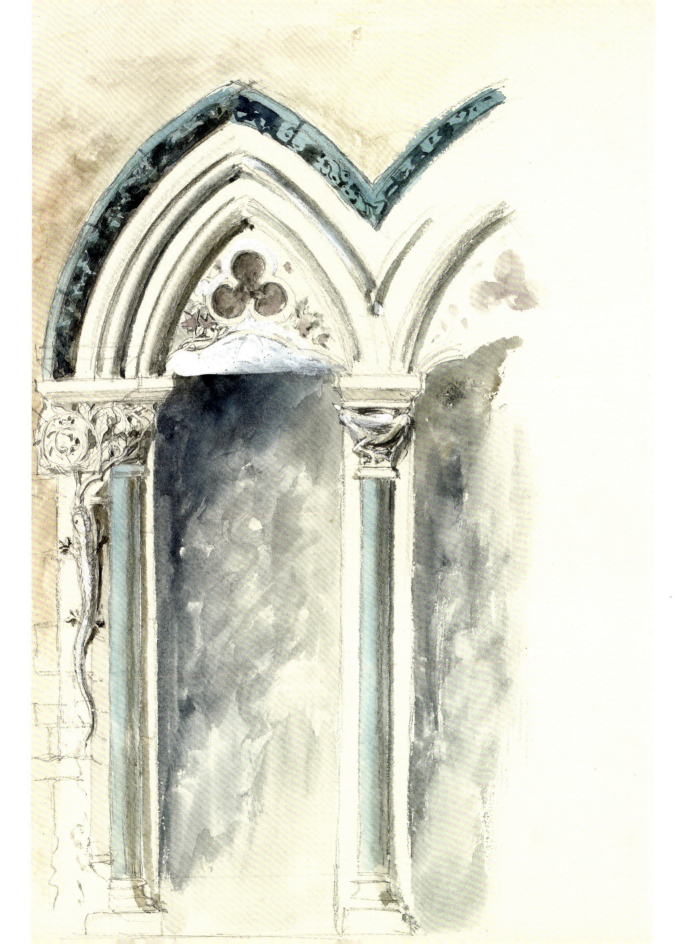

are tracery windows. Apart from the windows with balconies, Ruskin's designs were all for lancet windows. As Ruskin had no single design for O'Shea to follow, their collaboration was now on a more equal footing. O'Shea incorporated elements from five of Ruskin's drawings into his own comprehensive design for the next window. The theme of this is birds (figures 40 and 41). Features incorporated from Ruskin's designs include columns of birds up the jambs and oak leaves growing in a regular pattern around the arch. In two sketches – one in Oxford, the other in Lancaster – Ruskin places two heavier birds beak-to-beak above a lancet. O'Shea's carving compresses them into the space below the main arch of his window. Others birds in the tracery also take their general form from Ruskin's designs, including the one which stalks between the arches below the cinquefoil. It has stepped out of the most beautiful of Ruskin's drawings for the museum (figure 42), characterized by a deep turquoise, even malachite, stone and delicately imagined plants and animals. Of these, the bird on the capital between the two panes recurs – reversed, with its head up, not down – at the centre of O'Shea's window.

Ruskin left England for the Alps in May 1860, leaving O'Shea to press on with the next window. In June 1860 Woodward returned to Oxford. Suffering from tuberculosis, he had left for the continent the previous September for his health, before O'Shea carved the Cat Window. With his return, O'Shea's style changed yet again, with much more of the stone left uncarved on the last two upstairs windows to be decorated, while such carving as there is looks more stylized and less cluttered. The last windows to be carved were downstairs again. The refined scrollwork on the very last window stops halfway down (figure 43), marking, like the unfinished carving on the museum's entrance, the moment when the money ran out.

FIGURE 43 The last window carved at the museum, still showing where work was interrupted in 1861.

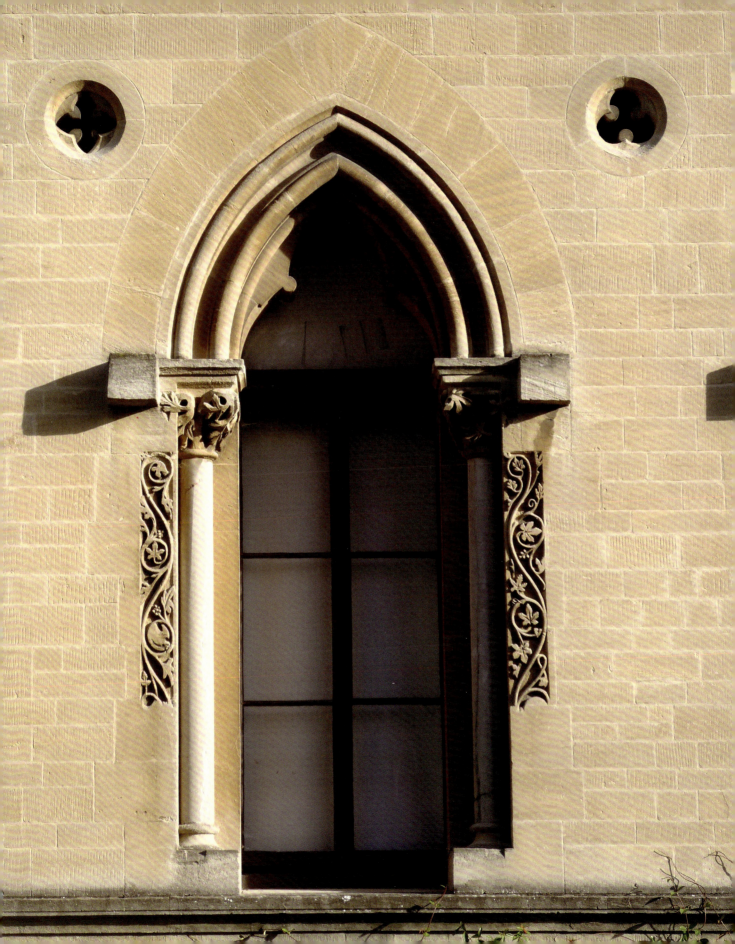

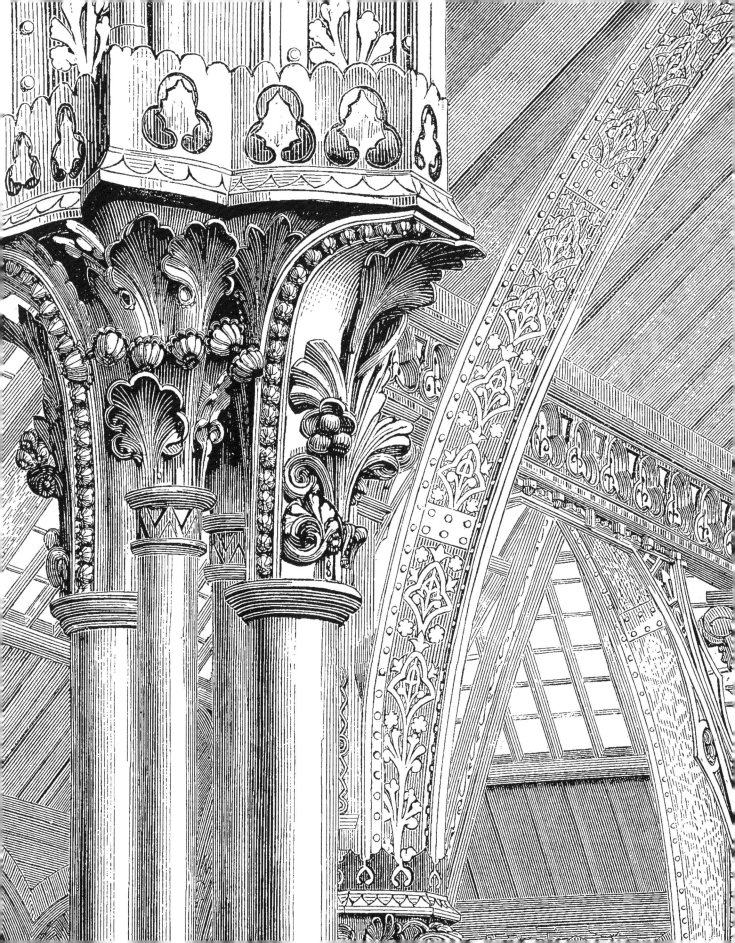

3
The 'Sanctuary of the Temple'
The central court

WHEN DAUBENY called the Oxford University Museum 'the Temple of Science', he imagined its central court (figure 45) as the inner sanctum.[1] The ecclesiastical resonances of the exterior were to continue inside the building. The colonnade around the court makes it seem like a grand, glass-roofed cloister, while the roof itself is held up by magnificent Gothic arches made from cast iron. But this was not simply a Christian temple, but a temple to science, too. The roof was to be a testimony to the achievements of modern engineering. The colonnade, with each column made from a single sample of a different rock, was an object lesson in geology. The ironwork and stonework, formed into living plants, made up a botanical catalogue, supplementing the museum's collections of animals and minerals.[2] Here and there, carved animals peeped out from stone surfaces or went about their business, showing natural history in action. The standard for this art – one of the most ambitious decorative schemes of the nineteenth century – was set by the Pre-Raphaelites, as Acland acknowledged. Each distinct component of the court resonated with their work in a different way even as it epitomized a different science.

Engineering: the roof

In planning to support the glass roof of the central court with Gothic vaulting in cast iron, Woodward brilliantly took Street's argument that modern engineering could learn from medieval Gothic to its logical conclusion. The roof itself was designed and built by Francis Skidmore, who was primarily a craftsman producing fine decorative metalwork for churches and other public buildings. He was not so well qualified as a structural engineer and he shared Ruskin's profound distaste for cast iron as a machine-made, standardized product of alienated labour. When tendering for the work on the roof, he had suggested that, instead of the combination of wrought and cast iron originally commissioned from him by Deane & Woodward, he could offer them a more innovative yet also more authentically Gothic structure supported by wrought iron alone.[3] As his quote for this version of the roof was over £2,000 cheaper, the architects took him up on the idea. Unfortunately, whatever its ideological and aesthetic

FIGURE 44 *previous spread* The central court of the Oxford University Museum of Natural History today.

FIGURE 45 *opposite* The central court of the museum soon after it opened to the public, from the *Illustrated London News*, 6 October 1860.

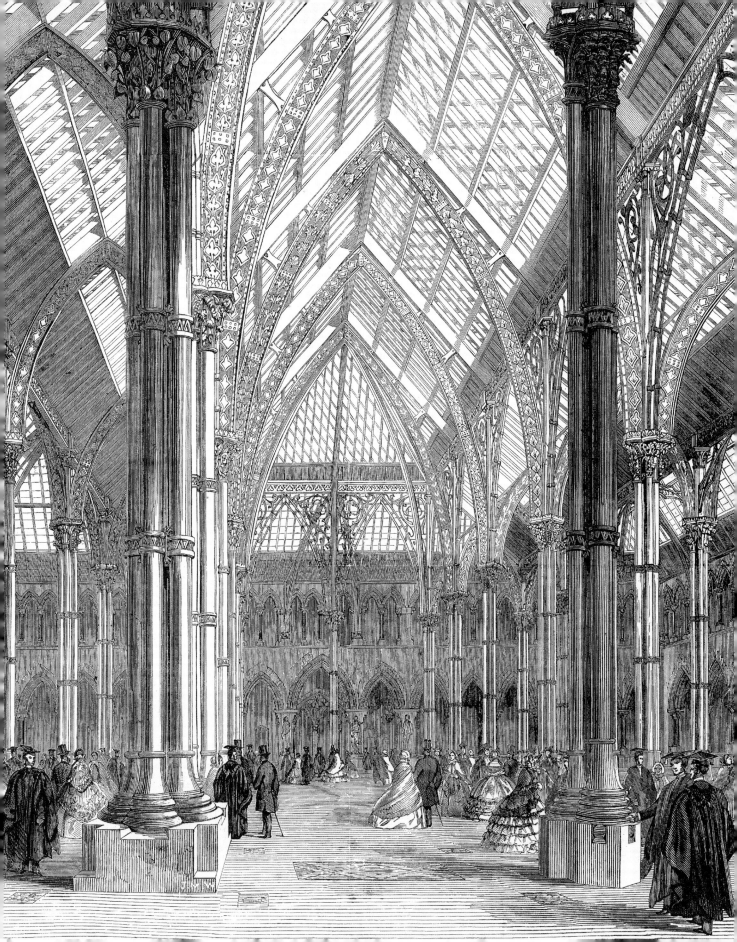

merits, wrought iron on its own was simply not strong enough to bear the weight of the roof. On 23 February 1858, the delegacy overseeing the construction of the museum for the University was called to an emergency meeting to discuss the fact that part of the roof had collapsed.[4] Skidmore was thrown back on a design which combined wrought and cast iron, with the cast-iron columns, girders and brackets taking most of the strain and the wrought-iron spandrels from the old roof redeployed principally though not exclusively to enhance the visual effect. Stencilled with stylized designs based loosely on plants and flowers, the girders sweep up in grand curves to form Gothic arches supporting the museum's glass roof (figure 46). Between them, from the apex of each aisle, hang the original gas lighting rings, another witness to the new advances of Victorian technology.

Acland had wanted to conduct an experiment 'to try how Gothic art could deal with those railway materials, iron and glass'.[5] In *The Germ*, Frederic Stephens had urged people to recognize 'the poetry of ... the endless novelties and wonders produced every day', from railways to steamships.[6] In its final version, Skidmore's roof pushes the aesthetic and architectural experiment with Victorian engineering far further than wrought iron alone could have done, spectacularly vindicating both Acland's vision for the museum and the Pre-Raphaelites' call for an artistic expression of the wonder of modern industrial technology.

Geology: the colonnades

In the introduction to the second edition of *Modern Painters*, Ruskin had stressed the importance of sound geological knowledge to landscape painting:

> It is just as impossible to generalize granite and slate, as it is to generalize a man and a cow. An animal must be either one animal or another animal: it cannot be a general animal, or it is no animal; and so a rock must be either one rock or another rock; it cannot be a general rock, or it is no rock.[7]

Stephens too insisted on accuracy in painting rocks, mocking how 'the Public are taught to look with delight ... upon rocks that make geologists wonder, their angles are so impossible, their fractures are so new'.[8] The care with which Millais painted the rocks on either side of the stream in the background to his portrait of Ruskin typifies this concern for the precise representation of geology in Pre-Raphaelite painting. Following the lead of Ruskin and the Pre-Raphaelites, a new school of Pre-Raphaelite landscape

FIGURE 46 The roof girders, still decorated with the stylized designs based on plants which were first completed in the early 1860s.

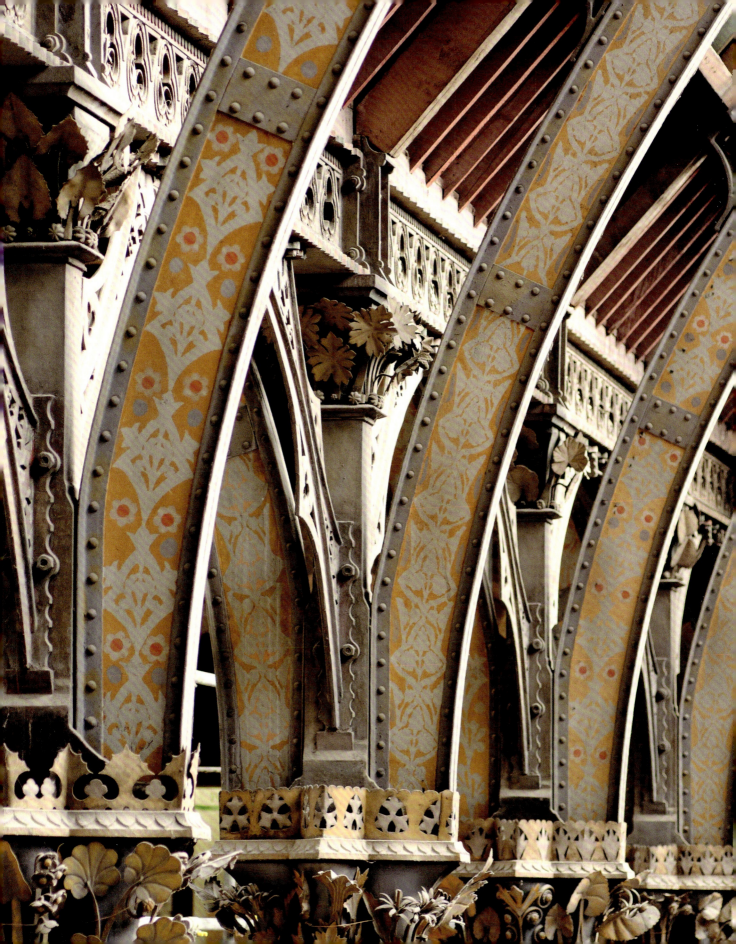

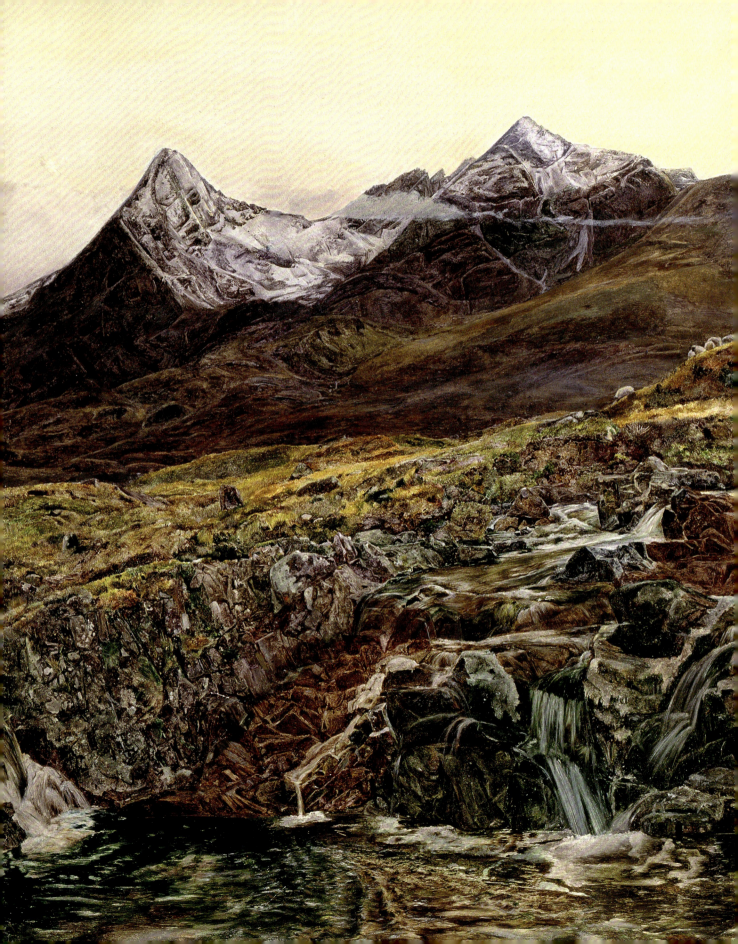

painting grew up in the 1850s even as the Oxford University Museum was being built. John William Inchbold's painting *The Burn* (figure 47) shows the care these young landscape painters took over their depiction of rock formations, colours and textures. It was painted in Autumn 1855, just as the building work on the museum was getting underway, exhibited at the Royal Academy in 1856, and is now in the Ashmolean in Oxford. Like Inchbold's painting, the colonnade around the central court at the museum shows not only scientific rigour but a keen sense of the beauty of colour and pattern offered by geology.

It was not unusual for Victorian geology museums to incorporate samples of particular types of stone into the fabric of their buildings. The portal of the Museum of Practical Geology in London, built between 1846 and 1851 for the Geological Survey, was made out of a selection of polished stones from across England.[9] The atrium of the Museum Building at Trinity College Dublin, constructed from 1854 to 1857, showcased beautiful Irish marbles in its columns and banisters.[10] Phillips had worked for the Geological Survey, while Woodward had designed and built the Trinity museum. Working together in Oxford, they took these recent precedents and made the motif fundamental to both the structure and the purpose of the Oxford University Museum. In London and Dublin, the aim was to make geology practically useful to builders and engineers. In Oxford, geology was incorporated into a comprehensive natural history. In Phillips's words, the columns were to form 'specimens of all the more important kinds' of 'British marbles', broadly defined to include granites, serpentines and other 'polishable stones' as well as the true limestone marbles. As he explained to Acland, in a letter written for the benefit of the museum's sponsors and visitors, they were chosen to be 'important on grounds of scientific interest, as well as for their commercial value and architectural utility'. Phillips's object was 'to make these ornamental parts of the fabric *really* and *obviously useful*, as a part of the exhibition of natural objects'.[11]

The columns (figure 48) on both levels around the central court are organized according to a complex plan which takes into account the type of rock, its age and its place of origin. The west side of the court is lined with granites of different kinds on both floors, for example. The north and south corridors on the upper floor cover the Devonian and Carboniferous periods, with Irish marbles along the northern side and English and Welsh ones from the same periods along the southern side. To a geological novice, the arrangement can be perplexing, but each column is helpfully labelled so it can form a point of reference for a student or for a professor like Phillips

FIGURE 47 *previous spread* John William Inchbold, *The Burn, November – the Cucullen Hills*, 1855, now known as *Cuillin Ridge, Skye, from Sligachan*. Inchbold's painting epitomizes the care that the new generation of Pre-Raphaelite landscape painters took over representing geology in the 1850s.

FIGURE 48 *opposite* The upper colonnade, showing the use of different kinds and colours of marble. The colonnade was in place by 1857, although the carving on the upper level was not completed until the early twentieth century.

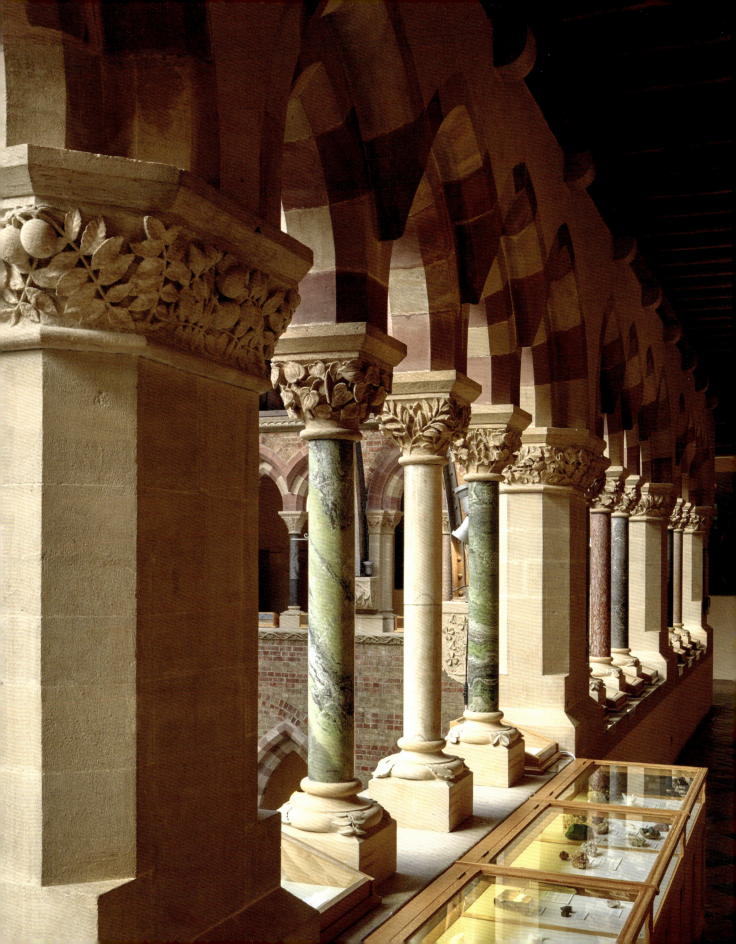

FIGURE 49 Detail of Charles Collins, *Convent Thoughts*, 1851, praised by Ruskin for its accuracy as a 'botanical study'.

himself. Together they form a beautifully modulated and varied pattern of different colours and visible textures. Several columns preserve fossils at the surface of the marble, hinting at palaeontology and the history of life as well as teaching the sequence, structure and location of the different rocks.

Botany: stonework and ironwork

While the colonnade formed a collection of geological specimens, the carved capitals were to stand in for a herbarium. As Phillips explained:

> as far as possible, the representations of plants (varied here and there by animals geographically and naturally associated with them), will be placed, with so much of system as to help the memory, and will be sculptured with so much attention to their natural habit, as to satisfy the botanist as well as the artist.[12]

Because the marble columns on the ground floor alternated with stone piers, each capital was matched with two corbels, forming a bay depicting related species from the same family or order. Together, the carvings would illustrate, as well as human skill could manage, the work, in Phillips's words, of 'the GREAT ARTIFICER' who 'moulds the lilies of the field and the leaves of the forest'.[13]

Ruskin commented of Collins's *Convent Thoughts* (figure 49) that 'as a

mere botanical study of the water lily and *Alisma*, as well as of the common lily and several other garden flowers, this picture would be invaluable to me'.[14] As Acland promised, the same Pre-Raphaelite precision of botanical observation would characterize both the stone carvings and the ironwork at the museum. Collins had painted a garden. One of the capitals at the museum, originating in a now lost design by Pauline Trevelyan, also celebrates cultivated flowers with a glorious bouquet of tulips and lilies (figure 50), while another bay charts the progression from grasses to crops. For the most part, though, the capitals at the museum present the natural history of wild plants, tracing their growth and here and there exploring their ecology through the animals that live among them.

The Caen stone capitals on the ground floor around the court were carved by the brothers James and John O'Shea and their nephew Edward Whelan, with assistance from a fourth, untraced sculptor named Flinn.[15] With suggestions and contributions from the Trevelyans and others, Phillips laid out the plan according to which the capitals would be arranged and sketched out some designs (figure 51). When it came to the carving (figure 52), however, the sculptors worked principally from live specimens rather than designs, varying them too, in line with Phillips's own remarks, by including birds and other animals creeping and hunting among the leaves and feeding on their fruit.

In 1909 the physiologist Horace Middleton Vernon, who had studied and worked at the museum since the 1890s, and his wife, historian Katharine Dorothea Vernon, published *A History of the Oxford Museum*. They describe the O'Sheas' working practices:

> They would go off to the Botanical Gardens, choose a fine specimen of a plant, according to the grouping selected by Professor Phillips, and, taking it back to their scaffolding, they would copy its living form on capital or window-arch with extraordinary vivacity and sympathetic comprehension.[16]

The O'Sheas' carvings are among the most accomplished botanical sculptures ever made in stone. Reviewing the museum for *Macmillan's Magazine* in 1862, Stephens praised them for having 'tenderly, cunningly, and lovingly studied natural forms, and reproduced them with marvellous fidelity and elaborateness'. All their carvings, he said, were 'infinitely above the level of similar modern works'.[17] Dante Gabriel Rossetti agreed, saying that the O'Sheas had produced, under Woodward's direction, 'innumerable works of real beauty in all branches of architectural carving'.[18] Many years later, Ruskin too paid tribute to James O'Shea specifically as 'a man of the truest genius, and of the kindest nature. Not only the best, but the only person, who could have done anything of what we wanted to do here.'[19] Both the Oxford scientists and the Pre-Raphaelites themselves recognized the O'Sheas as Pre-Raphaelite artists in their own right and the finest decorative sculptors of their age.

In his review, Stephens imagines the sculptors steeping themselves in nature, carrying out their own field work and coaxing the plants into a partnership with art:

FIGURE 50 Capital depicting tulips and lilies, attributed to Edward Whelan and derived from a lost design by Pauline Trevelyan, c.1858.

FIGURE 51 John Phillips's design for a capital showing a date palm, c.1857.

FIGURE 52 Date palm capital, attributed to James O'Shea, c.1858.

FIGURE 53 James O'Shea's carving of golden leatherferns, c.1859.

FIGURE 54 Edward Whelan's carving of an aloe, c.1858.

FIGURE 55 John O'Shea's carving of German irises, c.1859.

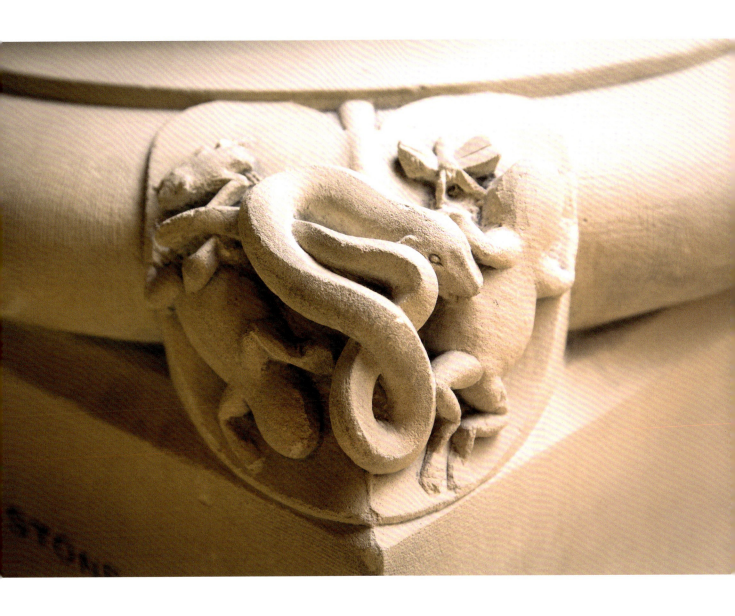

FIGURE 56 Carving of a snake with ears, attributed to James O'Shea, c.1859.

The artizan has sought in the lush recesses of the neighbouring river-bank for crisp water plants, or those that love the margins and whip the stream; in the shady woods dank ferns have been found to be models of loveliest form; the humblest field weed has yielded up her shy beauty, and stands immortalized here in the stone; the lilies have an unchanging glory; the hillside-loving pine has bent her sturdy branches and been found delightful; while the wide-blooming marsh-mallow is here steadfast for ever.[20]

At the same time, he discerns differences in style between the three main sculptors at work on the court. As one of the key theorists of Pre-Raphaelitism, Stephens relishes the liveliness and meticulous observation of James O'Shea's work, drawing attention to how he captures the textures of the different plants that he carves (figure 53), from the 'rigid spines' of the date palm to the 'featheriness' and 'plume-like involutions' of the hart's-tongue fern. 'Nothing', to Stephens's eye, 'can be more intelligently faithful than these works.'[21] He is equally delighted by Edward Whelan's carving of an aloe (figure 54) which conveys its 'fleshy stiffness' even as it 'so skilfully dodges the angle' at the corner of the court.[22] But Stephens reserves his deepest admiration for John O'Shea, whose carvings he describes as 'Simpler in the general forms, chastened and more severe … with notably less luxuriance and delight of love in the "lush green" than his competitors'. Stephens singles out his carving of German irises (figure 55), 'where the systematized symmetry of the iris-bloom has been brought to each corner of the octangular cap, and the broad flag-like leaves are traced rather than carved upon the vase', as indicative of the 'reticence of skill' which characterizes his sculpture in particular. In properly valuing simplicity and symmetry, Stephens concludes, 'Mr. John O'Shea seems to us to have seen something deeper into the needs of architectural art.'[23]

As well as being botanically precise, the O'Sheas' sculpture at the museum is also playful. The comedy comes not from the plants themselves but from the animals that live among them. Along with the birds, frogs and insects which can be spotted among the plants of the capitals, there are several other animals here and there within the stonework of the corridor which runs round the court. The north-west corner is crawling with hunting snakes, including a curious little creature that looks like a snake with ears (figure 56). Snakes were associated with Asclepius, the ancient Greek god of medicine. This part of the building was where the medical department was housed, so the deadly snakes here seem to be an ironic allusion to the

FIGURE 57 Capital carved by James O'Shea depicting a Mexican cycad with indigenous animals, 1860.

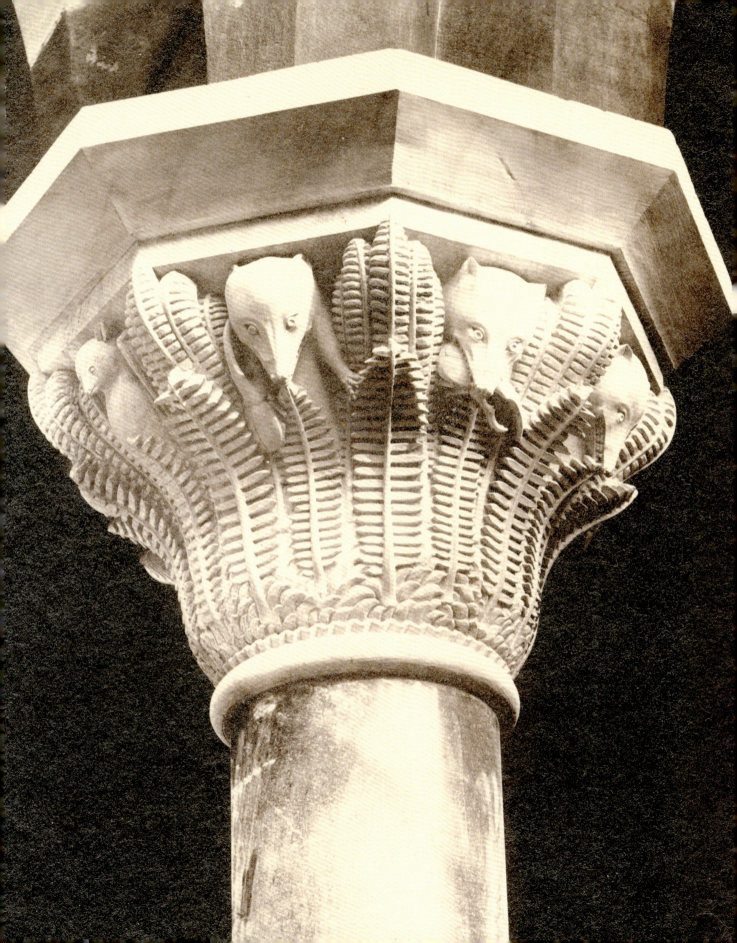

classics. On the other side of the court a pair of puzzled-looking monkeys are just round the corner from the monkey puzzle capital.

The most elaborately comic carving of animals in the central court is a capital (figure 57) completed by James O'Shea in early 1860 in between his work on the two windows designed by and with Ruskin.[24] It gives us another glimpse into their collaboration. As Eve Blau noted in her book *Ruskinian Gothic*, on Deane & Woodward's architectural practice, it is modelled on a capital at the Doge's Palace in Venice (figure 58), which was pictured in Ruskin's illustrated book *Examples of the Architecture of Venice*.[25] More precisely, O'Shea's capital is a parody of the Venetian original, which he was mostly likely shown by Ruskin himself. At Oxford, the Doge's fierce and supposedly noble lions, wolves and wolfhounds are replaced with cute and curious armadillos, fruit bats and coatis. Modelled in part on specimens from the museum, these comical creatures are an ecological match for the endemic Mexican cycad *Dioon edule* on the same capital. Ruskin had promised Pauline Trevelyan that they would have 'all the Monsters in the Museum' included in the decoration.[26] Here O'Shea takes up this suggestion in an impish allusion to one of the greatest Gothic buildings, singled out for praise by Ruskin himself.

Phillips's plan for the carvings on the ground floor was very precise, down to the level of the species. The columns on the upper corridors were thinner, closer together and more numerous, and topped with capitals of Taynton stone which was less fine-grained and so harder to carve with precision than the Caen stone below.[27] The scheme Phillips sketched out for these was much simpler, specifying only the principle groups of plants to be represented. Whelan made a start on carving them but work stopped in 1861, with the capitals on three sides of the court and more left uncarved.[28] In 1905, H.T. Morgan, a clergyman from Lincoln who had studied at Oxford as an undergraduate in the 1850s and had seen the O'Sheas at work, gave the museum's then curator, the mineralogist Henry Alexander Miers, a donation to complete the carving of the west and south upper corridors. Miers put out a request for further donations, suggesting that the completed series of botanical carvings would be a 'fitting memorial of Professor Ruskin', who had died in 1900.[29] Over the decade that followed, all the first-floor capitals were carved, along with a decorative frieze that runs all round the court.

The work was undertaken by two sculptors from the London firm of Farmer & Brindley whose names were Mills and Holt (figure 59).[30] Their working methods, as described by Miers, were similar to the O'Sheas. They

FIGURE 58 Illustration of a capital from the Doge's Palace in Venice, from John Ruskin, *Examples of the Architecture of Venice*, 1851. It was parodied by James O'Shea in his carving at the museum.

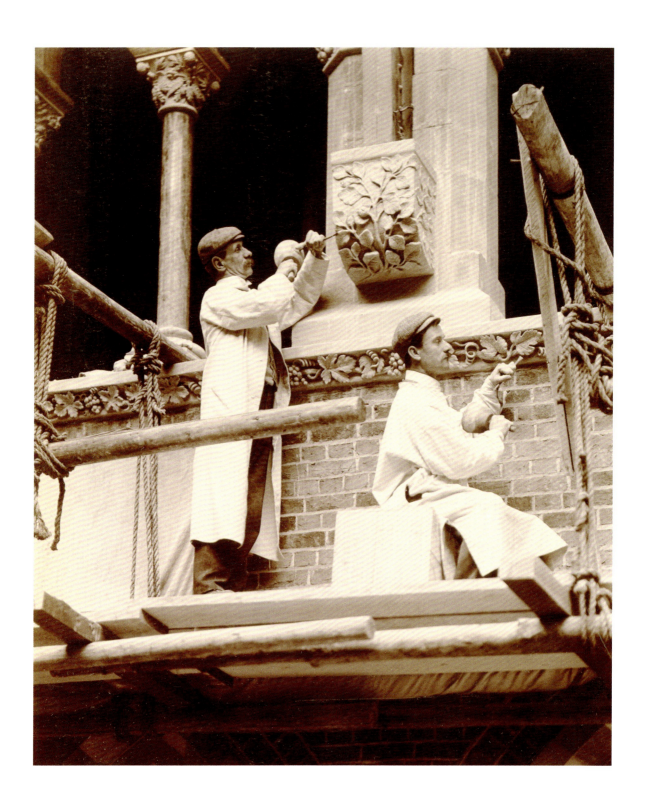

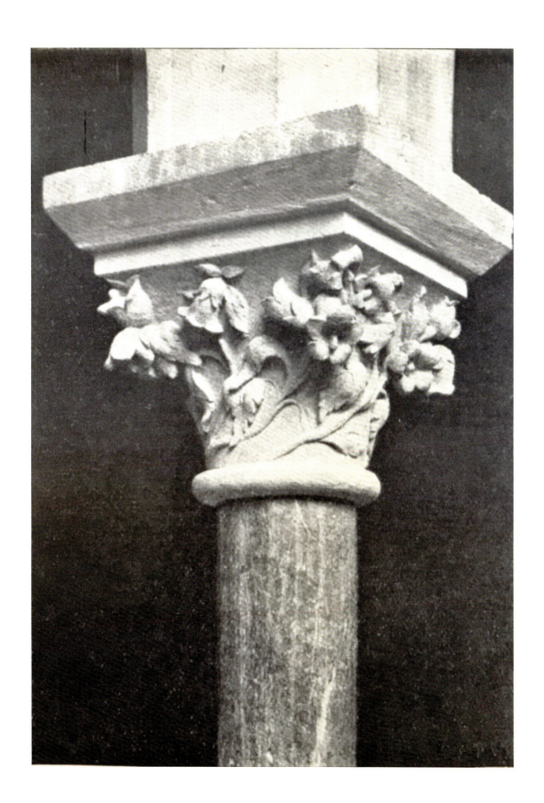

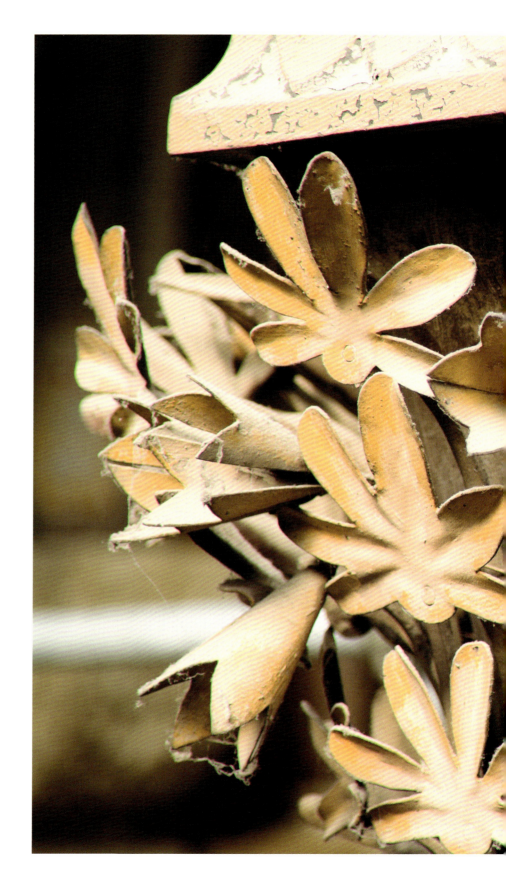

FIGURE 59 *previous spread left* Mills and Holt carving decorations at the museum, c.1912.

FIGURE 60 *previous spread right* Photograph of the Canterbury bell capital, carved by Mills or Holt, reprinted in Vernon and Vernon, *A History of the Oxford Museum*, 1909.

FIGURE 61 *right* Francis Skidmore, capital, c.1858.

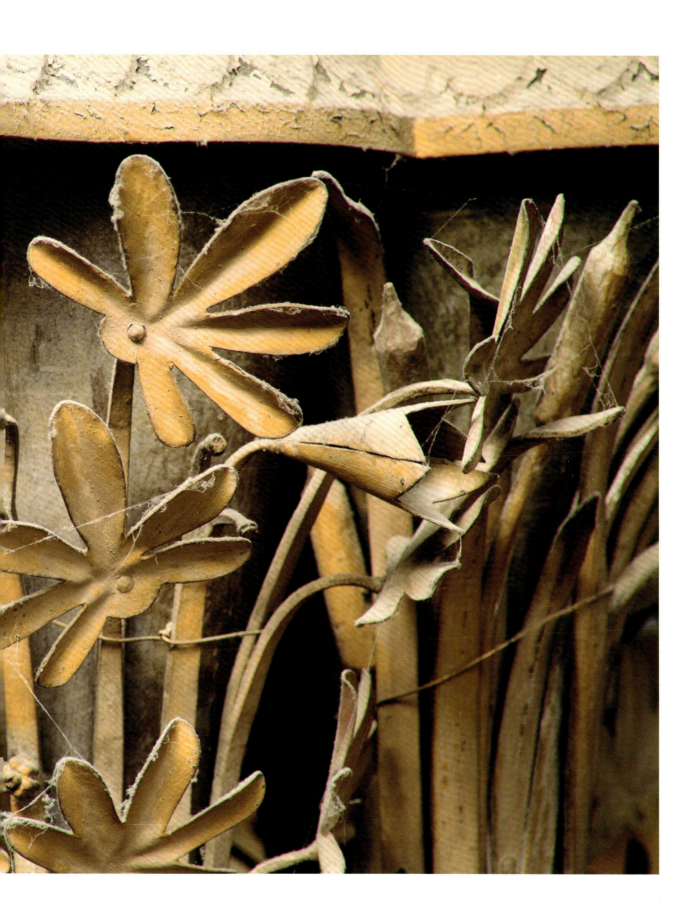

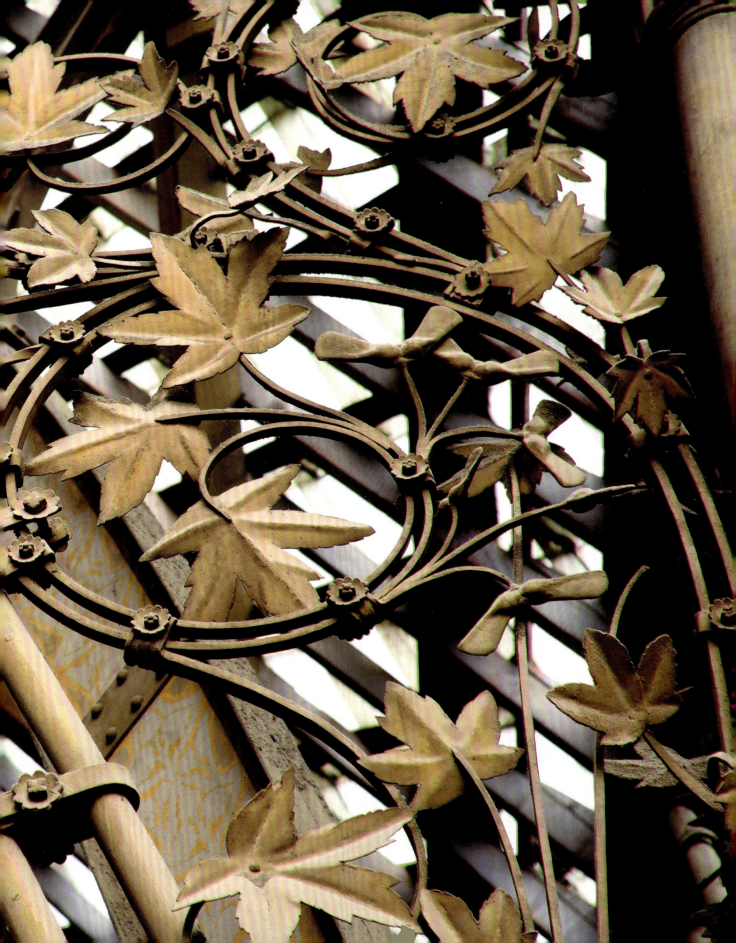

would begin by making 'a finished artistic sketch from the living plant at the Botanic Garden' and then elaborate the carving itself 'with the help of the sketch and a specimen of the flower and foliage'.[31]

Their best work was represented by a photograph, circulated by Miers, of the Canterbury bell capital (figure 60). The Vernons thought their work perhaps even better than the O'Sheas'.[32] Taken as a whole, the upper colonnade is not as distinctive, imaginative and virtuosic as a collection of sculptures as the lower colonnade. Nonetheless, it remains a more than satisfactory completion to both the botanical survey and the ecological vision of nature carved into the fabric of the central court, as well as a fitting monument to Ruskin, as Miers proposed.

The carefully planned encyclopaedia of botany in stone at the museum is complemented by its freer exploration in iron. The cast-iron columns which support the girders of the roof are topped with purely decorative wrought-iron capitals. Viewed at eye level, several of these are in fact flowers or water plants such as bulrushes (figure 61), but the overall effect is to create what Frederick Stephens called a '*quasi*-forest'.[33] The impression that the columns form a forest is intensified by the second, finer component of Skidmore's decorative ironwork: the wrought-iron brackets which help to brace the roof of the central aisle. The surviving relics of the museum's original roof, these form spandrels filled with scrollwork where the leaves and seeds of trees such as sycamore (figure 62) or horse chestnut sprout from the curved lines of iron. It is just possible that Ruskin may have had a hand in designing these spandrels. According to the nineteenth-century editors of the *Bibliography of Ruskin*, a publisher on the Strand in London issued a series of photographs which claimed to be of 'eight brackets, designed by Mr. Ruskin, for the Oxford Museum'.[34] But the editors did not claim to have seen the prints themselves and one of them, T.J. Wise, was later exposed as a forger. Besides, the publishers may well have based their claim merely on Ruskin's known connection to the museum. Though this remains a tantalizing glimpse of another possible aspect of his work at the museum, Ruskin himself was lukewarm in his praise for the spandrels as Skidmore designed them, arguing that 'deeper research into nature' might have enabled him 'to have given vigorous expression, not of the shapes of leaves and nuts only, but of their peculiar radiant or fanned expansion, and other conditions of group and growth in the tree'.[35] For Ruskin, Skidmore had not followed the precedent of Pre-Raphaelitism far enough. Judged on its own less-exacting terms, however, Skidmore's ironwork gives an elegant finish to the museum's botanical décor.

FIGURE 62 *previous spread* Francis Skidmore, sycamore spandrel, c.1857.

History: the unpainted murals

Fifty years after the Oxford University Museum was built, the Pre-Raphaelite painter William Holman Hunt claimed that the dons at Oxford had been keen to cover its walls with murals illustrating key ideas from the history and philosophy of science. The example he gave was 'Newton gathering pebbles on the shore of the Ocean of Truth'. As Hunt remarked, such themes would have 'severely strained the aesthetic sense and requirements of the artist', especially Rossetti, who, according to Hunt, promptly deserted the project to take charge of the painting of Arthurian murals at the Oxford Union Society instead.[36] No other sources have come to light to corroborate the details of Hunt's story, although Acland did express hope at one stage that more frescos might be painted at the museum.[37]

A large, unsigned design for a mural (figure 63) hangs at the museum, but if the scientific scenes would have been a challenge for the artist this surviving design appears to have nothing to offer the scientist. It shows the interior of the museum with some of the statues in place and more or less academic conversations being conducted on both floors. The walls between the arches are plastered and painted, apparently showing battle scenes with soldiers dressed in what look like costumes and armour from the English Civil War. They seem to have no direct relevance to the museum at all, unless, like the proposed painting of Newton, they have some lost allegorical significance. The Vernons joked that it was fortunate that these murals were never painted:

> Sir Walter Trevelyan feared lest the carving on the capitals might distract students from their research. There would have been reason for such a fear if the wall had been painted with struggling figures of men and horses, like those depicted in a rough sketch which is still extant.[38]

In the end, the only decorative painting done in the central court was a fragment of a frieze that can just be seen in the south-east corner, suggesting stylized plants in keeping with Skidmore's ironwork. The rest of the court is unpainted, as it was in 1877, when Ruskin grumbled to his students that it was a 'very shabby bit of work', remarking that, 'in declaring that material should be honestly shown, I never meant that a handsome building could be built of common brickbats, if only you showed the bricks inside as well as out'.[39]

FIGURE 63 Unsigned design for historical murals at the museum, c.1858–60.

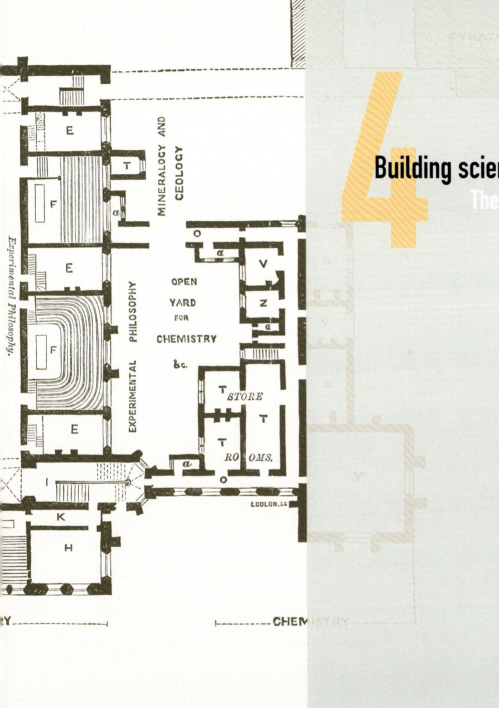

4
Building scientific disciplines
The lecture rooms and laboratories

THE NINETEENTH CENTURY was a crucial period in the formation of scientific disciplines as we understand them today. This process was driven by the practical applications of different sciences, growing specialization in research and the need to design scientific curriculums for universities and schools. The Oxford University Museum was never just a museum as we understand the term today. It was an entire science faculty. Designated laboratories, libraries, dissecting rooms, lecture rooms and research collections were housed around the main collection in the central court (figure 64), along with offices for the professors themselves, characterized by Daubeny as 'the chambers of the ministering Priests' of science.[1]

The early plans of the museum show separate suites of rooms for Anatomy, Physiology and Zoology, Medicine, Chemistry, Experimental Philosophy, and Mineralogy and Geology around the ground floor, with Astronomy, Geometry and Entomology on the first floor, along with the library and a large lecture theatre. Each suite was purpose-built to satisfy the requirements of its own specific discipline. In several cases, this extended to the decorations as well as the fixtures and fittings, always imagined in line with the museum's overall Gothic and Pre-Raphaelite aesthetic.

The Geology Lecture Room

When *The Builder*'s reviewer visited the museum in June 1859, he noted that 'In the Geological lecture-room the Rev. Mr. Tyrwhitt, of Christchurch, is covering the walls with representations of mountains, but these were not sufficiently advanced to admit of safe judgment.'[2] Richard St John Tyrwhitt was the vicar of St Mary Magdalen in Oxford. Later in life, he would become one of Ruskin's most dedicated acolytes, acting as his secretary, writing his own art books on Ruskinian principles, and standing aside to allow him to become the first Slade Professor of Art at Oxford. In the summer of 1859 his wife Eliza, the sister of the Pre-Raphaelite painter John Roddam Spencer Stanhope, was pregnant. Eliza died that September, two days after their son was born. Soon after, Tyrwhitt left England to recuperate, making a pilgrimage to the Holy Land which took him to the Alps on the way out and

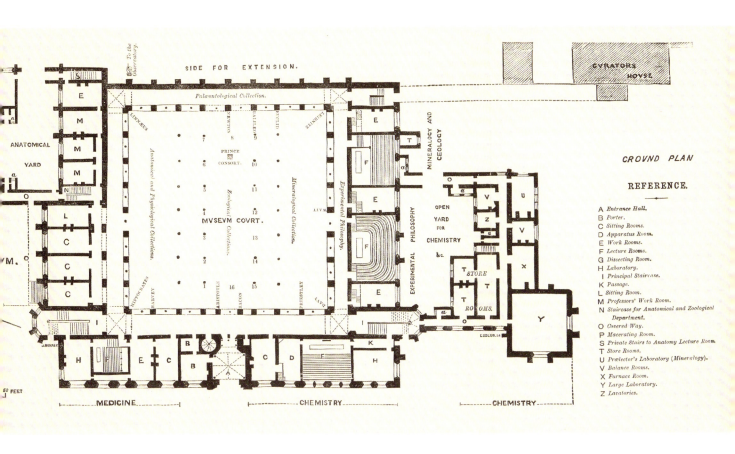

up through Italy on the way back. Although one of his murals depicts the Mer de Glace near Chamonix and the other the Bay of Naples, viewed from the slopes of Vesuvius, it seems that he must have painted them ahead of his visits to the sites themselves, as a delegacy report from the beginning of June 1860, when Tyrwhitt returned from his tour, suggests they were already completed.[3] They remain unfinished, however, showing drips of paint that were never cleaned up and pencilled details, such as an ibex overlooking the Mer de Glace, which were either never filled in or painted out. Their condition is a quietly moving record of the tragic disruption to Tyrwhitt's life so soon after he embarked on painting them.

FIGURE 64 *previous spread and above* Ground plan of the museum showing the different subjects taught on the ground floor, from Henry W. Acland and John Phillips, *The Oxford Museum*, 4th ed., 1867.

In the same room as the murals hang two oil paintings of the same subjects, also by Tyrwhitt. The stories they tell, however, are subtly different. Tyrwhitt's interest in the Mer de Glace seems to have begun with Ruskin.[4] Ruskin wrote to encourage Tyrwhitt as he was painting the oil. It seems to be closely based on a daguerreotype (figures 65 and 66) which Ruskin had had taken of the glacier and which, presumably, he lent him. In painting the mural (figure 67), Tyrwhitt radically altered the composition, positioning the viewer closer to the glacier itself and within the mouth of a cave, so we seem to be looking out on an Ice Age landscape. Although Tyrwhitt left no commentary on his murals, it seems likely that this change in perspective alludes to Buckland's work on glaciation combined with the discovery, as recently as 1858, of human remains alongside those of ancient animals in a cave near Brixham, Devon.[5] In his paintings of Vesuvius, the order of composition was reversed. In the mural (figure 68), the viewer is looking out to sea over a desolate landscape. In the oil, the angle of vantage has been turned through 180 degrees and we are now looking up the mountain. The oil painting was done by Tyrwhitt on his tour, revisiting the subject of his mural in a new work, as the inscription in the lower corner of the oil painting, 'On Vesuvius above Resina', makes clear.

Tyrwhitt's murals depict two of the great geological forces that shape the earth. They face each other across the room, implicitly opposing ice and fire,

FIGURE 65 *above* John Ruskin and Frederick Crawley, daguerreotype of the Mer de Glace, 1854.

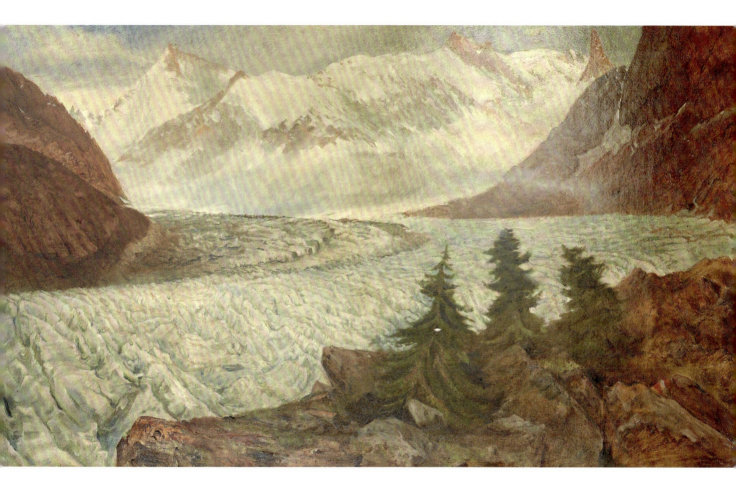

erosion and eruption. The old Geology Lecture Room is now the office of the museum's Director, with a false floor installed to created storage space beneath. In its original form and layout, there would have been raked seating for the students, flanked by the murals which would have loomed over them on either side as they listened to their lectures. There are glimpses within Tyrwhitt's composition – in the flowers and ferns growing on the lip of the cave above the Mer de Glace, for instance – of a Pre-Raphaelite attention to detail. The primary effect, however, of the pairing of two such large murals is to invite the students not to see them simply as landscapes but to consider how those landscapes were formed. As the Mer de Glace shows the power of ice to gouge out great valleys, the bleak landscape above the Bay of Naples shows the devastation wrought by volcanoes.

FIGURE 66 *above* Richard St John Tyrwhitt, *Mer de Glace* (oil painting), c.1859.

FIGURE 67 *following spread* Richard St John Tyrwhitt, *Mer de Glace* (mural), 1859.

Entomology: the Hope Museum

One of the Oxford University Museum's founding collections consisted of thousands of insects collected by Frederick William Hope, who had been taught by John Kidd at Oxford in the 1810s. Hope gave his collection to the University in 1849 and, when the museum opened in 1860, he endowed Oxford's first chair in zoology. The first Hope Professor of Zoology was his close friend, the eminent entomologist and committed natural theologian, John Obadiah Westwood. To house the collection, Oxford designated a particular room on the first floor of the museum as 'Mr. Hope's Entomological Museum', with the Curator's Sitting-Room next door for Westwood himself.[6]

As in the Geology Lecture Room, the decorative schema in the Hope Museum reflected its function. The centrepiece is a fireplace (figure 69), carved by Edward Whelan. It is another example of an artist collaborating with a scientist – most likely Westwood in this case – to create apt decorations for the museum. Whelan's carving illustrates the life cycle of two insects, the stag beetle and the death's-head hawk-moth. They are shown

FIGURE 68 *previous spread* Richard St John Tyrwhitt, *Bay of Naples from the Slopes of Vesuvius* (mural), 1859.

FIGURE 69 *below* Edward Whelan, fireplace for the Hope Museum of Entomology, 1860, now the Westwood Room.

FIGURE 70 *opposite* Detail of Henry Swan's painting in the Hope Museum of Entomology, 1859, now the Westwood Room.

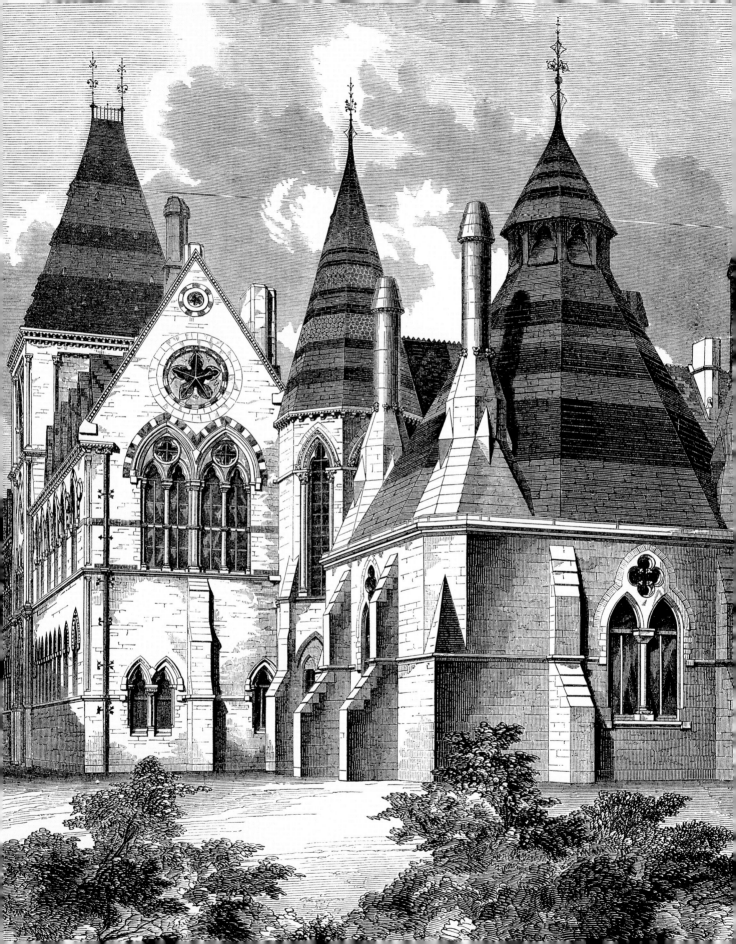

living in their favoured habitats, among oak and potato leaves respectively. Besides the insects and the plants, there is a third party implied in these relationships. Both potatoes and oaks were of profound importance to the British in the mid-nineteenth century, underpinning their diet and their global trade through ship-building. The sculpture gestures to a detailed knowledge of entomology and a recognition of the economic and ecological relations between human beings and insects.

The walls and ceiling of the Hope Museum were painted by Henry Swan, who was taught by Ruskin at the Working Men's College in London and went on to be the first curator of the Museum of the Guild of St George, founded by Ruskin in Sheffield.[7] *The Builder*'s reviewer praised Swan's paintwork for its 'great life and variety'.[8] Although a design representing a scarab beetle over a doorway was approved by Sir Thomas Deane, it was not used directly by Swan in his paintwork. On first glance, the patterning on the walls represents instead geometrically stylized flowers, with the end of a lizard's tail darting off out of view at one point near the ceiling. But among some of the flowers are stems with leaves and buds which are deftly arranged to resemble dragonflies (figure 70). Here, too, the decoration hints at the particular science studied in this room, in the glimpses of insects themselves and their predators, and as a reminder of their crucial role in the pollination of flowers and crops.

Chemistry: the Abbot's Kitchen

Woodward's Gothic design allowed for certain facilities to be separated from or added to the main museum building as required. One of these was the large chemistry laboratory (figure 71), which Woodward chose, in one of his most unlikely medieval flourishes, to model on the Abbot's Kitchen from Glastonbury Abbey (figure 72). The Abbot's Kitchen had been celebrated as an exemplary piece of medieval English architecture by Augustus Welby Pugin, the champion of Gothic architecture who worked with Charles Barry on the new Houses of Parliament.[9] Oxford's own expert on medieval architecture, John Henry Parker, called it 'a noble structure … so firmly built that it still stands entire when all the other buildings [of the Abbey] have disappeared'.[10] Parker published his book on medieval domestic architecture in 1853, a year before Woodward drew up his plans for the museum. It seems likely that his design for the laboratory was inspired by Parker's appreciative

FIGURE 71 *opposite* Illustration of the museum from *The Builder*, 9 April 1859, with the Gothic chemistry laboratory in the foreground.

FIGURE 72 *above* The Abbot's Kitchen at Glastonbury Abbey, drawn by Augustus Welby Pugin for *Examples of Gothic Architecture*, 1836.

remark that: 'The construction of the lantern is exceedingly ingenious, being well calculated for relieving the kitchen from excessive heat or smoke, and at the same time light and strong, as its durability has evinced.'[11] If the design worked so well in keeping a kitchen cool and well ventilated, why should it not work equally well for a chemistry laboratory?

Where the rest of the museum convincingly repurposes Gothic for a new age, Woodward's chemistry laboratory seems almost perverse in its insistence on historical continuity. The Victorian architectural historian James Fergusson, who opposed the museum's Gothic style as inappropriate for a science museum, imagined that a professor might be seen in the laboratory 'practising alchemy'.[12] The Abbot's Kitchen, as it is still known within the museum, is an appealing quirk in Woodward's design, but it would be hard to claim it as a plausible architectural match for what Frederic Stephens called 'the modern science' in *The Germ*.[13]

Meteorology: the central tower

Woodward's designs for the museum evolved over the course of building it. Not all of his proposals were accepted, even when he had the support of Oxford's leading scientists. One proposal that was not adopted was a design for an observation gallery around the central tower (figure 73) which could be used for taking atmospheric and meteorological measurements. Phillips and Acland were broadly supportive, as were the Radcliffe Observer, Manuel Johnson, and his colleague William Donkin, the Savilian Professor of Astronomy. Greswell, by contrast, was opposed on aesthetic grounds. In the end, it was the budget that put paid to Woodward's plan, as the dons were unwilling to vote the extra money that would have been required for the modified design to be built.[14] Woodward's drawings, now in the Oxford University Archive, are all that remain of a plan which would have turned the museum building itself into a scientific instrument, useful not only for teaching and laboratory work, but for taking measurements in conditions that could not be achieved at ground level.

FIGURE 73 Benjamin Woodward's perspective drawing for a proposed observation gallery around the museum's central tower, 1858.

5 A scientific pantheon
The portrait statues

THE DECORATIVE SCHEMA at the Oxford University Museum was to be completed with a series of portrait statues of 'the great Founders and Improvers of Natural Knowledge' (figure 74).[1] The University drew up a list of scientists to be included in this pantheon. In line with Acland's promise that a university founded on the classics could accommodate science on its own terms, the list was headed by six ancient Greek mathematicians and natural philosophers. They were joined by eleven modern scientists proposed in the first instance, five representing the physical and mathematical sciences, the other six natural history and medicine.[2] Like the rest of the museum's decorations, these statues were to be funded by private subscription, at the cost of £70 each.[3] Queen Victoria herself made the first donation, giving £350 for statues of the first five modern scientists. The undergraduates of Oxford followed, pledging to fund the statues of Aristotle and Georges Cuvier, modern Europe's leading comparative anatomist.[4] The original pantheon was international in its outlook and emphasized the long history of science, but as donations began to come in for statues not on the original list more emphasis came to be placed on British science and technological innovation. At the same time, funding for many of the statues that were originally proposed, including that of Cuvier, never materialized, further altering the story that the collection tells. As well as the choice of statues, their positioning changed in the course of building the museum. Ruskin had originally wanted them to be set in niches so as 'to help the architecture', but he was overruled.[5] Instead, the plan was to place the ancient Greek scientists in the entrance hall and the moderns around the court, but in the end all eighteen statues that were carved were ranged round the court, where they remain today.

Including Woolner's memorial to Prince Albert, ten of the nineteen statues at the museum are the work of Pre-Raphaelite sculptors. None of them had experience of carving full-size statues before. Looking back on it, Oxford took an extraordinary gamble in commissioning these untried young artists to carve the museum's pantheon. The gamble paid off so well that, in 1865, the *Illustrated Times* remarked that the museum would house 'the finest collection of portrait statues in the kingdom' once they had all

FIGURE 74 *previous spread* Statues on the east side of the central court. From left to right, Henry Hope-Pinker, *Charles Darwin*, 1899; and Alexander Munro, *Isaac Newton* and *Galileo*, c.1857–60.

been completed.[6] The Pre-Raphaelite statues in particular possess an animation quite unlike most Victorian public monuments. They show scientists researching, inventing, teaching, theorizing. In all cases, the key to their genius is the imagination. In this pantheon, art and science come together in a single unified ideal, as artists who modelled their practice on science found a way to depict scientists whose special art was to discover new truths about the world. Taken as a whole, the pantheon forms a unique gallery of Pre-Raphaelite statuary to accompany the O'Sheas' Pre-Raphaelite natural history sculpture.

The founders of natural knowledge: Aristotle and Bacon

As you enter the central court of the museum, you pass between the statues of Aristotle and Francis Bacon. They have this place of honour as, in Acland's words, 'those who have laid the deepest and widest the foundations of science'.[7] The statue of Bacon was one of the first to be commissioned. Paid for by Queen Victoria, it was carved by Thomas Woolner, the one member of the original Pre-Raphaelite Brotherhood who was a sculptor by profession. Woolner's statue of Bacon (figure 75) is one of the most commanding of all pieces of Pre-Raphaelite sculpture. The intensity of Bacon's facial expression and the determination in the way one hand presses down upon the other make for a vivid depiction of genius in action. This is a man with a point to make, fittingly enough, as it was Bacon who set the course for empirical science from the seventeenth through to the mid-nineteenth century. Woolner wrote, on reading Bacon's essays, that his prose 'sheds truth as the sun does light', and his statue is a powerful assertion of the Pre-Raphaelite project of grounding art in science as well as an artistic representation of science itself.[8] In designing it, he consulted with James Spedding, who was completing the first comprehensive edition of Bacon's works in seven volumes.[9] As well as researching his subject rigorously, Woolner carved the details of his statue himself, as the conventional practice of having a stonemason transfer the design from a model to the block of stone did not capture the precision he was after.[10] As a result he was able to give an extraordinary degree of texture to the finished stone, from the 'heavy softness' of Bacon's robes praised by his fellow Pre-Raphaelite Brother Frederic Stephens to the delicate folds of his ruff and the veins clearly visible under the skin of his hands.[11]

The statue of Aristotle (figure 76) was paid for by the undergraduates of Oxford, who clubbed together to raise the £70 needed to fund a statue at the museum.[12] It was fitting that they should choose this one in particular.

FIGURE 75 *above* Detail of Thomas Woolner, *Sir Francis Bacon*, 1856–7.

FIGURE 76 *opposite* Henry Hugh Armstead, *Aristotle*, c.1858–60.

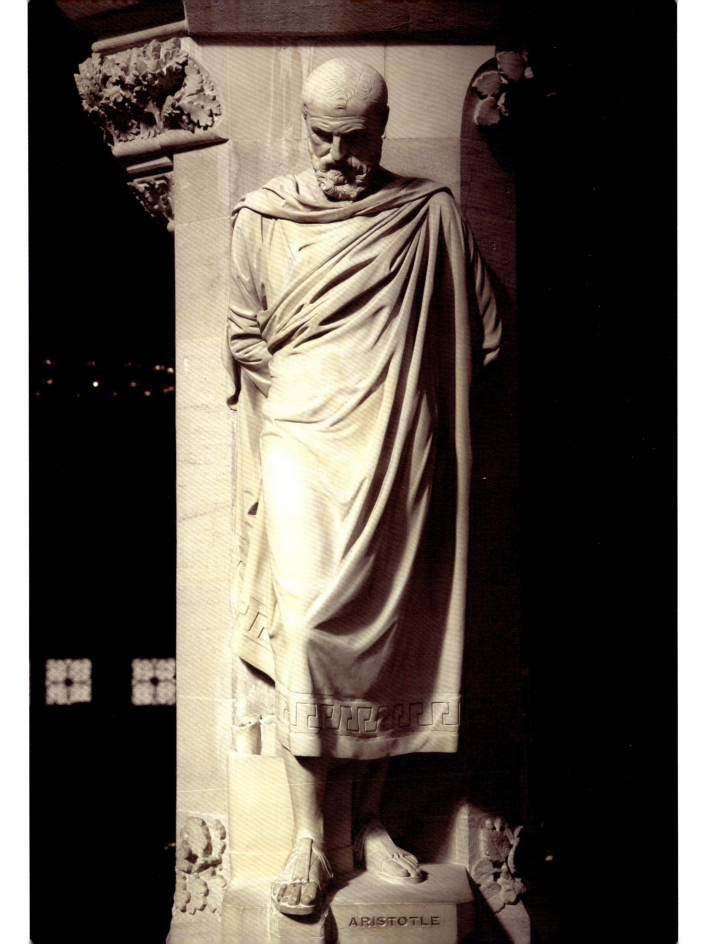

Aristotle's presence at the entrance to the central court is a clear sign of the continuity between Oxford's classical curriculum and the modern science taught at the museum. The commission for the statue went to Henry Hugh Armstead. Armstead was as yet largely unknown as a sculptor, though he would go on to preside over the stonework for the Albert Memorial, working alongside Skidmore and Gilbert Scott.[13] He is not usually considered a Pre-Raphaelite, but he was a close friend of William Holman Hunt, which may well be how he came by the commission, and his statue fits in well with the Pre-Raphaelites' own work at the museum. Armstead's Aristotle has what Tupper, describing the low-relief portraits of composers on the Albert Memorial, would go on to call 'a living look'.[14] Where most Victorian statues stand still, even including most of those at the museum, Aristotle is striding out, his manuscript scrolls unconsulted at his feet. This movement is an allusion to the nickname he was given by his students. Aristotle was known as the Peripatetic, because he used to walk back and forth as he lectured. As Armstead worked on his statue, Woolner visited his studio and discussed it with him. He was unimpressed by Armstead's decision to leave Aristotle's hands hidden behind his back, remarking in a letter to Woodward, perhaps with his own statue of Bacon in mind, that the hands were important for 'illustrating the character of the subject treated'.[15] While Armstead may have been shying away, as an inexperienced sculptor, from tackling the challenge of Aristotle's hands, in placing them behind his back he gives him an individuality and a dynamism of his own. Like Woolner's Bacon, this is a man in thought, wrestling with the complex ideas he would teach to his students.

'One great anthem': Linnaeus

Only one statue at the Oxford museum took Pre-Raphaelite principles in sculpture to greater lengths than Woolner's Bacon. This was the statue of the eighteenth-century Swedish botanist Carolus Linnaeus (figure 77), the founder of modern biological taxonomy. It was paid for by Frederick Hope, the founder of the Hope Museum of Entomology, and carved by John Lucas Tupper. Tupper was a little older than the seven original Pre-Raphaelites themselves, and had been a friend and mentor to them since the foundation of the Brotherhood in the late 1840s. Of all the Pre-Raphaelite artists, he had the most extensive knowledge of modern science. By profession, Tupper was an anatomical draughtsman at Guy's Hospital in London. In 1851 he submitted a bas-relief to the Royal Academy exhibition. Now lost, it illustrated the 'Merchant's Tale' from Chaucer's *Canterbury Tales*. William

FIGURE 77 *opposite* John Lucas Tupper, *Linnaeus*, 1859, mended 1862.

Rossetti described it as 'at the extremest edge of P.R.Bism, most conscientiously copied from Nature' and 'a perfect sculpturesque heresy' as far as the Academy was concerned.[16]

Tupper put these same principles into practice in his statue of Linnaeus, which is the most thoroughgoing of all surviving works of Pre-Raphaelite sculpture. It shows Linnaeus doing his field work, collecting specimens in Lapland. His outdoor clothes – a fur suit and hat and leather boots – are re-created in stone with what William Rossetti rightly called an 'unsparing precision of detail'.[17] His face is closely based on a contemporary portrait of Linnaeus by Alexander Roslin, a copy of which hangs in the museum. Like many of the statues in the museum, his line of sight is such that visitors standing beneath him in the court meet his gaze.

As Rossetti remarked, Tupper's statue was 'a highly naturalistic treatment of a naturalist'.[18] But Linnaeus was not just a naturalist for Tupper. He was a visionary. This is the central idea of a poem written by Tupper and published posthumously by Rossetti (see overleaf). Many of the Pre-Raphaelites wrote poems to accompany their own and each other's paintings and designs. Tupper may have intended his poem to complement his statue, or perhaps it was part of the process of designing it, like a verbal cartoon. Either way, it captures his admiration for Linnaeus as a seer, gifted with the ability to apprehend the unity of nature. Tupper's Linnaeus is a scientist, but his conception of him also recalls the Romantic poet William Wordsworth, who was the main influence on the form and style of Tupper's poem. The poem recalls the museum too, with its bones and rocks and other specimens, stone ferns growing only a few feet away from Linnaeus himself, and a view up through the sunny air and the glass roof to the heavens. Where the museum unifies its vision of nature through architecture, Tupper's poem uses verse and the idea of music. Like Ruskin and many of the Oxford scientists, Tupper rejected the theory of evolution, and his conception of nature in his poem is firmly anthropocentric. Even so, his image of mankind as the dominant, piercing note, rending apart the harmony of the natural anthem, is troubling, hinting at humanity's arrogance and our violation of ecology as much as it affirms human uniqueness.

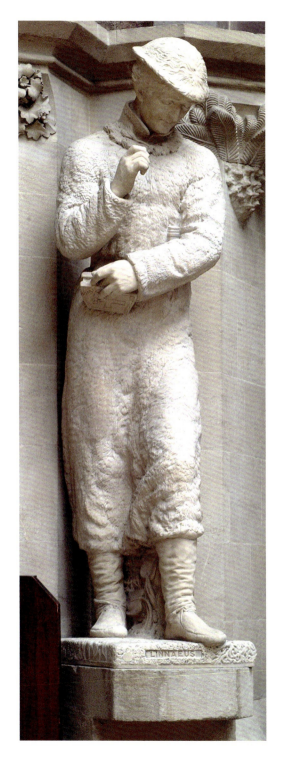

A SCIENTIFIC PANTHEON

A Vision of Linnaeus

I saw a youth walking upon the hills
In the breme Lapland morning, while the sun
Now swerving upward (as a swallow turns
That has not rested on the earth) emblazed
The close fur wrapping him with gold that rippled
I' the flying wind: what time I certified
His cap of fox-skin, and his coat of deer:
And, as he walked, how he would stay his step,
Against the unconquered wind to scrutinize
The ground with flowers and rare growths mottled o'er
In that high region; and the rocks and pools
Sucked there by spongy herbage—not as a girl
Culling wild flowers, who looks for these alone,
But taking with a wide glance all that was
As each a limb of one great animal.
For whether it were moss or flower or fern,
Or fungus growth of rottenness, the bare
Bleached jaw-bone of some stag, or wind-bleached rock,
Or raven's wing in rocky cleft, or foot
Of hare the eagle-owl left, nesting close:
Each sang keen notes of one great anthem still,
Of which the dominant (man, in health, disease,
Or death) rang joyous, with a cry that rent
The harmony up through sunny air to heaven.
Grandly he walked, or grander stood, the wind
Passing, and great thoughts passing on more swift
Within him, what the world had been and was;
While in his hand the flower, held listlessly,
I saw he saw not, for his soul was rapt—
As one who has fasted feels a lightness go
Throughout his frame, conversing more with air
Than solid earth, and running seems to fly.
I saw him hovering about that hill
Like an alighted eagle, staring round
A strange world with a glory in his gaze:
A visitant who momently we fear
Even while we gaze may find his task complete,
And merge into the skies in mystery.[19]

The scientific imagination: Munro's statues

The sculptor who contributed the most statues to the museum's pantheon was Alexander Munro, a close friend and collaborator to the Pre-Raphaelite painter Dante Gabriel Rossetti. As a friend too of Acland and the Butlers, who were some of his most dedicated patrons, Munro got the lion's share of the commission: seven statues in total, six as carved, making up a third of the whole collection as it stands today. Munro's statues form a representative sample of the history of science as it was seen by Oxford's Victorian scientists. When Queen Victoria sponsored statues of the first five modern scientists on the University's list, all the commissions apart from Bacon went to Munro. He completed three of them: Galileo, Newton and Leibnitz. He never completed the fourth, a statue of the Danish physicist Hans Christian Ørsted, who discovered electromagnetism in 1820. As Ørsted had died as recently as 1851, Munro was not prepared to make a portrait of him unless the University provided him with a likeness, which it repeatedly failed to do.[20] Eventually a plaster cast of a statue of Ørsted was sent over to the museum from Denmark in 1885 to take the place of Munro's unmade statue. As well as the four 'moderns', Munro was commissioned to carve the statue of Hippocrates, which was donated by Ruskin's father. Two more commissions followed, extending Oxford's intended canon of scientists, as Ørsted did, into the more recent past and the world of technology. One was the chemist Humphry Davy, proposed and sponsored by the Marquis of Lothian. The other was James Watt, the inventor of the modern steam engine, sponsored by the grandson of Watt's partner Matthew Boulton.

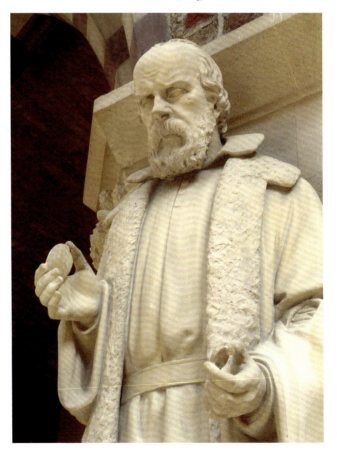

FIGURE 78 Detail of Alexander Munro, *Galileo*, c.1857–60.

Munro's statues are some of the most vivid depictions of the scientific imagination in process in the museum. At the same time, he uses carefully chosen symbolism to show where that imagination leads. Galileo is not shown holding a finished telescope as you might expect but rather in the act of inventing it, deciding how to position two lenses of different diameters relative to one another (figure 78). Leibnitz is consulting a star chart, checking the position of moving bodies in the night sky. Newton is shown as a young man, contemplating

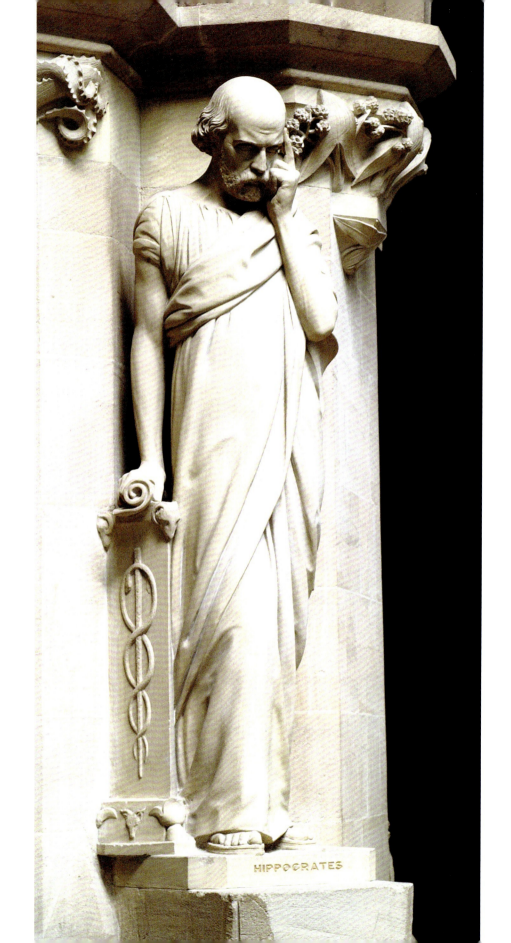

the fallen apple, while holding, in a proleptic piece of symbolism, his *Principia Mathematica*. Hippocrates is in a classic pose of thought, presumably deducing prognoses from his patients' symptoms (figure 79), while Watt is stepping purposefully forwards to test out a new piece of scientific technology. The statue of Davy is more conventional, as it is based closely on a portrait by Thomas Lawrence. Nonetheless, it shows Davy with his most well-known practical invention, the Davy mining lamp. Taken together, Munro's statues show science at work in the discovery of new technologies, mathematical principles and medical practices.

Building up the canon of science

The first nine statues on display at the museum were by the four Pre-Raphaelite sculptors Woolner, Tupper, Munro and Armstead. The four statues of scientists which followed in the 1860s were carved by older, more established sculptors. One of the earlier commissions was for a statue of William Harvey, who discovered the circulation of the blood. This went to Henry Weekes, who had begun his career as an assistant to the fashionable Regency sculptor Francis Chantrey. In 1860, a group of subscribers from Birmingham offered to pay for a statue of the pioneering chemist Joseph Priestley. This commission went to Edward Stephens. Two more statues, of Euclid, the founder of Geometry, and the engineer George Stephenson, were carved by Joseph Durham. Stephens and Durham were from the same stable. Both learned their trade in the 1830s as pupils of Edward Hodges Baily, the silversmith and sculptor who would go on to design the monumental statue of Nelson on top of the column in Trafalgar Square. Stephens also had close connections to Acland, as he was working at the time on a monument in honour of his father, Sir Thomas Dyke Acland MP.

In spite of the links between Stephens and Durham, there is no single unifying style or principle behind the non-Pre-Raphaelite statues at the museum. None of them depart from the conventions of Victorian public statuary to the same extent as the Pre-Raphaelite statues. Stephens comes closest to the Pre-Raphaelites in the way he animates his statue. Priestley is imagined mid-lecture, his notes held loosely in his hand. He knows his subject well enough not to need to consult them. Durham shows Stephenson looking relaxed, the modern man of business who happens to be an engineer but could just as well not be. There is no attempt to represent science in action here, though the statue is a reminder of its day-to-day presence in the contemporary world. Euclid is shown holding a pencil and a scroll with a diagram representing the Pythagorean theorem. If he has just been drawing

FIGURE 79 Alexander Munro, *Hippocrates*, c.1857–60.

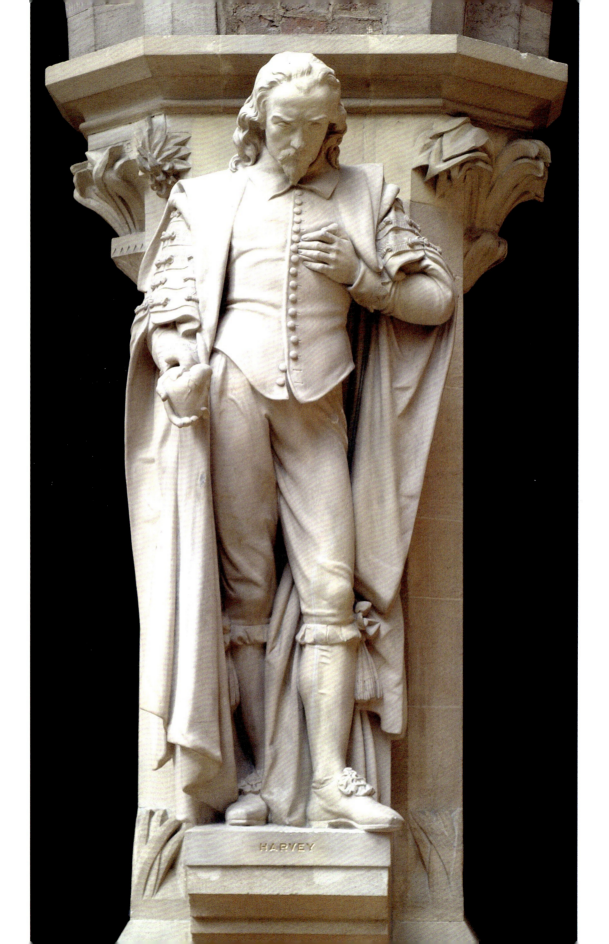

HARVEY

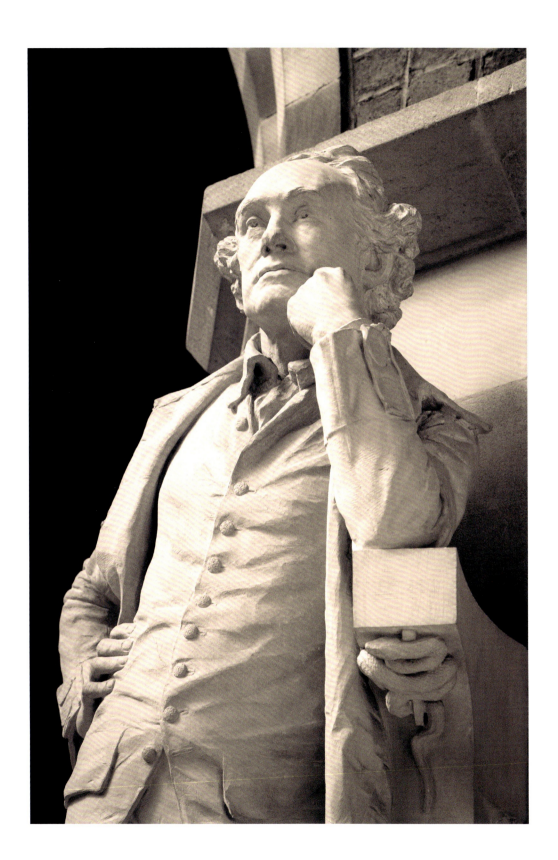

the diagram, then he seems more distracted than thoughtful. In reality, he is neither, as this is a more conventional piece of statuary where the scientist is merely shown with his attributes, not doing science. Weekes's statue of Harvey (figure 80) works on the same principle, but it is more arresting than Stephens's and Durham's statues, partly because the symbol here is a human heart, held in Harvey's right hand, but also because his downturned gaze shows the same intensity in intellectual enquiry as the Pre-Raphaelite sculptures. He may not be pursuing science as we watch, but he is very much capable of it, in thought as in deed.

From 1886 to 1914, four more statues were added to the pantheon of scientists at the Oxford museum, all of them by the same sculptor, Henry Hope-Pinker. Hope-Pinker was a successful portrait sculptor tangentially connected to the New Sculpture, a late Victorian movement led by Frederic Leighton, Alfred Gilbert, Edward Onslow Ford and Hamo Thornycroft, which celebrated the vitality of the human body. He and his work are virtually forgotten now, but his statues at the museum show a remarkable ability to capture in stone a more relaxed intelligence than the animating imagination that drives the earlier Pre-Raphaelite statues. They show too how science at the museum changed its implications as new scientists were added to the canon. The first two of Hope-Pinker's statues were both medical men: the eighteenth-century Scottish surgeon John Hunter and the seventeenth-century English physician Thomas Sydenham. Although both were on the original list of statues to be included, Hunter was not added until 1886 and Sydenham not until 1894. Hunter's posture alludes to a famous portrait by Sir Joshua Reynolds, and both men are shown with emblems of their contributions to science in the same way as Davy, Euclid and Harvey. As with Weekes's statue, this conventional approach to depicting the public man is made more personal by the mood of the individual subjects. Hunter is thoughtful but unflustered, apparently unaware that there is a snake just beneath his arm (figure 81). Sydenham is modest but quietly assured. Within the pantheon of the museum, these two statues mark a shift towards medicine. Connecting Hippocrates and Harvey to Aristotle, they enabled Acland, who was one of the sponsors of the statue of Sydenham, to claim even Aristotle himself, not altogether plausibly, as one of the founders of his own discipline.[21] As we shall see in the next chapter, a more fundamental shift in the museum's scientific loyalties was signalled by the inclusion of a statue of Darwin by Hope-Pinker in 1899, while his final statue, of Roger Bacon, reaffirmed its original programme of Christian natural theology.

FIGURE 80 *previous spread left* Henry Weekes, *William Harvey*, c.1860–63.

FIGURE 81 *previous spread right* Detail of Henry Hope-Pinker, *John Hunter*, 1886.

Science in Oxford: the portrait busts

The pantheon of eighteen scientists which surrounds the central court at the museum reaches over two thousand years and across Europe from Greece to Scandinavia. By the standards of its time, it is generously inclusive. Even so, looking at it now it is hard to miss the fact that the great men of science who are represented are indeed all men and all European. There are no Arab or Persian, Indian or Chinese scientists here, and of course no women. No new statues have been carved at the museum in over a hundred years, so the pantheon does not reflect the growing recognition of the important contributions made to science across its history by women and by non-Western cultures. Equally, there are no Americans, in spite of the dominance of American science in the twentieth and twenty-first centuries.

The international pantheon of the heroes of science is supplemented by a smaller, more local pantheon of busts representing scientists who worked at the museum itself. As a form, the bust does not allow for staging an act of science in the same way as a statue. The statues suggest that imagination is the essential element in scientific discovery. Through their studied seriousness and mostly academic dress, the busts place the emphasis instead on the rigour of Oxford's own contribution to science. Phillips and Acland are here, along with Phillips's uncle William Smith, William Buckland, Oxford's leading scientist in the decades before the museum was built, and the mathematician Henry Smith, who succeeded Phillips as Keeper of the museum in 1874. Another four professors who taught at the museum in the late nineteenth century are memorialized in busts carved by Hope-Pinker.

Like the pantheon of the heroes of science, the series of busts of Oxford scientists was frozen in time in the early twentieth century. Over a hundred years later, a new commission at last added a woman scientist to the pantheon. A bronze bust of Dorothy Hodgkin (figure 82), by Anthony Stones, was unveiled in 2010 to commemorate the hundredth anniversary of her birth. A pioneer of X-ray crystallography, Hodgkin won the Nobel Prize for Chemistry in 1964 for the work she did in her laboratory at the museum. Her addition to the pantheon of scientists at the Oxford University Museum is a sign of how profoundly science as a profession has changed since the museum's origins in the nineteenth century – a change celebrated in art, in accordance with the principles of its founders 150 years before.

FIGURE 82 Anthony Stones, *Dorothy Hodgkin*, 2010.

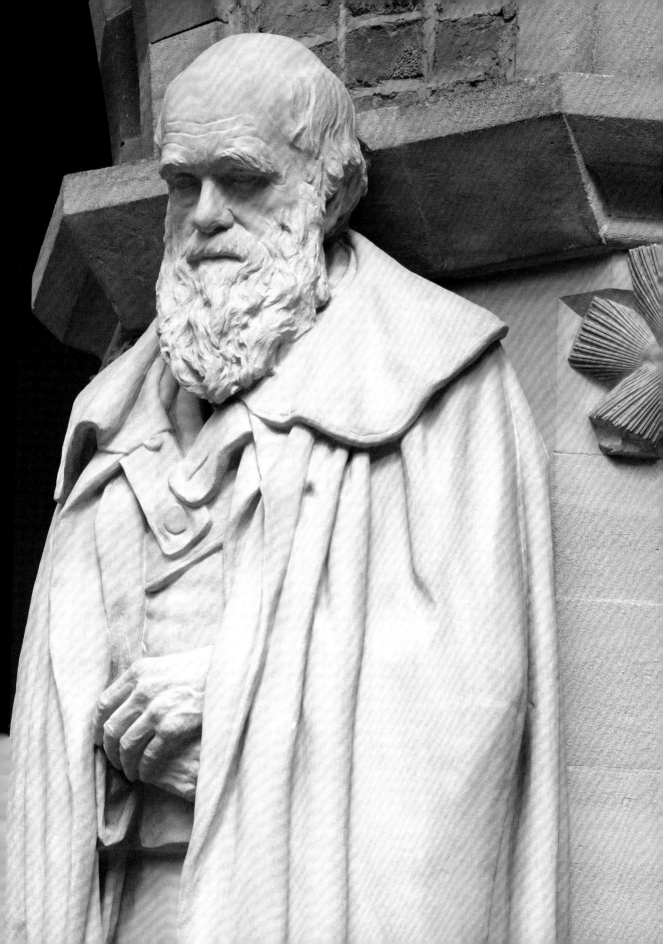

6 Babylon

FIGURE 83 *previous spread* Detail of Henry Hope-Pinker, *Charles Darwin*, 1899.

FIGURE 84 *below* Memorandum by 'A Member of Convocation', dated 3 May 1855, calling for the 'Babylon of a new Museum' to be stopped.

It took Daubeny and Acland eight years to persuade their colleagues at Oxford to agree to the building of the Oxford University Museum and another five years for it to be built. They had imagined the museum as a Temple of Science, built to honour the God of mid-Victorian natural theology. Working closely with Phillips and Woodward, Ruskin and the Pre-Raphaelites, the O'Sheas and Skidmore, they had achieved their ambition brilliantly. The Oxford University Museum of Natural History is at one and the same time one of the most original buildings of the Victorian Gothic Revival, a triumph of Pre-Raphaelite principles in art and architecture, and a comprehensive embodiment of natural science.

Building the museum was an explicitly Christian project. Even so, there were some in the University who remained entrenched in their opposition to it on religious grounds up until the last possible minute. As Nicolaas Rupke has shown, many of Oxford's Tractarians saw even natural theology as a slippery slope away from a belief in the truth of revelation.[1] One last vote was called in Convocation in May 1855 to try to stop the building of what an alarmist pamphlet called the 'Babylon of a new Museum' (figure 84).[2] It was defeated, but the anonymous dons who called the vote may well have felt vindicated five years later when the museum opened. In June 1860, Oxford welcomed back the British Association for the Advancement of Science, hosting their annual gathering in the new museum. This time the delegates included at least two of the Pre-Raphaelites, Hunt and Woolner.[3] On Saturday, 30 June several hundred people gathered for a debate in what was then the new Radcliffe Library's large reading room on the first floor of the museum. The subject was the viability and implications of the theory of evolution by natural selection proposed by Charles Darwin at

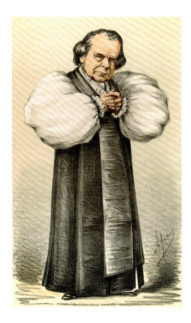

the end of the previous year in his book *On the Origin of Species*. Aside from one pregnant sentence in his conclusion – 'Light will be thrown on the origin of man and his history' – Darwin had studiously avoided the question of human evolution, let alone any potentially irreligious implications of his theory.[4] He had covered himself, but he had fooled no one, and the question of what evolution meant for humanity was one everyone wanted to hear answered.

The Great Debate, as it became known, has been much mythologized, and until very recently historians were inclined to doubt many of the stories that grew up around it. In 2017, however, the historian of science Richard England discovered a previously unnoticed report of the debate in a little-known local paper called the *Oxford Chronicle and Berks and Bucks Gazette*. From this report, which includes in brackets terse but vivid accounts of the audience's response, it is clear that the most famous episode did indeed take place. In the heat of the debate, the bishop of Oxford, Samuel Wilberforce (figure 85), asked the evolutionist T.H. Huxley (figure 86) 'if he had any particular predilection for a monkey ancestry, and if so, on which side – whether he would prefer an ape for his grandfather, and a woman for his grandmother, or a man for his grandfather, and an ape for his grandmother'. The *Oxford Chronicle* records '(Much laughter.)' from the audience at the bishop's smutty impropriety. Huxley replied that, 'if the alternative were given him of being descended from a man conspicuous for his talents and

FIGURE 85 *above left* Caricature of Samuel Wilberforce, Bishop of Oxford, from *Vanity Fair*, 24 July 1869.

FIGURE 86 *above right* Caricature of T.H. Huxley, from *Vanity Fair*, 28 January 1871.

eloquence, but who misused his gifts to ridicule the laborious investigators of science and obscure the light of scientific truth, or from the humble origin alluded to, he would far rather choose the latter than the former'. This time the audience's response is given as '(Oh, oh, and laughter and cheering.)'[5]

The audience was split in its loyalties and entertained by the speakers on both sides. Many younger biologists sided with Huxley, including Joseph Hooker and John Lubbock, but Oxford's older natural theologians, including Greswell and Daubeny, ranged themselves alongside the bishop. Greswell in particular took an active part in the debate, denying 'that any parallel could be drawn between the intellectual progress of man, and the physical development of the lower animals' and indignantly denying Huxley's claim 'that he was ever an atom of matter', provoking more 'loud laughter' from the audience.[6] It was not only humanity's evolutionary origins that were at stake, but the role of science itself. According to the logic of natural theology, science was subordinate to religion, as its object was to reveal God's hand in nature. But for Darwin, Huxley and their allies, this was to prejudge the question. Science had to be free to discover the nature of nature without interference from religion. Its working assumptions had to be materialist, whatever the scientist's individual beliefs, because supernatural or miraculous causes could not be demonstrated in action. Over the rest of the century this position, known as scientific naturalism or methodological materialism, would become the dominant logic of science.

Through the Great Debate, the museum, built to enshrine natural theology, became a crucible for scientific naturalism. By now Acland was the Regius Professor of Medicine. He was already more sympathetic to the evolutionist position than his older colleagues. So was the new Linacre Professor of Anatomy, George Rolleston. Darwin's science had not shaken their faith. Instead, it supplemented it. Both saw evolution as the unfolding of God's will through creation. On the other hand, they increasingly accepted that this could not be demonstrated scientifically. Soon they were joined at Oxford by other, more secular-minded evolutionists, including E. Ray Lankester, E.B. Tylor, W.F.R. Weldon and John Scott Burdon-Sanderson. In time, Rolleston, Weldon and Burdon-Sanderson would take their place in the museum's pantheon of busts of Oxford scientists (figure 87), as would Joseph Prestwich, who succeeded Phillips as Professor of Geology and whose research had been instrumental in proving that human beings had lived alongside extinct prehistoric animals.

As the science at the museum changed, so its art shifted its meanings to accommodate it. The carvings had always incorporated animals in among the

FIGURE 87 The north-west corner of the central court, including Henry Hope-Pinker's busts of John Scott Burdon-Sanderson, 1907, and W.F.R. Weldon, 1908. Burdon-Sanderson and Weldon were two of the Darwinian scientists who led research and teaching at the museum from the 1870s onwards.

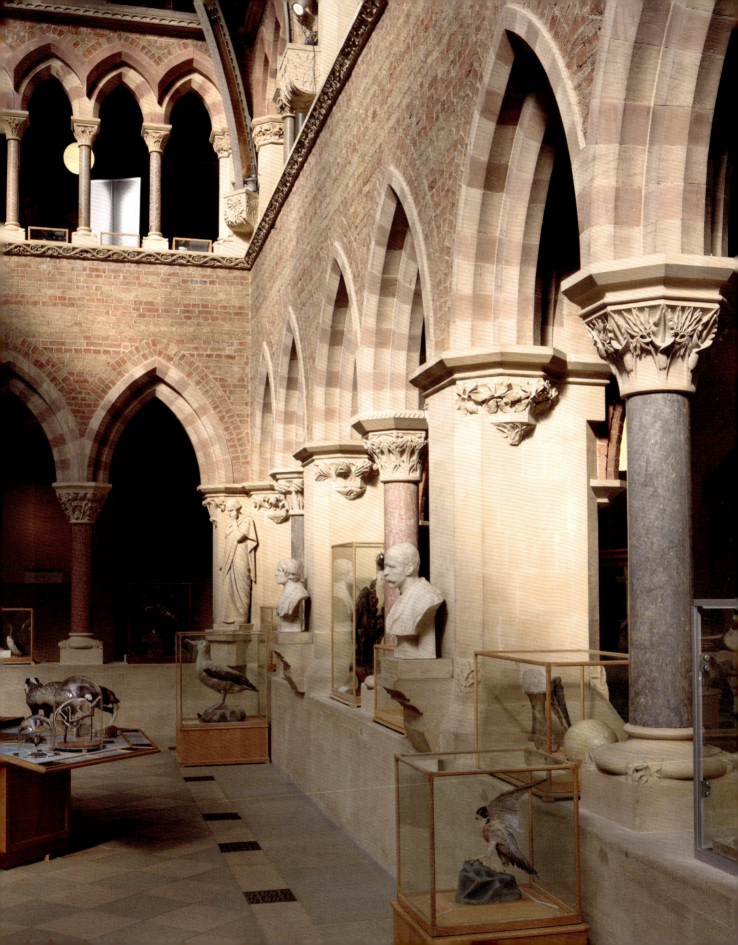

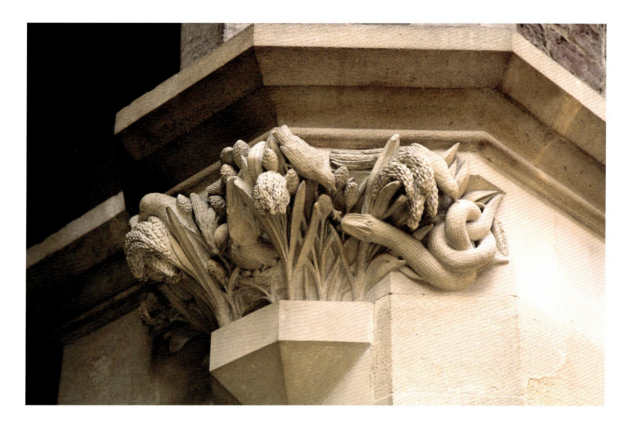

plants, offering an ecological vision of nature not unlike Darwin's own. In the conclusion to *On the Origin of Species*, Darwin invited his readers:

> to contemplate an entangled bank, clothed with many plants of many kinds, with birds singing on the bushes, with various insects flitting about, and with worms crawling through the damp earth, and to reflect that these elaborately constructed forms, so different from each other, and dependent on each other in so complex a manner, have all been produced by laws acting around us.[7]

The O'Shea family's capitals give us multiple different glimpses of this entangled bank. Among the plants themselves there are birds nesting (figure 88), stalking around (figure 89) or starting into flight. As well as the capitals themselves, odd nooks all round the central court are populated with snakes in search of prey, little rodents barking alarm calls, and monkeys looking shy or embarrassed, perhaps puzzling over the same question of their relation to the human beings around them that Wilberforce put to Huxley.

FIGURE 88 Rice and canary grass corbel with birds on the north side of the central court, attributed to Edward Whelan, c.1859.

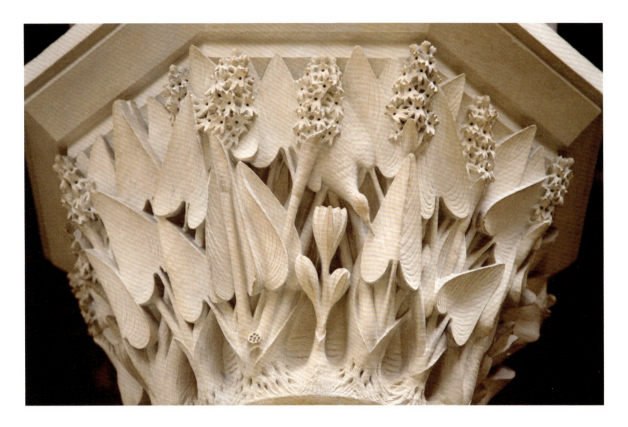

One playful carving on the façade of the building alludes directly to Darwin's theory. It was done by James O'Shea, on the window he worked on next after his collaboration with Ruskin. Ruskin had left the site by this point, and Woodward had not yet returned, so it seems likely that O'Shea was answering directly to the scientists. In his new book, Darwin had noted that a naturalist called Hearne had seen black bears 'swimming for hours with widely open mouth, thus catching, like a whale, insects in the water'. He postulated that, if this adaptation happened to give these bears a competitive advantage, they might end up 'being rendered, by natural selection, more and more aquatic in their structure and habits, with larger and larger mouths, till a creature was produced as monstrous as a whale'.[8] For many of Darwin's early readers, this was a fatuous flight of fancy which gave the lie to the rest of his theory. Spoofs of his book often latched on to this scene, with one anonymous poem on 'Darwin on Species' enjoying picturing how 'black bears dabbling in the sea for play, / Lapsed into whales, and grandly swam away'.[9] This particular poem tickled Daubeny, who kept it in an album which he would publish in 1869 under the title *Fugitive Poems Connected with Natural*

FIGURE 89 Pickerel capital with bird, attributed to John O'Shea, c.1858.

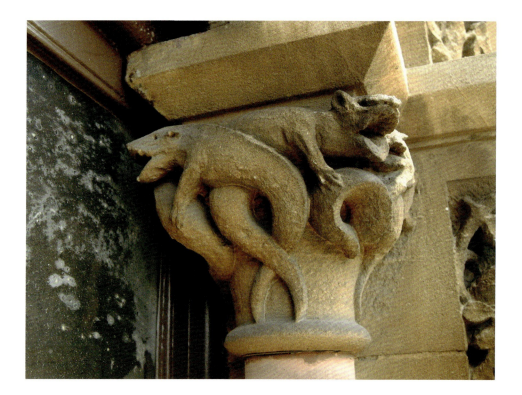

FIGURE 90 Bear-whales carved on the façade of the museum by James O'Shea, 1860, in an allusion to Darwin's *On the Origin of Species*, published in 1859.

History and Physical Science. Whether it was Daubeny or Acland who put O'Shea on to Darwin's fable, the creatures in this carving are not 'Monsters in the Museum' in Ruskin's sense but bear-whales (figure 90), representing an imaginary future stage in evolution or a just-so-story of how the whale became.[10] Their front halves look like large quadrupeds, their huge mouths wide open, while their back halves are long sinuous tails, narrowing to a point like eels. Unlike the museum's more Pre-Raphaelite sculpture, they do not represent the truth of nature as it is but a speculative fiction of how it might be or have been.

The O'Sheas' decorative sculpture offered a vision of the natural world that was, at times seriously, at times playfully, compatible with Darwinism. The carving around the main entrance (figure 33) was more of a challenge. When Pollen made his design (figure 32), he was a conservative Catholic convert with a creationist view of nature. In one of his last pieces of writing on the museum, published in 1894, Acland gamely reinterpreted the arch as a complex symbol of evolution, reducing Adam and Eve to moral emblems and spinning a complex reading of the relationship between the angel at the apex of the arch and the carved and uncarved spaces around it:

> At the apex of the arch is a figure sitting, the winged 'Angel of Life,' holding in the left hand a Disc, on which are carved the dividing cells and nuclei of *Schwann* and of *Schleiden* in token ... of Life as leading by constant change to death, and of Death as the resultant of ever onward change from life. In the right hand is an open book, which is the Book, setting forth all that can be known by faith or by revelation of the hidden work of the Infinite Creator. ... On either side will be observed ... a perpetual upward growth of life and evolution till the complex web of organization has reached the feet of the Angel of Life seated on the summit of all. Flowers and fruit, the passion-flower, and the thorny acanthus and vine, make a tangle at once beautiful and delicate. And what is to be the end beyond the Angel of Life? All is hidden. Here will be unceasing struggle between life and death in material evolution, with an unceasing yearning for spiritual good, for knowledge, and for truth. And so the poetical and mysterious Artist bids him, who enters the place of material and scientific study, remember that beyond all that he may learn by investigation of the physical creation, there lie hid spiritual revelations of a life beyond, which while here we can never fully know, but by hope and faith and love.[11]

Acland's reinterpretation of the museum's entrance is a *tour de force*. Pollen's design placed different kinds of creatures in their own distinct boxes, fixed and separated from each other, and ascending according to the successive days of the biblical Creation. As this part of the design was not carved, Acland is free to find an evolutionary symbolism instead in the plants growing up the archway towards the angel. He even makes a virtue of the fact that, cash not permitting, the spandrels above the arch remain uncarved, leaving a blank white space. In his account, this represents both the unknown future of evolution on earth and the unknowable promise of life after death.

Where the original design had united science and religion in natural theology, Acland subtly but studiously keeps them apart. This is the case even when, according to his interpretation, the same piece of carving – the blank spandrels, or the plants on the arch, which hint at Christ's Passion as well as evolution – represents them both. For Acland, God is still the Infinite Creator and the Artist of the universe, but the 'investigation of the physical creation' can no longer uncover 'spiritual revelations'. Instead these fall into

separate spheres. Acland's compromise preserved faith and science intact, allowing them to co-exist on the understanding that they did not interfere with one another or lay claim to each other's territory. Although the angel may hold the dividing cells, it no longer presides over the science that goes on in the museum itself. On the other hand, it does reassure visitors, as they enter the building, that they do not have to abandon their religious beliefs at the door, and that 'hope and faith and love' may reveal truths and meanings hidden to science itself.

Like its decorative art, the pantheon of scientists at the museum came to accommodate Darwin. Oxford's undergraduates had failed to muster enough donations to make good their promise of a statue of Cuvier. Cuvier had been a determined opponent of early theories of evolution in Paris in the first decades of the nineteenth century. His inadvertent absence from the museum's pantheon was not unhelpful when it came to affirming Darwinism at the end of the century. In June 1899, nearly forty years after the debate at the British Association meeting, Darwin's closest friend and scientific confidant Joseph Hooker unveiled a statue of him (figure 91) at the museum, carved by Henry Hope-Pinker and sponsored by the new Hope Professor of Zoology, E.B. Poulton.[12] Poulton was a staunch Darwinian. In 1893 he had succeeded John Obadiah Westwood, the first Hope Professor and the last surviving natural theologian of the old school, who had died in post in his late eighties. This appointment and the new statue marked the final victory of the Darwinian scientific naturalists in Oxford. Darwin was a tall man, and Hope-Pinker's statue is imposingly true to life, nearly a head taller than the other statues in the court. Loosely based on John Collier's painted portrait of Darwin towards the end of his life, it shows him in a relaxed pose, his legs crossed, his hands held together. His expression is abstracted, perhaps even a little sad. This is a man who has accomplished his major scientific discoveries, and now leaves us to ponder their ultimate significance for ourselves. As a statue, it had no need of attributes, because Darwin was already unmistakable, even as his legacy for science was unavoidable.

The turn away from natural theology to Darwinism at the Oxford University Museum was anathema to one of its founding fathers in particular. When Ruskin was Slade Professor of Fine Art at Oxford from 1869 to 1878 and again from 1883 to 1885, he taught largely at the museum. Ruskin could not bear the materialist implications and methods of Darwinism, and he increasingly disliked the way science as a whole was taught and studied. In the end, he turned against the museum itself,

FIGURE 91 Henry Hope-Pinker, *Charles Darwin*, 1899.

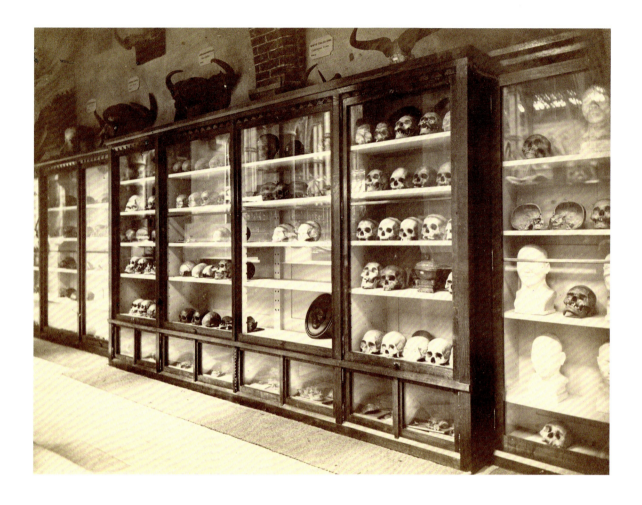

FIGURE 92 Archive photograph of the Anatomical Department cabinets in the late nineteenth century, showing vividly why Ruskin accused his colleagues at the museum of displaying death not life.

denouncing it to his students as 'a very shabby bit of work of mine' and decrying how 'in the natural history museum of Oxford, humanity has been hitherto taught, not by portraits of great men, but by the skulls of cretins'.[13] He was distressed by Rolleston's displays of animal and human skeletons and pathological specimens (figure 92) and appalled by Burdon-Sanderson's use of vivisection in his research. As he told his students, Ruskin had expected the museum to celebrate 'the light and beauty and life of the works of God'. But instead of showing 'the life of this world' it had ended up displaying 'the Devil's working in it through disease, and his triumph over it in death'.[14] For Ruskin, the museum's early detractors had been proven right. Instead of a Christian temple it had become a materialist Babylon.

Ruskin was acutely aware that, according to Darwin's theory, the engine of creation – natural selection – was powered by death. Only organisms

150 | TEMPLE OF SCIENCE

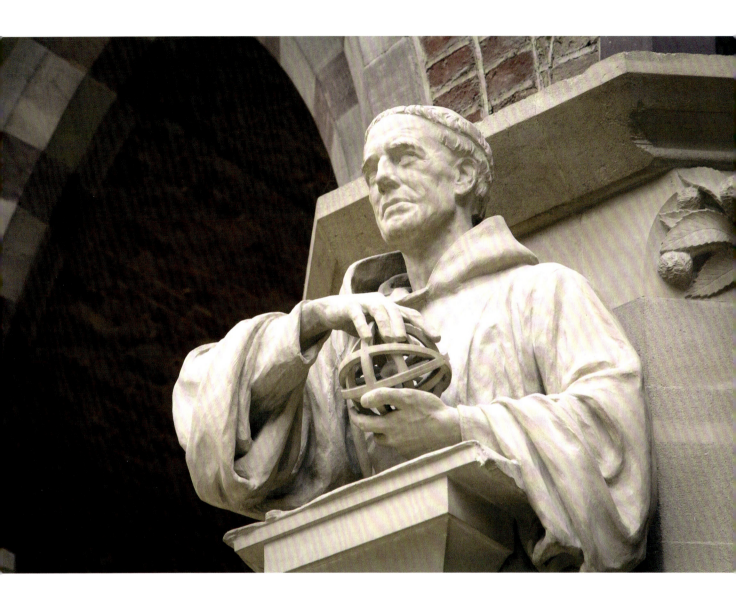

FIGURE 93 Henry Hope-Pinker, *Roger Bacon*, 1914.

that survive long enough and are healthy enough get to reproduce and pass on their traits to later generations. Like Darwin himself, Ruskin found it hard to square that process with a belief in a benevolent God. Faced with a choice between science and faith, Ruskin rejected the theory of natural selection and with it modern science at large. He even argued, in another set of lectures which he gave in Oxford as early as 1872, that science itself should not be considered to be 'the arrangement of new systems, nor the discovery of new facts' but rather 'the submission to an eternal system, and the proper grasp of facts already known'. Using the old Latin term, he called this *scientia*, which he defined as 'knowledge of constant things'.[15]

In championing *scientia*, Ruskin wanted the museum to return to the ideal expressed in Pollen's original design for the entrance arch, in which nature was a written book, fixed for ever and open for us to read. Unlike Acland, Ruskin did not believe that modern Darwinian science was compatible with what he held to be the factual and moral truths of Christianity. Yet the museum itself, in keeping with its founding purpose, always maintained a place for religion in alliance with, not in opposition to, science. The last scientist to be added to the pantheon of statues, carved by Hope-Pinker in 1914, was the thirteenth-century philosopher, experimentalist and Franciscan friar Roger Bacon (figure 93). The inclusion of the statue of this medieval natural philosopher (commissioned to celebrate the anniversary of Bacon's birth, traditionally dated to 1214) vindicated the museum's Gothic architecture on the very grounds that Richard Owen had given for rejecting it. Owen had protested to Acland that the sciences 'were not born or nursed' in the Gothic Middle Ages, yet Bacon's researches proved otherwise.[16] If Darwin carried the museum into an intellectual future it had no choice but to face, Bacon reaffirmed the value of a past in which science and religion had gone hand-in-hand. His friendly lined face seems on the cusp of a smile as he demonstrates the workings of the armillary sphere in his hands. Hope-Pinker's final statue restores a fresh vitality to intellectual enquiry even as it returns us to a medieval moment usually passed over in the history of science.

Nearly fifty years before, Acland had assured his Oxford colleagues that, if they embraced science, they could incorporate it into their own ideal of a humane, liberal, Christian education. In the years immediately after the museum was built, the scientific naturalists demolished the assumptions of natural theology and jettisoned its methods. By shifting ground, conceding the material world to material science, while retaining a central place for religion, art and the humanities, Acland was able to sustain Oxford's

educational ideal. Since his death in 1900, British society has become more secular, for all that, in many other parts of the world, religious beliefs have entrenched themselves, at times at the expense of science. In modern Britain, Pollen's angel looks like a relic of an earlier worldview, out of keeping with a museum dedicated to the scientific study of nature. But it remains a reminder not only of the Oxford University Museum's original mission and how it has changed since it was first built, but also of the more constant principle that religious beliefs, myths and art are not always or intrinsically incompatible with science, and that dialogues between them, bringing about mutual understanding and shared acts of creation and imagination, can offer us a richer conception of ourselves and of the natural world than any one of them can offer alone.

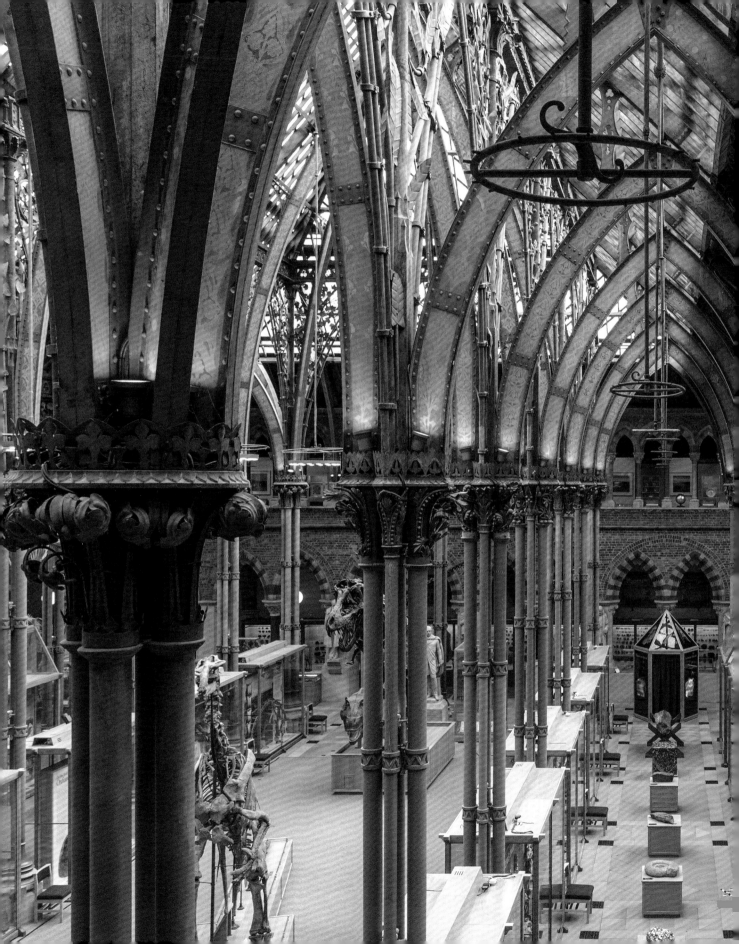

7 Legacies

BENJAMIN WOODWARD suffered with tuberculosis throughout the building of the Oxford University Museum. From the late 1850s, he wintered in the south of France, hoping to prolong his life. He lived to see the museum open, but the carving was still in process when he died in Lyons in May 1861. Acland and others commissioned a monument to him by Alexander Munro (figure 19), who had worked closely with him at the museum. It captures, movingly, the quiet, self-effacing manner which accompanied Woodward's far-seeing vision. His design for the museum took Victorian Gothic architecture out of its initial backward-looking and imitative phase, enabling it to become its own fresh, imaginatively free style. Frederic Stephens was struck by the 'principle of diversity in unity' which characterized its decoration.[1] In Woodward's design, Gothic forms give unity to a rich eclectic diversity. The Oxford museum recalls the Middle Ages – the Gothic arch is a recurrent pattern wherever you look – but it is not bound by a rigid medieval purism. The colonnade is more Renaissance, the statuary somewhat classical, the capitals gesture towards Corinthian. The roof is startlingly modern and startlingly Gothic at the same time. Woodward's pioneering design paved the way for further Gothic buildings as exciting and diverse as Street's Royal Courts of Justice, George Gilbert Scott's St Pancras Station, Alfred Waterhouse's Natural History Museum and, in the final twentieth-century apotheosis of Gothic, Giles Gilbert Scott's Liverpool Cathedral. These buildings are on a grander scale than the Oxford museum, but none of them exceeds it for architectural originality, imagination or brilliance.

The art of the Oxford University Museum combines architecture, decorative carvings, ironwork, portrait sculptures and landscape painting. Its governing principle was the Pre-Raphaelite dedication to truth to nature, but, as Stephens's remark implies, it fulfils this in many different ways, showing plants growing, animals moving, ecologies thriving, landscapes forming and scientists thinking. Because it was created by so many different artists, each working to a greater or lesser degree according to Ruskin's principle that the individual craftsman should be trusted to make his own art, and in collaboration with scientists who had their own individual

FIGURE 94 *previous spread* Interior view of the Oxford University Museum of Natural History.

perspectives on nature and the scientific enterprise, the museum has never been tied down to a single story. Instead, the building as a whole offers us a complex, intricate and yet comprehensive artistic representation of science and nature. As an architectural space, it is immersive, while each individual carving, spandrel, mural or statue is an artwork in its own right. Together they have a good claim to make up the single greatest work of Pre-Raphaelite art.

The museum was foundational for the Arts and Crafts movement too. As Tuckwell noted in his recollections of its construction, two of the many recent Oxford students who gathered round Woodward and eagerly watched his building going up were William Morris and Edward Burne-Jones. Woodward's attention to the fixtures and fittings at the museum was quietly inspirational. For Tuckwell, 'its every detail, down to panels and footboards, gas-burners and door handles' (figure 95) was 'an object lesson in art, stamped with Woodward's picturesque inventiveness and refinement'.[2] While Woodward was at work on the museum, Morris and Philip Webb worked for his comrade-in-arms George Edmund Street in his Oxford office.

FIGURE 95 Inner door handle on the main entrance to the central court, designed by Benjamin Woodward, c.1860.

FIGURE 96 The old debating chamber, now the library, of the Oxford Union Society, designed by Benjamin Woodward and decorated by Dante Gabriel Rossetti, William Morris and others, 1856–9, with the ceiling repainted by Morris in 1875.

In Tuckwell's plausible account, the seed from which Morris & Co., the Red House and Kelmscott Press would all bloom was planted at the Oxford museum.

The first spin-off from Woodward's collaboration with the Pre-Raphaelites on the museum was the project to build and decorate a new debating chamber for the Oxford Union Society, between 1856 and 1859 (figure 96). In the process, what was in effect a second Pre-Raphaelite Brotherhood was born, with Dante Gabriel Rossetti, Morris, Burne-Jones and the poet Algernon Charles Swinburne, then a student at Balliol College, at its heart. In 1856, Morris and Burne-Jones launched the *Oxford and Cambridge Magazine*. They based it on *The Germ*, even going to the lengths of soliciting poems from their idol Rossetti.[3] Rossetti had always been half-hearted in his commitment to the scientific principles of the original Pre-Raphaelite enterprise. At the Oxford Union, he had the chance to work with Woodward on a project which had nothing to do with science, indulging his love of medievalism for its own sake. Rossetti gathered round him a group of enthusiastic young artists, Morris and Burne-Jones among them, as well as a number of Woodward's other collaborators, including Munro and Pollen. Together, they set about creating a cycle of murals and sculpture depicting Arthurian legends, set off by decorative work on the roof by Morris, Tyrwhitt, Swan and Morris's future business partner Charles Faulkner.[4] The Union Society murals were compositionally and technically demanding, and few of the young artists were fully up to the challenge. The most compelling panels are Rossetti's *Sir Lancelot's Vision of the Sangrael* (figure 97) and Pollen's *King Arthur Receiving His Sword Excalibur*, both of which realize the Arthurian stories with an unsettling otherworldliness. The series was left unfinished, to be completed by the more conventional painters William and Briton Rivière. The murals that were finished began to deteriorate almost immediately, as the ground had not been properly prepared, while the ceiling had to be redecorated by Morris in 1875. It has only been possible to see the whole ensemble at its best again since extensive and expensive restoration work was undertaken in the 1980s.

After Woodward's death, Thomas Newenham Deane continued the firm's connection with Oxford. As Acland had argued, one of the advantages of adopting Gothic as an architectural style was that, unlike classical styles, it did not require symmetry, so as new sciences developed within the University new facilities could be added to the original museum building on any side to accommodate them. Deane built the two most substantial of these extensions, each effectively a new building in its own right. The first

was the Clarendon Laboratory of Physics. The first purpose-built physics laboratory in England, it was opened in 1872. It has since been subsumed under more recent buildings, although a few of the original details can still be seen. The second was the Pitt Rivers Museum (figure 98), built in the mid-1880s by Deane and his son and partner Thomas Manley Deane, the third generation of the same family to join the practice. In 1884 the anthropologist Lieutenant General Augustus Pitt-Rivers gave his collection of over 20,000 archaeological and ethnological artefacts to Oxford on the condition that the University build a museum to house them. The rear wall of the original museum had been left purposely free from offices and lecture rooms to allow for extension, and visitors now have to walk through the Oxford University Museum of Natural History to get to to the Pitt Rivers Museum. The effect of going from one museum into the other is architecturally striking, even disorienting. Whereas what is now the natural history museum is light and airy, with its vaulted glass roof, the Pitt Rivers Museum's original glass roof was blacked out in the twentieth century to preserve the specimens. As a result, it has no natural light, so it feels at once enticing and forbidding. This effect is enhanced as you walk down into its main court, cramped with case after case of infinitely intriguing objects from musical instruments to shrunken heads.

The Oxford University Museum continued to grow, as it had always been intended to do. As well as the Clarendon Laboratory and the Pitt Rivers Museum, new buildings were erected for the study of morphology, physiology and human anatomy, along with additional rooms for chemistry and geology. Architecturally, however, the buildings which budded off from Woodward's original museum in Oxford are ultimately less significant than the lineage of other natural history museums which descended from it. In 1860, when the museum opened, it was a unique experiment in using architecture to represent a scientific vision of nature. By 1900 – the year both Acland and Ruskin died – it had been joined by further museums across Europe. In London, Alfred Waterhouse built a Romanesque cathedral to nature for Owen, who had been in charge of the natural history collections at the British Museum since the mid-1850s. After visiting Oxford, Waterhouse had employed Woolner and the O'Sheas as sculptors on his first major commission, the Assize Courts in Manchester, which were subsequently destroyed during the Second World War. Learning from their work at the Oxford museum and from the building as a whole, he went on to build the Natural History Museum (figure 99) to embody Owen's explicitly Christian understanding of God's design in nature.[5]

FIGURE 97 *following spread* Dante Gabriel Rossetti, study for *Sir Lancelot's Vision of the Sangrael*, 1857, his mural at the Oxford Union Society.

FIGURE 98 *previous spread* The Pitt Rivers Museum, Oxford, built by Thomas Newenham Deane & Son, 1885–6.

FIGURE 99 *right* The Central Hall of the Natural History Museum, London, built by Alfred Waterhouse, 1873–81, now known as Hintze Hall. The use of iron and glass and the echoes of church architecture show the influence of the Oxford University Museum.

The Natural History Museum opened in 1881. The Naturhistorisches Museum in Vienna followed in 1889. Here the architects Gottfried Semper and Carl von Hasenauer worked with dozens of local artists to depict the workings of nature and the history of science in a cornucopia of statues, mythic caryatids, realist paintings and rococo stucco work and stencilling. Where Oxford and London used medieval architectural styles to represent a Christian view of nature, the museum in Vienna was a baroque extravaganza which, as its resident art historian Stefanie Jovanovic-Kruspel has shown, embodied the liberal, Darwinist science of the first director, Ferdinand von Hochstetter.[6] A harsher Darwinian message, stressing the violence of nature and the struggle to survive, runs through the art decorating the comparative anatomy and palaeontology galleries in the Jardin des Plantes in Paris, which opened in 1898. For all their differences in style and scientific ideology, these four museums – Oxford, London, Vienna and Paris – share an artistic flair and independence which enriches their scientific interpretations of nature. Today natural history museums still follow Oxford's lead in looking to natural forms to inspire their architecture, like the cocoon at the Darwin Centre in London or the Michael Lee-Chin Crystal at the Royal Ontario Museum in Toronto (figure 100).

The Oxford University Museum of Natural History stands as a tribute to the scientists and artists who created it. In 2016, the museum launched Visions of Nature, a year-long project to pay tribute to and revive the fusion of science and art on which it was founded. The programme for the year included art and photography, poets in residence and an exhibition of the original designs for the museum itself. Since then, the arts have become integral to the work that the museum does to communicate, interpret and examine current science – a trend which, like its original architectural principles, is taking hold in other natural history museums around the world. Science is vital to our understanding not only of the natural world but of our impact on it. We need science to work out how best to survive the perilous environmental crisis which we have created for ourselves. At the same time we need art, in all its forms, to bring this need to the forefront of people's imaginations, to realize what it means to us as human animals to be living through this moment, and to move us to act. Science and its methods are once again absolutely central to what Frederic Stephens called 'the moral purposes of the arts', but without art science itself can seem remote or impersonal, its truths hardly registering as reality.[7] Natural history museums have a key role in engaging the public with science, not only to

teach us the facts but to allow us to reflect and act on their implications. As the Oxford museum shows, then and now, by working together, art and science can create visions of nature that are at once inspiring, moving and morally profound.

FIGURE 100 The Michael Lee-Chin Crystal at the Royal Ontario Museum, Toronto, designed by Daniel Libeskind, completed in 2007. Like the Oxford museum, the Crystal combines natural forms with the exuberant use of glass and metal.

Notes

Chapter 1

1. Charles W.J. Withers, *Geography and Science in Britain, 1831–1939: A Study of the British Association for the Advancement of Science*, Manchester University Press, Manchester, 2010, p. 47. In addition to the specific sources listed, biographical information regarding the individual scientists discussed in the chapter is drawn from Bernard Lightman (ed.), *The Dictionary of Nineteenth-Century British Scientists*, 4 vols, Thoemmes Continuum, Bristol, 2004.
2. Robert Fox, 'The University Museum and Oxford Science, 1850–1880', in M.G. Brock and M.C. Curthoys (eds), *The History of the University of Oxford*, vol. vi, *Nineteenth-Century Oxford, Part 1*, Oxford University Press, Oxford, 1997, pp. 641–91 (pp. 642–3).
3. OUMNH archives, HBM Box 5, file 9.
4. *The Unveiling of the Statue of Sydenham in the Oxford Museum August 9, 1894, by the Marquess of Salisbury, with an Address by Sir Henry W. Acland*, Horace Hart, Oxford, 1894, p. 8.
5. Fox, 'The University Museum and Oxford Science', p. 646.
6. OUMNH archives, HBM Box 5, file 7.
7. Charles Daubeny, *Brief Remarks on the Correlation of the Natural Sciences, drawn up with reference to the scheme for the extension and better management of the studies of the University, now in agitation*, Vincent, Oxford, 1848.
8. Henry Wentworth Acland, *Remarks on the Extension of Education at the University of Oxford, in a letter to the Rev. W. Jacobson, D.D.*, Parker, Oxford, 1848, p. 12.
9. *A Catalogue of the Ashmolean Museums, Descriptive of the Zoological Specimens, Antiquities, Coins, and Miscellaneous Curiosities*, Collingwood, Oxford, 1836, p. vii. See Arthur MacGregor and Abigail Headon, 'Re-inventing the Ashmolean: Natural History and Natural Theology at Oxford in the 1820s to 1850s', *Archives of Natural History*, vol. 27, 2000, pp. 369–406.
10. John Kidd, *An introductory lecture to a course in comparative anatomy, illustrative of Paley's natural theology*, Oxford University Press, Oxford, 1824, p. 1.
11. J.B. Atlay, *Sir Henry Wentworth Acland: A Memoir*, Smith, Elder, London, 1903, pp. 140–41.
12. Acland, *Remarks*, p. 39.
13. Oxford University Archives, NW2/1/1.
14. Oxford University Archives, NW2/1/2.
15. Oxford University Archives, NW2/1/8: Richard Greswell, *Memorial on the (Proposed) Oxford University Lecture Rooms, Library, Museums, &c*, privately printed, Oxford, 1853 (including a reprint of an earlier memorial from 1850).
16. H.E. Strickland, *On Geology in Relation to the Studies of the University of Oxford*, Vincent, Oxford, 1852.
17. Oxford University Archives, NW2/1/4–5, 7, 9–10, 19.
18. Fox, 'The University Museum and Oxford Science', pp. 649–50.
19. William Michael Rossetti, 'Fine Arts: Pre-Raphaelitism', *Spectator*, vol. 24, 1851, pp. 955–7 (p. 955).
20. John Lucas Tupper, 'The Subject in Art', *The Germ*, no. 1, 1850, pp. 11–18, 118–25 (p. 14).
21. Rossetti, 'Fine Arts: Pre-Raphaelitism', p. 55.
22. Rossetti, 'Fine Arts: Pre-Raphaelitism', p. 56.
23. Frederic George Stephens (as John Seward), 'The Purpose and Tendency of Early Italian Art', *The Germ*, no. 1, 1850, pp. 58–64 (p. 61).
24. Stephens (as Laura Savage), 'Modern Giants', *The Germ*, no. 1, 1850, pp. 169–73 (p. 170).
25. Tupper, 'The Subject in Art', p. 122.
26. This account of the Pre-Raphaelites' early connection to Oxford is based on the thorough scholarship for the catalogue of the 1984 exhibition of Pre-Raphaelite art at the Tate Gallery. See *The Pre-Raphaelites*, Tate Gallery, London, 1984, pp. 74–7, 80–82, 86–90, 202.
27. *The Pre-Raphaelites*, pp. 117–19.
28. Strickland, *On Geology*, p. 12.
29. Daubeny, *An Introduction to Atomic Chemistry*, John Murray, Oxford, 1831, pp. 2–3.
30. Daubeny, *An Introduction to Atomic Chemistry*, p. 2.
31. W. Holman Hunt, *Pre-Raphaelitism and the Pre-Raphaelite Brotherhood*, 2 vols, Macmillan, London, 1905, 1, p. 159; Stephens, 'The Two Pre-Raphaelitisms', *The Crayon*, vol.

3, 1856, pp. 225–8, 289–92, 321–4, 353–6, and vol. 4, 1857, pp. 261–5, 298–302, 325–9, 361–3 (p. 362).

32 Hunt, *Pre-Raphaelitism*, II, p. 312.
33 *The Works of John Ruskin*, ed. E.T. Cook and Alexander Wedderburn, 39 vols, George Allen, London, 1903–12, digitized by the Ruskin Library and Research Centre, Lancaster University, xxxv, p. 198.
34 Tim Hilton recounts the events of this trip to Scotland in *John Ruskin*, Yale University Press, New Haven, CT, and London, 2002, pp. 181–95. For a full documentary account, see Mary Lutyens, *Millais and the Ruskins*, John Murray, London, 1967.
35 Atlay, *Sir Henry Wentworth Acland*, p. 173.
36 *The Pre-Raphaelites*, p. 117.
37 Stephen Wildman (ed.), *Ruskin and the Pre-Raphaelites*, Pallas Athene, London, 2012, p. 127.
38 Quoted in Nicolaas Rupke, *Richard Owen: Biology without Darwin*, 2nd ed., University of Chicago Press, Chicago, 2009, p. 253.
39 Anon., 'The New Museum at Oxford', *Athenaeum*, no. 1411, 11 November 1854, pp. 1372–3 (p. 1373).
40 George Edmund Street, *An Urgent Plea for the Revival of True Principles of Architecture in the Public Buildings of the University of Oxford*, John Henry Parker, Oxford, 1853, p. 12.
41 Street, *An Urgent Plea*, p. 17.
42 Daubeny, *Miscellanies*, 2 vols, James Parker, Oxford, 1867, II, p. 172.
43 J.H. Parker (attr.), *The Old English Style of Architecture, as Applicable to Modern Requirements, or, Suggestions for the New Museum at Oxford*, privately printed, Oxford [1853], p. 4.
44 Anon., 'The New Museum at Oxford', p. 1372.
45 Street, 'On the Future of Art in England', *Ecclesiologist*, vol. 19, 1858, pp. 232–40 (p. 234).
46 Oxford University Archives, NW2/1/16 and MU1/1.
47 Oxford University Archives, MU1/1, p. 49
48 Oxford University Archives, NW2/1/21.
49 Oxford University Archives, NW2/1/19.
50 Frederic O'Dwyer, *The Architecture of Deane and Woodward*, Cork University Press, Cork, 1997, p. 172.
51 Fox, 'The University Museum and Oxford Science', p. 641.
52 Lutyens, *Millais and the Ruskins*, p. 247.
53 Bodleian Library, MS Acland d. 72: 43. The letter itself is undated, but a transcription in the OUMNH archives, Edmonds J3, gives the date as 13 December 1854.
54 OUMNH archives, Edmonds J3, from a letter transcribed by R. Trevelyan, 8 July 1873. A slightly different transcription of the same letter is included in *Reflections of a Friendship: John Ruskin's Letters to Pauline Trevelyan 1848–1866*, ed. Virginia Surtees, Allen & Unwin, London, 1979.
55 Lutyens, *Millais and the Ruskins*, p. 248.
56 John Rylands Library, Rylands English MS 1254.
57 Katherine Macdonald, 'Alexander Munro: Pre-Raphaelite Associate', in Benedict Read and Joanna Barnes (eds), *Pre-Raphaelite Sculpture: Nature and Imagination in British Sculpture 1848–1914*, Henry Moore Foundation, London, 1991, pp. 46–8, 57–8 (pp. 58–9). A letter from Munro to Acland dated 18 September 1847 survives in the Bodleian Library, MS Acland d. 71: 40.
58 Oxford University Archives, MU1/1, p. 62.
59 *Oxford Architectural Society: Reports of Meetings from July 1853, to May 31, 1856*, pp. 70–71.
60 Acland and Ruskin, *The Oxford Museum*, 5th ed., George Allen, London, 1893, p. 106.
61 Street, *An Urgent Plea*, p. 4.
62 Strickland, *On Geology in Relation to the Studies of the University of Oxford*, p. 8.
63 Phillips quoted in Acland and Ruskin, *The Oxford Museum*, pp. 100, 92.
64 O'Dwyer, *The Architecture of Deane and Woodward*, p. 153.
65 *The Correspondence of Dante Gabriel Rossetti*, ed. William E. Fredeman, 9 vols, D.S. Brewer, Cambridge, 2002–10, II.ii, p. 175.
66 For differing interpretations of the relationship between

the Trinity College Dublin Museum Building and the Oxford University Museum, see Patrick N. Wyse Jackson and Peter S. Wyse Jackson, 'A Stone Menagerie and Botanical Conservatory: The Naturalistic Carvings of the Museum Building', in Christine Casey and Patrick Wyse Jackson (eds), *The Museum Building of Trinity College Dublin: A Model of Victorian Craftsmanship*, Four Courts Press, Dublin, 2019), pp. 217–51; and John Holmes, 'Science and the Language of Natural History Museum Architecture: Problems of Interpretation', *Museum and Society*, vol. 17, no. 3, 2019, pp. 342–61 (pp. 345–7).
67 Dante Gabriel Rossetti quoted in Alexander Gilchrist, 'The Late Mr. Woodward', *The Critic*, 23 1861, pp. 181–2 (p. 182, emphasis in the original).
68 Acland and Ruskin, *The Oxford Museum*, p. 57. For a discussion of the relationship between the design and decoration of the Oxford University Museum and Pauline Trevelyan's collaboration with Scott and Ruskin at Wallington Hall, see Lucy West,'"She enclosed & decorated this hall on the advice of John Ruskin": Pauline, Lady Trevelyan and the Creation of Wallington Hall's Central Hall', *Journal of Art Historiography*, no. 22, 2020 [https://arthistoriography.files.wordpress.com/2020/05/west.pdf].
69 Bodleian Library, MS Acland d. 72: 68r.
70 OUMNH archives, Edmonds J8.
71 Josephine E. Butler, *Recollections of George Butler*, Arrowsmith, Bristol, 1892, p. 90.
72 Atlay, *Sir Henry Wentworth Acland*, pp. 228, 392.
73 Rossetti, *Correspondence*, II.ii, p. 52.
74 Ibid., pp. 47–8.
75 Ibid., p. 44.
76 OUMNH archives, HBM Box 2, file 4.
77 Rossetti, *Correspondence*, II.ii, pp. 109–15.
78 Ruskin, *Works*, III, p. 33.
79 Ibid., p. 37.
80 W. Tuckwell, *Reminiscences of Oxford*, 2nd ed., Smith, Elder, London, 1907, p. 52.
81 *Oxford Architectural Society: Reports of Meetings*, pp. 34–5.
82 Ibid., p. 69.
83 Ruskin, *Works*, XVI, p. 387.
84 Greswell, *Memorial*, p. 7, emphasis in the original.
85 Translated in Acland and Ruskin, *The Oxford Museum*, p. 34. Quoted from Hippocrates, *Aphorisms*, 1, 1. The inscription itself reads 'ΒΙΟΣ ΒΡΑΧΥΣ. ΤΕΧΝΗ ΜΑΚΡΗ. ΚΑΙΡΟΣ ΟΞΥΣ. ΠΕΙΡΑ ΣΦΑΛΕΡΗ. ΚΡΙΣΙΣ ΧΑΛΕΠΗ.'

Chapter 2
1 Greswell, *Memorial*, p. 7, emphasis in the original.
2 Acland and Ruskin, *The Oxford Museum*, p. 57.
3 Street, *An Urgent Plea*, p. 1.
4 O'Dwyer, *The Architecture of Deane and Woodward*, p. 192.
5 Bodleian Library, MS Acland d. 95: 62; OUMNH archives, HBM Box 5a, Museum Delegates record, vol. 2, p. 28.
6 Letter from Woolner to Woodward, Bodleian Library, MS Acland d. 95: 62.
7 *Unveiling of the Statue of Sydenham*, p. 36.
8 Ibid., p. 35.
9 Acland and Ruskin, *The Oxford Museum*, pp. 106–7.
10 Oxford University Archives, NW2/1/28.
11 Bodleian Library, MS Acland d. 95: 42v.
12 Acland and Ruskin, *The Oxford Museum*, pp. 106–8.
13 James Fergusson, *History of the Modern Styles of Architecture*, Murray, London 1862, p. 328.
14 See O'Dwyer, *Architecture of Deane and Woodward*, pp. 231–42, for an exhaustive discussion of this story and what may actually have happened.

Chapter 3
1 Daubeny, *Miscellanies*, II, p. 172.
2 *Oxford Architectural Society: Reports of Meetings*, p. 70.
3 OUMNH archives, Edmonds J51.
4 O'Dwyer, *The Architecture of Deane and Woodward*, p. 263.
5 *Oxford Architectural Society: Reports of Meetings*, p. 70.
6 Stephens, 'Modern Giants', p. 170.
7 Ruskin, *Works*, III, p. 34.

8 Stephens, 'Modern Giants', pp. 172–3.
9 Carla Yanni, *Nature's Museums: Victorian Science and the Architecture of Display*, Princeton Architectural Press, New York, 2005, p. 54.
10 Patrick Wyse Jackson, 'A Victorian Landmark: Trinity College's Museum Building', *Irish Arts Review Yearbook*, vol. 11, 1995, pp. 149–54 (pp. 152–3); and Casey and Wyse Jackson, *The Museum Building of Trinity College Dublin*.
11 Acland and Ruskin, *The Oxford Museum*, p. 92, emphasis in the original.
12 Acland and Ruskin, *The Oxford Museum*, p. 99.
13 Ibid.
14 Ruskin, *Works*, XII, p. 321.
15 O'Dwyer, *Architecture of Deane and Woodward*, pp. 250–51; Blair J. Gilbert, 'Puncturing an Oxford Myth: The Truth about the "Infamous" O'Sheas and the Oxford University Museum', *Oxoniensia*, vol. 74, 2009, pp. 87–112 (p. 91).
16 H.M. Vernon and K. Dorothea Vernon, *A History of the Oxford Museum*, Clarendon Press, Oxford, 1909, p. 79.
17 Stephens, 'The Oxford University Museum', *Macmillan's Magazine*, vol. 5, 1862, pp. 525–33 (p. 529).
18 Quoted in [Gilchrist,] 'The Late Mr. Woodward', p. 182.
19 Ruskin, *Works*, XXII, p. 525.
20 Stephens, 'The Oxford University Museum', p. 528.
21 Ibid., p. 530.
22 Ibid., pp. 530, 528.
23 Ibid., p. 530.
24 Gilbert, 'Puncturing an Oxford Myth', pp. 100–101.
25 Eve Blau, *Ruskinian Gothic: The Architecture of Deane and Woodward 1845–61*, Princeton University Press, Princeton, NJ, 1982, p. 68.
26 OUMNH archives, Edmonds J3.
27 O'Dwyer, *Architecture of Deane and Woodward*, p. 247.
28 Ibid., pp. 246–51.
29 Henry A. Miers, 'The New Carvings at the University Museum', quoted in Ruskin, *Works*, XXXVIII, p. 366.
30 Vernon and Vernon, *A History of the Oxford Museum*, p. 85.
31 Miers, 'The New Carvings at the University Museum', quoted in Ruskin, *Works*, XXXVIII, p. 366.
32 Vernon and Vernon, *A History of the Oxford Museum*, p. 86.
33 Stephens, 'The Oxford University Museum', p. 528.
34 Cited in Ruskin, *Works*, XVI, p. xlvi.
35 Acland and Ruskin, *The Oxford Museum*, p. 88.
36 W. Holman Hunt, *Oxford Union Society: The Story of the Painting of the Pictures on the Walls and Decorations on the Ceiling of the Old Debating Hall (Now the Library) in the Years 1857-8-9*, Oxford University Press, Oxford, 1906, p. 10.
37 Acland and Ruskin, *The Oxford Museum*, pp. 35–6.
38 Vernon and Vernon, *A History of the Oxford Museum*, p. 82.
39 Ruskin, *Works*, XXII, pp. 523–4.

Chapter 4
1 Daubeny, *Miscellanies*, II, p. 172.
2 Anon., 'Oxford Museum.—Balliol Chapel.—Blenheim', *The Builder*, vol. 17, 1859, pp. 401–2 (p. 401).
3 Jason M. Rosenfeld, 'New Languages of Nature in Victorian England: The Pre-Raphaelite Landscape, Natural History and Modern Architecture in the 1850s', unpublished PhD dissertation, New York University, 1999, pp. 285–6.
4 Jay Wood Claiborne, 'Two Secretaries: The Letters of John Ruskin to Charles Augustus Howell and the Rev. Richard St. John Tyrwhitt', unpublished PhD dissertation, University of Texas at Austin, 1969, pp. 175, 179–81.
5 Chris Stringer, *Homo Britannicus: The Incredible Story of Human Life in Britain*, Penguin, London, 2006, pp. 12–14.
6 See the plan of the first floor of the museum in Henry Acland and John Phillips, *The Oxford Museum*, 4th ed., Parker, Oxford, 1867.

7 James S. Dearden, *John Ruskin: A Life in Pictures*, Sheffield Academic Press, Sheffield, 1999, p. 48.
8 Anon., 'Oxford Museum', p. 401.
9 A. Pugin, A.W. Pugin and E.J. Willson, *Examples of Gothic Architecture*, vol. 2, Bohn, London, [1836] 1839, pp. 51–2.
10 John Henry Parker, *Some Account of Domestic Architecture in England from Edward I. to Richard II.*, Parker, Oxford, 1853), pp. 120–21.
11 Ibid., p. 121.
12 Fergusson, *History of the Modern Styles of Architecture*, p. 328.
13 Stephens, 'Modern Giants', p. 171.
14 O'Dwyer, *Architecture of Deane and Woodward*, pp. 201–3.

Chapter 5
1 OUMNH archives, HBM Box 2, file 144.
2 The original list of statues proposed comprised Euclid, Archimedes, Hipparchus, Aristotle, Hippocrates and Pliny for the ancients and Bacon, Galileo, Newton, Leibnitz, Ørsted, Lavoisier, Linnaeus, Cuvier, Harvey, Hunter and Sydenham for the moderns. Of these, Archimedes, Hipparchus, Pliny, Lavoisier and Cuvier were never commissioned.
3 OUMNH archives, HBM Box 22, file 144.
4 Oxford University Archives, NW2/1/28.
5 Bodleian Library, MS Acland d. 72: 85.
6 OUMNH archives, HM (1874–1902), Box 4, press cutting from 'The New University Museum at Oxford', *Illustrated Times*, 4 March 1865, pp. 141–2 (p. 142).
7 Acland and Ruskin, *The Oxford Museum*, p. 25.
8 Amy Woolner, *Thomas Woolner, R.A., Sculptor and Poet: His Life in Letters*, Chapman and Hall, London, 1917, p. 93.
9 Ibid., pp. 117, 128–9, 144.
10 Read, 'Thomas Woolner: PRB, RA', in Read and Barnes (eds), *Pre-Raphaelite Sculpture*, pp. 21–33 (p. 26).
11 Stephens, 'The Two Pre-Raphaelitisms', *The Crayon*, vol. 4, 1857, p. 362.
12 Acland and Ruskin, *The Oxford Museum*, p. 25.
13 Read, 'Introduction', in Read and Barnes (eds), *Pre-Raphaelite Sculpture*, pp. 7–11 (p. 9).
14 Tupper, 'English Artists of the Present Day. XXIX.— Henry Hugh Armstead', *The Portfolio*, vol. 2, 1871, pp. 128–34 (p. 132).
15 Bodleian Library, MS Acland d. 95: 63.
16 *The P.R.B. Journal: William Michael Rossetti's Diary of the Pre-Raphaelite Brotherhood, 1849–1853, together with other Pre-Raphaelite Documents*, ed. William E. Fredeman, Oxford University press, Oxford, 1975, p. 96.
17 *Poems by the Late John Lucas Tupper*, ed. William Michael Rossetti, Longmans, London, 1897, p. ix.
18 W.M. Rossetti, *Some Reminiscences*, 2 vols, Scribner's, New York, 1906, 1, p. 160.
19 Tupper, *Poems*, pp. 21–2.
20 OUMNH archives, HBM Box 2, files 136, 139–40.
21 *Unveiling of the Statue of Sydenham*, pp. 10–11.

Chapter 6
1 Nicolaas Rupke, *The Great Chain of History: William Buckland and the English School of Geology (1814–1849)*, Oxford University Press, Oxford, 1983, pp. 42–50, 209–18, 267–74.
2 Anon., 'The New Museum', privately printed, Oxford, 1855.
3 Woolner, *Thomas Woolner*, p. 194.
4 Charles Darwin, *On the Origin of Species by Means of Natural Selection*, ed. Joseph Carroll, Broadview, Peterborough, Ontario, 2003, p. 397.
5 Richard England, 'Censoring Huxley and Wilberforce: A New Source for the Meeting that the *Athenaeum* "Wisely Softened Down"', *Notes and Records*, 14 pp., https://royalsocietypublishing.org/doi/10.1098/rsnr.2016.0058 (pp. 5–6).
6 England, 'Censoring Huxley and Wilberforce', pp. 5, 8.
7 Darwin, *On the Origin of Species*, p. 397.
8 Darwin, *On the Origin of Species*, p. 210.
9 *Fugitive Poems Connected with Natural History and Physical*

Science, ed. Charles Daubeny, James Parker, Oxford, 1869, p. 140.
10 OUMNH archives, Edmonds J3.
11 *Unveiling of the Statue of Sydenham*, pp. 35–7.
12 'Twelfth Annual Report of the Delegates of the University Museum (for 1899)', p. 4.
13 Ruskin, *Works*, XXII, p. 523; XXXIV, pp. 72–3.
14 Ruskin, *Works*, XXII, p. 517.
15 Ibid., p. 150.
16 Quoted in Rupke, *Richard Owen*, p. 253.

Chapter 7
1 Stephens, 'The Oxford University Museum', p. 527.
2 Tuckwell, *Reminiscences*, p. 51.
3 Paola Spinozzi and Elisa Bizzotto, *The Germ: Origins and Progenies of Pre-Raphaelite Interart Aesthetics*, Peter Lang, Bern, 2012, pp. 175–96.
4 Rosenfeld, 'New Languages of Nature', p. 281.
5 For accounts of the design and decoration of the Natural History Museum, see J.B. Bullen, 'Alfred Waterhouse's Romanesque "Temple of Nature": The Natural History Museum, London', *Architectural History*, vol. 49, 2006, pp. 257–85; Colin Cunningham, *The Terracotta Designs of Alfred Waterhouse*, Natural History Museum, London, 2001; Mark Girouard, *Alfred Waterhouse and the Natural History Museum*, 2nd ed., Natural History Museum, London, 1999; John Holmes, *The Pre-Raphaelites and Science*, Yale University Press, London and New Haven, NJ, 2018, pp. 207–33; and Yanni, *Nature's Museums*, pp. 111–46.
6 Stefanie Jovanovic-Kruspel and Alice Schumacher, *The Natural History Museum: The History of the Construction, its Conception and Architecture*, Naturhistorisches Museum, Vienna, 2017.
7 Stephens, 'The Purpose and Tendency of Early Italian Art', p. 61.

Further reading

Henry Acland and John Ruskin, *The Oxford Museum*, 5th ed. (London: George Allen, 1893)

Eve Blau, *Ruskinian Gothic: The Architecture of Deane and Woodward 1845–61* (Princeton: Princeton University Press, 1982)

Michael W. Brooks, *John Ruskin and Victorian Architecture* (London: Thames & Hudson, 1989)

Kelvin Browne, *Bold Visions: The Architecture of the Royal Ontario Museum* (Toronto: Royal Ontario Museum, 2008)

Christine Casey and Patrick Wyse Jackson (eds), *The Museum Building of Trinity College Dublin: A Model of Victorian Craftsmanship* (Dublin: Four Courts Press, 2019)

Colin Cunningham, *The Terracotta Designs of Alfred Waterhouse* (London: Natural History Museum, 2001)

Trevor Garnham, *Oxford Museum: Deane and Woodward* (London: Phaidon, 1992)

Blair J. Gilbert, 'Puncturing an Oxford Myth: The Truth about the "Infamous" O'Sheas and the Oxford University Museum', *Oxoniensia*, 74 (2009), pp. 87–112

Mark Girouard, *Alfred Waterhouse and the Natural History Museum*, 2nd ed. (London: Natural History Museum, 1999)

Ian Hesketh, *Of Apes and Ancestors: Evolution, Christianity and the Oxford Debate* (Toronto: University of Toronto Press, 2009)

John Holmes, *The Pre-Raphaelites and Science* (London and New Haven: Yale University Press, 2018)

John Holmes, 'Science and the Language of Natural History Museum Architecture: Problems of Interpretation', *Museum and Society*, 17.3 (2019), pp. 342–61

John Holmes (ed.), *Guests of Time: Poetry from the Oxford University Museum of Natural History*, with photographs by Scott Billings (Scarborough: Valley Press, 2016)

John Holmes and Paul Smith, 'Visions of nature: reviving Ruskin's legacy at the Oxford University Museum', *Journal of Art Historiography*, 22 (2020), 15pp [https://arthistoriography.files.wordpress.com/2020/05/holmes-and-smith.pdf]

Stefanie Jovanovic-Kruspel and Alice Schumacher, *The Natural History Museum: The History of the Construction, its Conception and Architecture* (Vienna: Naturhistorisches Museum, 2017)

Frederic O'Dwyer, *The Architecture of Deane and Woodward* (Cork: Cork University Press, 1997)

Nicholas Penny, *Ruskin's Drawings* (Oxford: Ashmolean, 2013)

Elizabeth Prettejohn, *The Art of the Pre-Raphaelites* (London: Tate, 2000)

Benedict Read and Joanna Barnes (eds), *Pre-Raphaelite Sculpture: Nature and Imagination in British Sculpture 1848–1914* (London: Henry Moore Foundation, 1991)

John D. Renton, *The Oxford Union Murals* (privately printed, 2005)

Andrea Rose (ed.), *The Germ: The Literary Magazine of the Pre-Raphaelites* (Oxford: Ashmolean, 1979)

Nicolaas Rupke, *The Great Chain of History: William Buckland and the English School of Geology (1814–1849)* (Oxford: Oxford University Press, 1983)

Allen Staley and Christopher Newall, *Pre-Raphaelite Vision: Truth to Nature* (London: Tate, 2004)

Carla Yanni, *Nature's Museums: Victorian Science and the Architecture of Display* (New York: Princeton Architectural Press, 2005)

Picture credits

© **Ashmolean Museum, University of Oxford**
WA1894.10: figs 10; 49
WA1894.16: fig. 22
WA1894.20: fig. 11
WA1909.1: fig. 47
WA1931.48: fig. 42
WA1931.50: fig. 38
WA1931.53: fig. 35
WA1950.7: fig. 97
WA2013.67: fig. 14

Bodleian Library, Oxford University Archives
MU 4/1/9: fig. 1
MU 4/1/5: fig. 2
NW 2/1/13: fig. 15b
MU 4/1/5: fig. 30
MU 4/2/2: fig. 73

Bodleian Library, University of Oxford
MS. Acland d.95: figs 36 (fol. 42v); 84 (fol. 86)
MS. Don d. 14, fol. 23r: fig. 13
MS. Top. Oxon. c. 16, fol. 137v: fig. 3
17006 e.147 (v.1): fig. 7
17364 e.3, plate 2: fig. 15a
1734 c.2, plate II: fig. 72
Arch. K c.4, fol. 14: fig. 26
G.A. Oxon 16° 108, plate VII: fig. 60
G.A. Oxon 8° 285 (1): fig. 64
Mason EE 35, plate 1: fig. 58
N. 2288 b.6, vol. 26, p. 652: fig. 17
N. 2288 b.6, vol. 37, p. 310: fig. 45
N. 1863 c.1, vol. 13: figs 27 (p. 318); 29 (p. 319)
N. 1863 c.1, vol. 17: figs 25 (p. 408); 71 (p. 253)
N. 1863 c.1, vol. 18: figs 37 (p. 398); 44 (p. 399)

© **Bridgeman Images** fig. 9

© **Meraj Chhaya** fig. 96

© **History of Science Museum, University of Oxford**
Inv. 45625: fig. 4

John Holmes figs 43; 53; 75; 78

**Courtesy of Studio Daniel Libeskind /
© Elliott Lewis Photography** fig. 100

Natural History Museum, London / Kevin Webb 2013
fig. 99

Oxford University Images / © Whitaker Studio
fig. 28

© **Oxford University Museum of Natural History**
fig. 6 (Museum Print Collection); figs 12; 18; 19; 21; 23; 24; 31; 32; 33; 34; 39; 40; 41; 46; 48; 50; fig. 51 (HBM box 2, folder 6:24); figs 52; 54; 55; 56; 57; fig. 59 (HBM036); figs 61; 62; 63; 66; 67; 68; 69; 70; 74; 76; 77; 79; 80; 81; 82; 83; 87; 88; 89; 90; 91; fig. 92 (Zoological Collections); figs 93; 94; 95

© **Pitt Rivers Museum, University of Oxford** fig. 98

RIBA Collections, SB48/5(1) fig. 16

© **The Ruskin - Library, Museum and Research Centre (University of Lancaster)** figs 5; 65

Trinity College Dublin fig. 20

University of Birmingham, Cadbury Research Library
fig. 8

Wellcome Collection fig. 86

Wikimedia Commons fig. 85

Index

Numbers in italics refer to artworks and illustrations. Where the people listed were directly involved in the creation of the museum or went on to work there, their role is given in brackets.

Abbot's Kitchen 118–9, 119–20
Acland, Henry Wentworth (physician and campaigner) 12–16, *13*, 25–8, *26*, 32–42, 46–51, 54, 62–5, 78, 103, 120, 124–5, 131–7, 140, 142, 146–8, 152, 156, 161
Acland, Sarah Angelina
 photograph of Ruskin and Acland *26*
Albert, Prince 46, 124
Albert Memorial, London 50, 128
Allingham, William 46
anthropology 161
Aristotle 124–8, *127*, 136
Armstead, Henry Hugh (sculptor) 128
 Aristotle 125–8, *127*
Arts and Crafts 157–60
Ashmolean Museum, Old 10, *11*, 15

Bacon, Francis 24, 25, 28, *125*, 126
Bacon, Roger *151*, 152
Baily, Edward Hodges 133
Barry, Charles 16, 119
Barry, Edward Middleton (runner-up architect) 32–3
 design for the museum *34–5*
bear-whales 145–6, *146*
Blau, Eve 94
Botanic Garden, Oxford 12, 47–8, 85, 102
botany 37, 62, 84–102
Boulton, Matthew (donor) 131
Bridgewater Treatises 16
British Association for the Advancement of Science 10–12, 38, 140
Buckland, William 14–16, *14*, 27, 38, 110, 137
Burdon-Sanderson, John Scott (physiologist) 142, *142*, 150
Burne-Jones, Edward 157, 160
busts 39–40, 137, *137*, 142, *143*
Butler, George (secretary) 43, 131
Butler, Josephine (designer) 43, 131
 arum lilies *43*

capitals and corbels 36–8, 42–3, *43*, 47–8, 49, 51, 84–94, *85–91*, *93*, *97*, 102–3, 144, *144–5*, 156
Cat Window *48*, 65–6, *66*, *68*, 72
Chantrey, Francis 133
chemistry 15, 19, 25, 108, 118–20, 137
Collins, Charles 18, 23
 Convent Thoughts 22, 23, 25, 84, *84*
Collinson, James *17*, 18
colonnade 37–8, 42, 50–51, 76, 78–84, *83*, 94
Combe, Thomas (Pre-Raphaelite patron) 23, *23*, 25, 55
Crawley, Frederick
 daguerreotype of the Mer de Glace *110*
Cuvier, Georges 124, 148

Darwin, Charles 10, *122–3*, 136, *138–9*, 140–52, *149*, 168
Daubeny, Charles (chemist, botanist and campaigner) 10–16, *12*, 25, 31, 47, 76, 108, 140, 142, 145–6
Davy, Humphry 131–3
Deane, Thomas (architect) 40, 119
Deane, Thomas Manley 161
Deane, Thomas Newenham (architect) 40, 160–61
Deane & Woodward (architectural practice) 32–3, 40–42, 76
 monogram *7*
 see also Thomas Deane, Benjamin Woodward
Doge's Palace, Venice 94, *95*
Donkin, William (astronomer) 120
Duncan, John Shute 15
Duncan, Philip Bury (curator and campaigner) 10–12, 15–16, 38
Durham, Joseph (sculptor) 133–6

engineering 28, 37–8, 76–8, 133
England, Richard 141
entomology 51, 108, 116–19
entrance 46, 54–63, *58–62*, 146–7, 152
Euclid 133–6
evolution 140–53

Farmer & Brindley (firm of sculptors) 94
Faulkner, Charles 160
Fergusson, James 65–6, 120
fireplaces 51, 116, *116*, 119
Flinn (sculptor) 85

Galileo 122–3, 131, *131*
geology 16–17, 19, 25, 37–8, 51, 78–84, 108–15
The Germ 18–19, *18*, 160
Gladstone, William Ewart (donor) 16
Glastonbury Abbey 119–20, *119*
Gothic Revival 27–33
Grant, Robert 10
Greswell, Richard (academic and campaigner) 16, 50, 54, 120, 142

Hardwick, Philip and Philip Charles (architectural consultants) 32
Harvey, William 133–6, *134*
Hippocrates 51, 131–3, *132*, 136
history 103–5
Hodgkin, Dorothy (chemist) 137, *137*
Holt (sculptor) 94, *96*, 102
 Canterbury bell capital *97*
Hooker, Joseph 142, 148
Hope, Frederick William (entomologist and donor) 116, 128
Hope-Pinker, Henry (sculptor) 136
 busts 137, *143*
 Charles Darwin 122–3, 136, 138–9, 148, *149*
 John Hunter 135, *136*
 Roger Bacon 136, 151, *152*
Hughes, Arthur
 Pre-Raphaelite Meeting 17
Hunt, William Holman 18, 20–25, 37, 103, 128, 140
 Pre-Raphaelite Meeting 17
 Thomas Combe 23
Hunter, John 135, *136*
Huxley, Thomas Henry 141–4, *141*

Inchbold, John William
 The Burn, November – the Cucullen Hills 80–81, *82*
ironwork 50–51, *51*, 98–101, 102

Jacobson, William 15
Jardin des Plantes, Paris 168
Johnson, Manuel (astronomer) 32, 120
Jovanovic-Kruspel, Stefanie 168

Kidd, John 15–16, 116

Lankester, E. Ray (biologist) 142
Leibnitz, Gottfried Wilhelm 131
Linnaeus, Carl 46, *47*, 128–30, *129*
Lothian, Marquis of (donor) 131
Lubbock, John 142

mathematics 12, 15
medicine 12, 51, 63, 92, 108, 136
meteorology 120–21
Miers, Henry Alexander (mineralogist) 94, 102
Millais, John Everett 17, 18, 20–28, 36–7, 55
 Ferdinand Lured by Ariel 20, *21*
 Henry Wentworth Acland 13
 John Ruskin 27–8, *29*, 36, 78
Mills (sculptor) 94, *96*, 102
 Canterbury bell capital *97*
Morgan, H.T. (donor) 94
Morris, William 157–60
Munro, Alexander (sculptor) 18, 37, 42, 131–3, 160
 Benjamin Woodward 40, 156
 Galileo 122–3, 131, *131*
 Hippocrates 131–3, *132*
 Isaac Newton 122–3, 131–3
murals 103, *104–5*, 108–11, *112–15*
Museum of Practical Geology 82

Natural History Museum, London 156, 161, *166–7*, 168
natural history 30–31, 37–8, 63–73, 128–30
 see also botany, entomology, evolution, geology, zoology
natural history museums 161, 168–9
natural theology 15–17, 54–63, 140–53
Naturhistorisches Museum, Vienna 168
New Sculpture 136
Newman, John Henry 12, 55
Newton, Isaac 25, 103, 122–3, 131–33
Noble, Matthew
 John Phillips 39

Ørsted, Hans Christian 131
O'Shea, James (sculptor) 46, 48, 161
 capitals and corbels 47–8, *49*, 85–94, *87–8*, *91*, *93*, 144
 window carvings *48*, 65–72, *65–6*, *68–70*, 145–6, *146*
O'Shea, John (sculptor) 46, 161
 capitals and corbels *43*, 47–8, *49*, 85–94, *90*, 144, *145*
Owen, Richard 16, 28, 152, 161
Oxford Movement 12, 23
Oxford Union Society 42, 103, 140, *158–9*, 160

paintwork *117*, 119
Paley, William 15–16
Parker, John Henry (architectural advisor) 31–2, 119–20
 design for the museum 31
Peel, Robert (donor) 14, 16
Phillips, John (geologist and first Keeper) 38–9, *39*, 46–7, 50, 82–5, 94, 120, 137
 design for date-palm capital 86
physics 15, 161
physiology 15–16, 108
Pitt Rivers Museum 161, *164–5*
Pitt-Rivers, Augustus (donor) 161
Plumptre, Frederick (academic) 65
Pollen, John Hungerford (designer) 55, 146, 160
 design for entrance arch 55, 60, 62–3, 146–7, 152–3
Poulton, E. B. (zoologist) 148

Pre-Raphaelite Brotherhood 17, 18–28, 160
Prestwich, Joseph (geologist) 142
Priestley, Joseph 133
Pugin, Augustus Welby 119
 drawing of the Abbot's Kitchen, Glastonbury 119
Pusey, Edward 12, 16

Remak, Robert 62
Rivière, Briton and William 160
roof 37–8, 50, *50*, 54, 76–8, *77*, *79*, 102, 129, 156, 161
Rolleston, George (anatomist) 142, 150
Rossetti, Dante Gabriel (design consultant) 17, 18, 20, 25, 36–7, 42, 46–7, 55, 85, 103, 131, 158–63
 Dante drawing an Angel on the Anniversary of Beatrice's Death 44–5
 Sir Lancelot's Vision of the Sangrael 160, *162–3*
Rossetti, William Michael 17, 18–19, 129
Royal Academy Schools 18–20
Royal Ontario Museum, Toronto 168, *169*
Rupke, Nicolaas 140
Ruskin, Effie 27, 37
Ruskin, John (designer and campaigner) 25–9, *26*, 29, 31, 36–7, 40, 43, 46–51, 76–8, 84–5, 94–5, 102–3, 108–10, 119, 124, 145–6, 148–52, 161
 daguerreotype of the Mer de Glace 110
 designs for windows 63–72, *64*, *67*, *71*
 illustration of a capital from the Doge's Palace, Venice 94, *95*
Ruskin, John James (donor) 131

Schleiden, Matthias 62, 147
Schwann, Theodor 62, 147
scientific naturalism 142
Scott, George Gilbert 48, 128, 156
Scott, Giles Gilbert 156
Scott, William Bell (designer) 42–3
Siddall, Elizabeth 46–7
Skidmore, Francis (engineer and ironworker) 48–50, 76–8, 128
 ironwork for museum roof 50, *51*, *79*, *98–101*, 102

Smith, Henry (mathematician) 137
Smith, William 38, 137
Spedding, James 125
statues 24, 25, 38, 46–7, 47, 51, 122–37, 122–3, 126–7, 129, 131–2, 134–5, 138–9, 148, 149, 151, 152
Stephens, Edward (sculptor) 133
Stephens, Frederick George 17, 18–25, 78, 85, 92, 102, 120, 125, 156, 168
Stephenson, George 133
Stones, Anthony (sculptor) 137
 Dorothy Hodgkin 137
Street, George Edmund (architectural advisor) 28–32, 54, 156–7
 design for the museum 30
Strickland, Hugh (geologist) 16–17, 25, 38
Swan, Henry (painter) 119, 160
 paintwork 117
Swinburne, Algernon Charles 160
Sydenham, Thomas 136

Thomson, William, Lord Kelvin 10
tower 54, 120, 121
Trevelyan Pauline (designer) 27, 36, 43, 84–5, 94
 tulips and lilies 85
Trevelyan, Sir Walter (donor) 27, 85, 103
Trinity College Dublin Museum Building 41, 42, 46–7, 82
Tuckwell, William 47, 157–60
Tupper, John Lucas (sculptor) 18, 20, 46, 128
 'A Vision of Linnaeus' 130
 Linnaeus 46, 47, 128–9, 129
Tylor, E.B. (anthropologist) 142
Tyrwhitt, Richard St John (painter) 51, 108–11, 160
 Bay of Naples from the Slopes of Vesuvius 109–11, 114–15
 Mer de Glace (mural) 109–11, 112–13
 Mer de Glace (oil painting) 110, 111

Vernon, Horace Middleton (physiologist) and Katharine Dorothea 85, 102–3

Victoria, Queen (donor) 124–5, 131
Virchow, Rudolph 63

Walker, Robert (physicist and campaigner) 12
Waterhouse, Alfred 156, 161
Watt, James 131–3
Webb, Philip 157
Weekes, Henry (sculptor) 133–6
 William Harvey 133–6, 134
Weldon, W.F.R. (biologist) 142, 142
Westwood, John Obadiah (entomologist) 116, 148
Westwood Room 116, 116–7, 119
Whelan, Edward (sculptor) 46
 capitals and corbels 47–8, 49, 85–94, 85, 89, 144, 144
 entomological museum fireplace 51, 116–19, 116
Wilberforce, Samuel 141–4, 141
windows 48, 63–72, 64–73, 85, 145–6, 146
Wise, T.J. 102
Woodward, Benjamin (architect) 40–42, 40, 46, 48, 54–5, 63–6, 72, 76, 82, 85, 119–21, 128, 145, 156–61
 designs for the museum 8–9, 58, 121
 door handle 157
Woolner, Thomas (sculptor and designer) 17, 18, 46, 128, 140, 161
 design for entrance arch 55, 59, 62
 Sir Francis Bacon 24, 25, 46, 125, 126, 128
Wyatt, James 20

zoology 50, 62, 108, 116, 148

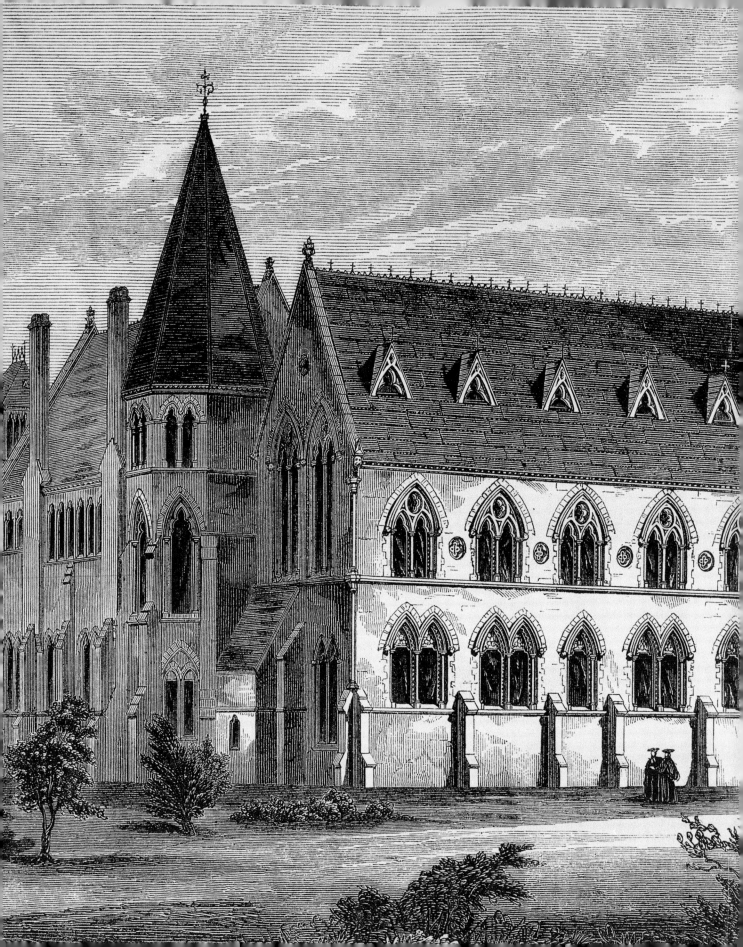

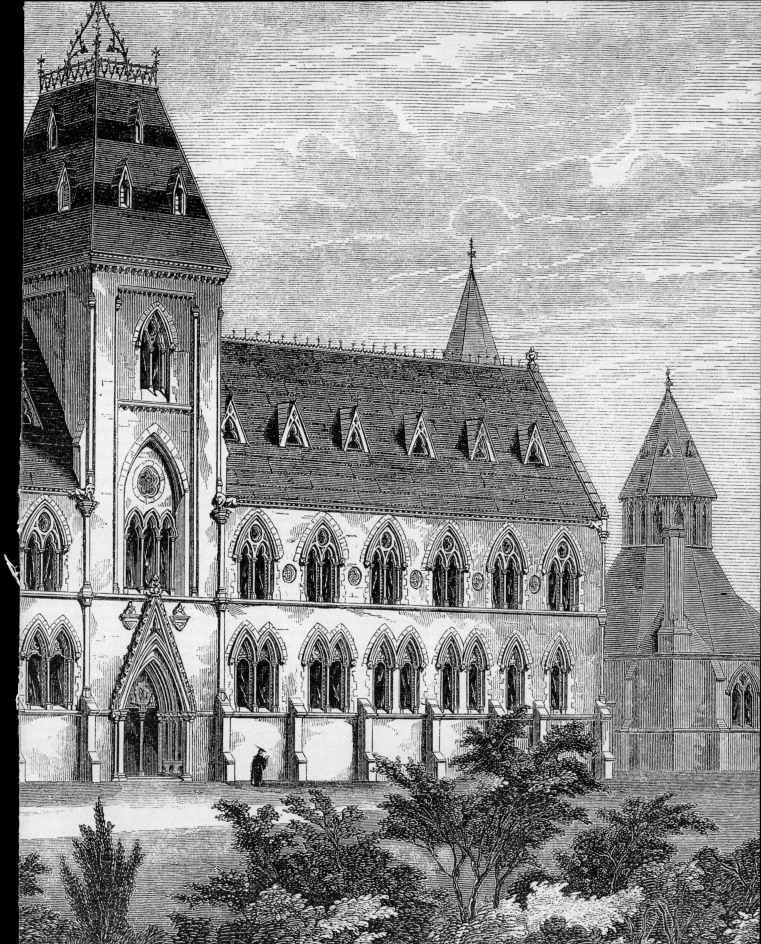

First published in 2020 by the Bodleian Library in association with
Oxford University Museum of Natural History
Broad Street, Oxford OX1 3BG
www.bodleianshop.co.uk

ISBN: 978 1 85124 556 7

Text © John Holmes, 2020

John Holmes has asserted his right to be identified as the author of this Work.

All images, unless specified on p. 177, © Bodleian Library, University of Oxford, 2020

All rights reserved

No part of this book may be reproduced, stored in a retrieval system, or transmitted in any form or by any means, electronic, mechanical, photocopying, recording, or otherwise, without the written permission of the Bodleian Library, except for the purpose of research or private study, or criticism or review.

Designed and typeset by Dot Little at the Bodleian Library in 10.5/14pt Adobe Jenson
Printed and bound through South Sea Global Services Limited
on 157gsm Golden Sun Matt Art paper

British Library Catalogue in Publishing Data
A CIP record of this publication is available from the British Library